D1530328

Flying Colors

Flying Colors

the story of a remarkable group of artists
and the transcendent power of art

Tim Lefens

BEACON PRESS · Boston

Beacon Press
25 Beacon Street
Boston, Massachusetts 02108–2892
www.beacon.org

Beacon Press books are published under the auspices of
the Unitarian Universalist Association of Congregations.

Printed in the United States of America
06 05 04 03 02 8 7 6 5 4 3 2 1

This book is printed on acid-free paper that meets
the uncoated paper ANSI/NISO specifications for
permanence as revised in 1992.

Text design by Melodie Wertelet
Composition by Wilsted & Taylor Publishing Services

Library of Congress Cataloging-in-Publication Data

Lefens, Tim.
 Flying colors : the story of a remarkable group of artists and
the transcendent power of art / Tim Lefens.
 p. cm.
 ISBN 0-8070-3180-1 (alk. paper)
1. Art—Study and teaching—United States. 2. People with
disabilities—Education—United States. 3. People with
disabilities and the arts—United States. I. Title.
 N88.3 .L44 2002
 371.9'04452'0973—dc21

 2002005377

for Anne Banister

Flying Colors

When you get to the top of the hill there are two ways to go: straight, which will take you into the woods, and left, which will take you to the hospital.

I had been told it was a school. The car slows to a crawl past the fancy wooden sign. It seemed like a nice enough thing, an abstract painter being invited to a school, but I, like you, am not anxious to go into a hospital, no matter what the reason.

The last acres of rising fields behind me now, the building appears; low, one-story, brick. It sits up on the top of this high hill: alone; quaint little towns and farmlands in the valley far below. A cardboard box under each arm, I wait outside the automatic glass doors of the main entrance. With a pneumatic exhale, the door rumbles open, and I step into the building. The receptionist is on the phone. When she gets off, she places a piece of paper and a blank ID badge on the counter, pushes them toward me.

"Fill these out," she says, then turns back to her work. Clipping the blank ID badge to my shirt, I hoist my slide projector and portable screen. Halfway down the main hall, fluorescent lights, gloss white cinderblock walls, shining linoleum floor, I have to step quickly to my right. Three doctors in white lab coats sweep past, behind them a child on a stretcher. The doctors, the child, and the man pushing the stretcher make a hard right turn and disappear.

The kid had not been on the stretcher the normal way. The stretcher had been rigged so it stood vertically, pushed ahead on a set of four wheels, the child lashed to the stretcher by a wide nylon belt that ran across his chest, up under his armpits, the little arms extending out and away from his body, fingers splayed, eyes glazed, tiny feet hanging above the rushing floor.

My stomach tightens. Further down the hall, two women stand together. A third, younger, sits in a wheelchair. As I move past them I hear their conversation.

"You're going to see a movie today." One of the standing women speaks singsong to the woman sitting in the wheelchair. "A movie. Yes, you are. Do you like movies?"

The young woman in the wheelchair stares vacantly at the floor.

"Anyway, like I was saying"—the standing woman turns to her coworker—"I am definitely getting that place down the shore this year."

Well past the women, I am drawn for some reason to stop, to look back, and am startled to see the young woman in the wheelchair watching me. She smiles, her eyes warm with the pleasure that we, at least our eyes, have met. Turning away, I blink. One moment the young woman looks brain-dead, the next completely alive. A little light-headed, the experience becoming surreal, I order my legs to move.

At the end of the hall, a set of glass doors with a warning: EMERGENCY EXIT ONLY, ALARM WILL SOUND. SALIDA DE EMERGENCIA SOLAMENTE. ALARMA FUNCIONARA. To the right of the fire-door alcove, a short unlit corridor. At the end of the corridor, an open door. I look back at the landscape outside the emergency exit, then turn to step into the dark.

In the center of the small room sits a—a something, a person, his head held upright by a network of stainless steel wires that run like spokes from a metallic headband to aluminum arma-

tures bolted to the back of the wheelchair. His underdeveloped body sits rigid, symmetrical as the chrome wheelchair. His brittle stick arms are strapped to the vinyl-padded armrests, his hands dangling off the ends, the fingers twisted, bent backward, welded into knots. From the immobilized head, his eyes meet mine. A burst of voltage passes from him, through his eyes to me. Totally disarmed by the force of this contact I look away. Disoriented, my eyes dart nervously around the room: a recessed window. On its sill mounds of objects made from chunks of torn Styrofoam, doused with diluted red paint. In the left corner, an upright piano beneath a sheet of transparent plastic, broken Styrofoam piled on top of it. In the far right corner, a sink full of black water. Against the side wall a metal desk, a rolling office chair, a white telephone attached to the white cinderblock wall, the receiver smeared with red paint. Bits of the brown linoleum floor show between layers of dried poster paint. Above, a dropped ceiling of acoustical tile, two banks of fluorescent lights that buzz and hum.

The young woman I had seen in the hall is wheeled into the room. Her head thrown back, she faces the ceiling, mouth open, large irregular teeth and gums exposed. Her arms extend sideways away from her body at right angles. One points down, the other up. The man who wheels her chair is the doctor who invited me here. Parking the woman between the window and the sink, he takes the handles of the chair of the man with the wired head and maneuvers him so that the back of his chair rests against the side wall between the sink and the metal desk.

"Well, look who's here," the doctor greets me. "Where can I put this?" I ask, nodding to the slide projector. "Oh, anywhere," he says, looking up from his clipboard. When I do not move, he looks at me. "I think there's a socket over there someplace." He points with his chin at a section of wall behind the man with the wired head.

I avoid the man's eyes, but in kneeling see his shoes. The toes point in at each other. With the projector plug pushed in, I get to my feet, wipe my hands on my jeans. The woman with the angled arms watches me.

"Hi," I say.

The woman's body explodes. Her arms and legs flapping wildly, they bang hard into the chrome tubing of her wheelchair. As suddenly as she had exploded, she is still. Her head rolls forward onto her shoulder. She smiles. Her eyelids lower very slowly, her big brown eyes close. Then smoothly, slowly, they open.

In the doorway, a boy. Maybe thirteen. Very white skin, short red hair, skinny, pointy nose. His forearms are lashed to the armrests of his wheelchair by wide black bands of Velcro. The woman who pushed him into the room leans to set the chair's parking brake, then turns and leaves without a word.

"Right on time," the doctor says to the boy.

"I"—the boy separates each of his words—"do. not. want. to. be. here."

"Well," the doctor says, "if you don't want to be here, you can wait in the hall."

The boy rises up against his restraints; his face turns bright red, his fingers draw into little fists, the knuckles showing white; he screams.

"I don't want to be here!"

The clipboard falls to the doctor's side.

"Like I said," he says, "if you don't want to be here, you can wait in the hall." The doctor releases the parking brake, takes the handles of the wheelchair, and maneuvers the boy against the wall next to the man with the wired head.

"Are we about ready?" the doctor asks me, then moves to the center of the splattered floor. Beneath the fluorescent lights, his lab coat glows white. "Tim," he addresses the class, "is a

professional artist. He has had shows in New York City. He is here today to show us some of his work and to share his ideas with us."

What ideas? I ask myself. Getting free of the limitations of the physical world? That was the point of my paintings. I'm supposed to share this zeal for freedom with them as they sit strapped in their wheelchairs? The urge to get back outdoors is overwhelming, if not for my exit at least to clear my head. I glance at the redheaded boy. Livid with anger, he glares down at his Plexiglas laptray. Feeling my eyes on him, he glares up at me, glares out the window, then back down at his tray.

The doctor pulls the door shut. The room goes black. My mind hovers.

Plip, plip, plip, droplets fall from the tap into the water in the sink. I hear the wrenching sobs of a child out in the main hall, muffled by the closed door.

"Tim?" the doctor asks.

I feel for the projector's on-off switch. A bright rectangle of light illuminates the white field of the portable screen, the same my father used to show us home movies. Flickering images of us kids, my brother, sisters, and me, swimming splashing laps in the sun-crazed swim-club pool.

In the light that escapes the ventilation grate on the back of the projector, I see the intense face of the boy. The incandescent light plays off the stainless steel wires that hold up the man's head. The young woman appears in silhouette, backlit by the dim light of the gray sky outside the recessed window. No sound now other than the water droplets and hum of the projector's fan.

"Tim?"

I reach out to press the button, the first of my paintings drops into view. It is tall, and quite narrow. A randomly slathered coating of cream-colored acrylic gel, three inches thick, had been

laid down first, then in the bottom left corner the outline of a square, crudely brushed in wide strokes of metallic rust and crimson. Rising up off the square is the furtive outline of a rectangle painted in four wispy thin strokes. It claims the greater space above the square, it is looser, freer. The awkward square, held down by gravity; the tracery of the thin rectangle, above it, dancing in the wind.

I glance down at the red-haired boy. How intensely he is looking at the image. I mean, he is really staring at it.

Stripped down, his life is raw, his energy: keen.

"Can you tell us about your painting?" the doctor asks.

I clear my throat. "Well," I say, "it's not always such a hot idea, talking about your own paintings. You make paintings to say something you can't say with words. But, well, if I had to describe what I was thinking about when I made these, it might be about being held down, and getting free. Like the little squashed square down there in the left-hand corner is a body, and the looser, bigger shape rising out of it is the thing that can't be held down. A thought. A feeling. Our spirit."

I reach for the projector. The second painting drops into view. As the rest are shown I manage to say a little something about how each was made. When the last one has been up for a few minutes, I say, "That's it."

A switch clicks, a buzzing sound, the fluorescent lights turn pale blue, then fill the room with white light. I know the doctor is speaking, but I do not take in his words. I look at the woman. Her head sways gently from side to side, her eyes holding mine.

". . . thank Tim for coming up today," the doctor is saying, "and maybe he will come up and see us again. What do you say, Tim?"

I look at the floor, then up at the man with the wired head. When our eyes meet, he nods, an inch, the metallic spokes of

his wire crown drawn downward with this slight movement of his head. I look at the fierce little redheaded boy. I look at the three. They look at me.

"See you," I say.

Down off the hill, through the countryside with its horse farms and wealthy estates, down the highway around the traffic circle, through the town of strip malls and condos, the drive back is less than pleasant. Incomplete thoughts, disparate, unfamiliar emotions lash about inside me. At a red light, cars from a gas station, McDonald's, Dunkin' Donuts vie to enter the intersection. Music pounds from a car with its windows tinted black.

Home, I rest my forehead on the kitchen table. For some time, I think of nothing. Then I see the man with the wired head. Not so much his body, but his eyes, that look he gave me when I first saw him. Clear, with a steely light, not at all sad or weak as you might expect. He had a second or less to connect with me before I looked away. He gave this second everything he had; his gray eyes open to me as he hoped I would be to him. This stays in my mind.

Making a drink, I sit back down at the kitchen table. I wonder what it is like for him not to be able to talk with anyone. As I sit here, he sits up there, on top of that hill, in that building, silent, motionless, looking straight ahead, at whatever wall they parked him toward.

I think of the young woman. She was flirting with me. She was not the zombie I saw in the hall. And the angry little redhaired kid. Fierce and determined as a wolf I had once seen, in a dog's pen. The next few nights, I lie awake. I think about the richness of a million things they cannot do. Like: open a window, hug a dog, climb a tree, call to a friend, scratch an itch, turn the pages of a book. Cordoned off from the outer, physical

world, they do not even touch the earth. I try to imagine never feeling bare feet on wet grass, burning sand, tilled soil, immersed in a cool and flashing stream. All the pleasures we enjoy are as far away from them as the moon. All out of reach, like all the things they must see going on around them without them. They live inside themselves.

There is something worse than their bodies not working. It is difficult to imagine anything harder than the restrictions they endure. But there is something worse — if they, as it appeared to me, are as alive as you or me and they are being treated like idiots.

On my way down the main hall, leaving the school, I saw six older students in wheelchairs in a classroom. They sat parked close together, side by side, facing a blaring TV. A purple dinosaur standing upright sang a saccharine children's song. Harmless and round as a velour hippo, it gestured with its little arms, the voice coming from the great toothy grin, "I love you. You love me. We're a happy family." The students looked as stupefied as you would expect from "vegetables," or as you yourself would look if you were strapped in a chair unable to speak your mind for fifteen, twenty, twenty-five years.

Trapped first by their bodies, then again by the people around them. One massive barrier wall stacked on top of another. Quite a height to overleap. The isolation must be crushing. Yet there is that light in their eyes. How had they kept their spirits alive? What would they tell us if they had the power?

In the morning after a cup of black coffee and some walking around, I call the school.

"Matheny School and Hospital. How may I help you?"

"I, I, I'm not exactly sure."

"How may I help you?"

"I was up there, at the school . . ."

The receptionist speaks with someone. I can tell when she puts her ear back to the phone.

"Who do you want to speak to?"

"The head of the art program."

"Do you have a name?" she asks.

"Do you have a list there or something?"

"Who runs our art program?" she asks her friend.

"I didn't know we had an art program," her friend says.

I hear the line ring, then a man's voice. He identifies himself as a doctor.

"May I ask you some questions about the students?" I say into the phone.

"What is your name?"

"Tim Lefens."

"Who do you represent?"

The doctor transfers my call to a teacher.

"Can I ask you some questions?"

"About what?"

"I was wondering if you could tell me a little about the students. I mean, well, has anyone introduced them to sophisticated systems where they make all the decisions?"

The teacher gives a light laugh.

"Did I say something funny?" I ask.

The teacher breathes out with mild exasperation. "You," she says, "can only expect so much from them." She finally connects me to the woman who runs the art program.

"Suzanne."

"Hi. I was up a week ago, showed slides of my paintings in Ron's class. I was wondering if there was any way I could come back to the school."

"To help with the class?"

"No," I say. "To start a new one."

*

A couple of weeks after I got the green light from Suzanne to start up a new class, I went up for employee orientation day. I was told that fifty years ago, a family that lived on the hill had a child with cerebral palsy. The parents started the school. The wealthy people in the valley joined the board of the Matheny School and the school went from being a little place with a little money to a fairly large place with a lot of money.

With this money, Matheny brought in experts in the medical field to join the staff. As technologies developed, they were utilized here before they were in most other facilities of their kind. This concentrated effort extended the lives of the students. The school—the hospital—is a residential care facility: eighty-three or so students live there. Each of the students requires individual, sometimes completely unique, treatment, both medically and in technical support.

Most of the students have cerebral palsy. CP is a condition that occurs when the part of the brain that controls the central nervous system hemorrhages, usually at birth. Damaged, it sends the body erroneous signals resulting in the tightening of muscles and spastic, involuntary movement. When they die young, it is sometimes from simple things that pose no threat to you or me. A common cold can be difficult to deal with, if the muscles that let us cough do not work.

The severity of the challenges the students face leaves them extremely dependent. Others feed them, wash them. There is a separate set of buildings at Matheny, brick two-story dorm blocks that house the personal care attendants (PCAs). Many of the PCAs are foreign-born and many do not speak English all that well. Few have cars. So, in a way, they are stuck up there like the students. In the halls, I often saw the PCAs pushing the students from class to class or to the bathroom or wherever they were going. I did not overhear a single word spoken by any of

them. On the other hand, the teachers I passed chattered like birds.

The school is run with efficiency. Each program has its own director. The directors control their employees. The president of Matheny controls the directors. He is liaison to the board of trustees with their wealth and influence. It costs somewhere between one hundred fifty and two hundred thousand dollars a year to house and care for each of the students. I do not know how much of the cost the parents assume. The state picks up some part, private donations the rest.

The students' bedrooms line either side of the long halls. All the doors are kept open; I saw the rooms were small. Some have two, some three, hospital-style beds; the bedroom walls, like the halls, cinderblock painted gloss white. There was none of the stuff kids tape up, no posters, stickers, pennants.

Other halls had classrooms. One hall was strictly for administration. There is a wing our tour guide pointed out as the children's wing. There was a lot of crying going on down there.

Our guide moved us on toward the new cafeteria. It is not dark the way you might imagine an institutional dining room would be. It has banks of big windows that look out toward the valley, with its fine estates, the headquarters for the U.S. equestrian team, quaint little towns that share the same little train, an hour's ride to Manhattan.

All the halls have sources of natural light. Many open onto a courtyard. I opened a door to one of the courtyards. It required pressure be placed on a spring-loaded aluminum bar, installed too high for a student to reach. The door would not stay open. When I let go, it returned quietly, the latch making a clack, then a thunk. The only way I saw for students to get outdoors on their own was to go down past the main desk and out the automatic glass doors. This would bring them to the edge of the parking

lot. Yet the school owns eighty acres of land on top of the hill; some of it woods, some fields. I think about the high quality of the clinical care the students get. Then I think about the bed-rooms devoid of privacy and the doors to the outside that will not open.

When I called the school about the possibility of running a class, it had been a tentative inquiry. I did not think they would say yes. When they did, and a date was set for the class to start, I had no idea of any technique that would allow the students to paint. Very few could hold a brush. Others I met at the orienta-tion day might be able to hold one, but could not control the movement of their arms. The technique I finally came up with would not give the students the ability to do realistic work, but could be used by them to make decisive abstract painting.

*I*t is hard to anticipate what will happen tomorrow with the first class. I am not sure how many students will be there or if those who are will want to be there. Without any teaching experience, I have no clear idea how to run a class. My plan will be to offer them the technique. The rest will be up to them.

I check my watch. It is time to head in, time to see about the power of Art.

As I lug the supplies past the receptionist, she hops off her seat, leans out over her counter.

"Sir!" she calls. "You need to sign in."

A man with a walkie-talkie walks up to me. "Let me see your ID," he says.

"I don't have any ID."

Both the man with the walkie-talkie and the receptionist watch as I attempt to fill out the forms. A large man with white

hair stands watching as well. Bob, the president of the school. His eyes narrow, sizing me up, apparently not liking what he sees: torn jeans, paint-smeared T-shirt with the sleeves torn off.

"Bob?" a woman in a business suit calls. As he turns, I hoist the two five-gallon pails, the roll of heavy unprimed canvas, the roll of plastic sheeting in a long cardboard box, and head for the main hall.

I had prepared myself for the sights I knew I would see. I could not allow them to get to me. I needed to maintain total concentration on making a clear connection with the students of my class. Two tiny little girls no more than two years old, with chubby cheeks, pursed lips, and big bright shining eyes, sit small as dolls in tiny plastic wheelchairs small as toys. Further down the hall, a boy sits in his wheelchair. A spray of liquid on the floor in front of him, pant legs soaked, a string of thick liquid hanging from his lower lip.

"Hello." I hear a voice in the unlit corridor.

"Hi," I say, unable to see the person speaking.

"Hello."

Continuing to move toward the door of the room, I catch sight of a dark figure sitting in a wheelchair.

"Hey there," I say, opening the door. "How are you?"

"Hello."

The room is empty. It is the first hot day of the year and, for whatever reason, the air-conditioning that cools the main hall has not reached Room 333. Black water is still in the sink, the Styrofoam projects are still where they were, new projects piled on top of them. Taking one of the new projects from the pile, I turn it in the light. It is a face made of hardened polyurethane foam, white, bloated as a drowning victim. From the materials stacked next to the sink, I can tell how it had been made. The teacher pressed aluminum foil over the student's face, then shot the mold full of foam wall insulation; removed it from the mold

when it was dry, then squeezed liquid color on top of the heads, the rivulets meant to represent hair. Some of the rivulets track down the forehead, some run into the eyes and nostrils, into the lips and down off the end of the chin. Each of the faces looks the same, unidentifiable as any particular individual, yet a number of them have been mounted on squares of plywood, a name written on them in fat black Magic Marker: Cindy, Chet. I put the face back on the pile.

With nothing to do, I sit on the rolling office chair, glance at my watch, then push off with my feet. Another few minutes pass with no signs of anyone showing up. I sit in the quiet room with the stale air, my hands on my thighs, the robust energies of life pared down to a dullness, an emptiness, the room emanating the qualities opposite of those that fuel Art's bright wildfire.

Click. Clickclickclick. I hear the electrical switch contacts.

As I turn to face the door, the toes of a pair of running shoes appear, then stop, a foot above the floor. Click. Click, click, click. My first student runs his wheelchair into the metal door-frame.

"Ohhh," he breathes out.

Exaggerated, almost clown-like melancholy draws the ends of his mouth downward. His arms are stiff and crooked. On the Plexiglas laptray of his electric wheelchair there are four brightly colored plastic circular pressure switches: red, green, blue, and yellow. After a long pause, grave disappointment added to his melancholy, he lifts his arm, as a crane, to lower his twisted fingers onto one of the switches. The chair backs away. When he touches the second switch, the chrome chair swivels left. A third switch pressed, he rolls into the room, and stops. Absorbed in the trials of his journey here, he takes no notice of me.

He has the air of a young professor in his mid-thirties, albeit dazed: a gentle air, deeply serious, Irish, his button nose, high cheeks, short-cropped hair, old-fashioned framed glasses. A

young professor who has fallen down, been helped back to sit on a chair, unsure of what has happened to him, pride affronted, a little angry with himself.

My second student enters the room with care. He directs the motion of his wheelchair with the same pressure switches the older student has. To reach the switch, his entire upper body is forced to rotate, the right arm coming forward as the left comes back. This effort makes him grimace. He is younger, black with the aquiline features of a North African. He wears Malcolm X glasses, the kind with the frame at the top, the side and bottom edges of the lenses unframed. Like the glasses of the older student, they are on a little crooked. When I catch his eye he gives me a nasty expression, a sneer. He says nothing.

I felt suffocated before, sitting alone in the room. Now I feel a cautious updraft. The aura of the first student is so thoughtful, the second rudely dismissive, both impressions very clear. They are in there, as rich in feeling as you or me.

The PCA who wheels in the third student sets the parking brake on the chrome wheelchair, then walks out of the room without having said a word. No good-bye to him, no hello to me.

The teenager looks at me, makes a crazy face, then leaps up, off the seat of his wheelchair. Wriggling, corkscrewing, he holds himself at the highest point of his rise, restrained from flying out of the chair by the wide black bands of Velcro that bind his forearms to the chair's armrests; crashing back down, he smiles. Crew cut, narrow face, eyes flashing, mischief in them, lips pursed. His head twists on his long neck, his fingers extend, then close. He shoots up again, the plastic and metal of his chair groaning, squeaking, then banging with his crash back down. His head lashes side to side with such force he faces directly behind him to the left, then the right. His eyes flare, his thin red lips and the muscles around his mouth distorting with the effort of his attempt to form a word. Steadied, he locks his eyes to

mine, molten sparks fired in place of the words he cannot get out.

"I'm Tim," I say.

The teenager rises to the limits of his restraints, gives me a nod as formal as a bow or curtsey, then crashes back onto his seat.

"Gotta cut some canvas," I announce.

The boy nods.

From the roll I pull a four-by-four foot square, reach to slip my Buck knife from its sheath on my belt. Folding it open, I hear the lock click, check his eyes.

"Go ahead," his eyes flash.

Draping the first piece of canvas over the foam projects, I move to cut a second. This guy, the youngest of the three, must be some wild kind of kid, unbeaten, it seems, by the institution. Sitting still for the first time, the teenager looks at the older student, then at the young guy with the Nation of Islam glasses. The boy blinks, looks at me, sits back, blinks again as if thinking something, then begins to bob lightly up and down.

I am not sure if there will be another student. If there is, I want to wait before I give the little talk about the technique. Cutting one more canvas, I sit on one of the white plastic five-gallon pails. The air in the room was too warm to start with. Now, with the four of us in this room as small as a janitor's closet, it heats up. Five minutes pass with no one saying anything. The boy closes his eyes. The older student with the tragic clown mouth is passed out. I can tell by the way he breathes. The black student remains awake, but will never look my way, instead looks blandly out the window. All their sneakers point in different directions. I check my watch, look out the window, at the sleeping student, then down at the floor, breathing in the hot air now stale with the smell of body lotion, the ammonia of diapers. In the silence, in the heat, time slows. Slowly winding down,

slowly, awkwardly dragging to a complete stop, my eyes close, our lives lost from the consciousness of the outside world. Down in the little town at the bottom of the hill, a mom backs a mini-van full of kids from her garage. An office worker taps at a computer keyboard. A UPS truck pulls up in front of a store. Up here, no one moves. It is hot.

In the midst of my agitation, I listen to the students breathing. In time my breathing calms. Eyes closed, their physical appearances swept aside, I sense them clearly, simply as three fellow human beings, stuck here in this room with me.

A fourth student glides into the room.

"Hello," she says. "My name is Tammy. Where is Suzanne?"

"My name is Tim and I don't know where Suzanne is. Are you here to paint?"

Her face is white, cheeks ruddy, short-cropped auburn hair, thick-lensed glasses; her T-shirt, pants, socks, and sneakers, pink. She, unlike the others, is almost plump. Her arms appear much more supple than theirs. She controls her chair from a joystick mounted on the tray of her wheelchair. A woman steps into the room. Dressed unlike any staff I have seen, she wears a loose pullover cotton dress: huge brightly colored paisleys rock this way and that. Her hair long, full, unbrushed. In her early forties, she looks like she could have been a hippie back in her school days. Suzanne's husband is the school's medical director.

"Suzanne." I extend my hand.

"Tim," she says. Taking my hand, she smiles, then looks to the slender teenager with the flashing eyes.

"Hello there, Chet." She smiles.

Chet gives her a bow.

Taking the handles of his chair, Suzanne rolls him to face out from the corner by the sink, then directs the other two young men to park with their backs against the wall where the man with the wired head sat when I showed the slides of my paint-

ings. I had asked after him. Suzanne said his name was John, and that he was no longer at the school.

Tammy backs into a space between the older student and the metal desk.

"Well, I see you've met the gang," Suzanne smiles my way.

"Not really," I tell her.

"Well then," she nods to Chet, "this is Chester Cheesman." The wild teen shoots up, waits until I nod back before slamming back down.

"This is James Lane."

"Hey, James Lane," I smile in return of his sneer.

"This is Eric Corbin." Suzanne nods to the older student with the downturned mouth. Eric's eyes are closed, his head resting on his right shoulder.

"And this is Tammy Heppner," she says.

"Tammy and I have met," I say.

"I'll be right back," Suzanne informs us.

With her disappearance, I sit on one of the five-gallon pails, breathe in, look at each of the students, then stand up.

"Let's get started," I say. "I have a way you guys can paint, a way you can make a real painting. Let's look at the materials. This is canvas. This"—I pry the lid off one of the five-gallon pails—"is acrylic gel. It is what they make artists' paint from. It comes clear. You add your own color to it. It is thick, so you can create textured paintings. Put it on thin, water it down, it comes out clear, like a sheet of glass, shiny, see-through. You with me?" I ask.

In fact, they are. My martial tone of voice has them on alert. "Today," I say, "we only have two colors, black and white." I pry the lid off the black, scoop out a handful, hold it out for them to see, invert my hand to demonstrate its viscosity. James snorts. I smile at him before he regains his sour puss.

"Okay." I whip the gleaming gel back into the pail, wipe my

hand on my jeans. Chet whoops, James snorts, Tammy laughs. It is a move I make unconsciously; for me it is nothing. For them it is wild. Bohemia meets the institution.

To regain the seriousness of the presentation, I give them a hard look, to ask, "What's so funny?" But it's not that easy to keep from smiling at the intense kick they got out of it.

"Here is how it works," I say. "Your canvas goes on the floor. It gets coated with black, over the whole thing. A thick coat of white goes over that, over the whole thing. Then we lay down a sheet of clear plastic. We tape it down. Then," I pause for effect, staring at each of the students in turn, "You drive right on to it."

Chet's eyes narrow, then pop open picturing doing something crazy and new. Tammy blinks, her head tipped to one side. James looks away as if he will not be bothered with it. Eric's eyes open then close.

"You can use the power and weight of your chair like the whole unit is a big pencil or a brush," I say. "Everywhere you go you will leave a mark. Can you picture how this will work?"

Eric's eyes are nearly closed, but I sense he is listening intently.

"You can make it look the way you want it to look," I say. "Horizontal lines"—I draw a finger along an imaginary horizon —"always suggest landscape. Vertical lines"—I trace a flat hand slowly downward—"can be calm and strong. Diagonal lines"—I rake both hands at an angle through the air—"have aggressive energy. You can make a million lines all over the place"—I stir my fingers wildly—"make it crazy. Or you can keep it very quiet; draw just one line. There is no way for you to make a mistake. You don't like how it comes out, you can go back into it. Don't like how that comes out? We'll throw it in the trash, get a fresh canvas. The thing I want to tell you,"—I place my hands on my hips—"the most important thing, is that you get it to look the way you want it to look. That's the thing. You

ready?" I eye each of them. "There isn't much time," I say, "so let's do it."

On my hands and knees, I tape the first canvas down in the center of the floor, push black evenly into the cotton weave and then apply a thick coating of white gel smoothed like icing, place a square of 4mm clear plastic carefully on top and tape the edges down. A bead of sweat drips off the tip of my nose; it lands with a *pip* on the plastic sheeting. Wiping my forehead with the back of my arm, a blob of gel smears onto my eyebrow. James snorts.

"You finding all this funny, Lane?" I ask.

He gives me a hard look, then turns his attention to the recessed window. When he looks back, our eyes lock. He sneers. I sneer back. After a few seconds of our holding our looks like this, neither of us blinking, James's eyes narrow with curiosity. I mimic this look as well. Reacting to my odd behavior, James scrunches up his face, then to my surprise, a big smile: warm, easy, open. As it had appeared, it disappears. His expression once again dismissive, he feigns interest in something out the window.

I would like to offer the first canvas to the first to arrive: the man with the downturned mouth, Eric Corbin. Eric is asleep. James got here second. Aware, I am sure, of my eyes on him, he will not look my way, his bland perusal of the opposite wall as obvious as someone whistling an aimless tune in order not to hear what is being said to him.

"James," I ask. "Are you ready to rock and roll?"

No reaction.

"This is yours." I point down at the canvas.

James looks down at the canvas then up at the ceiling, then out the window. Moving back to the door, I drag one of the five-gallon pails over, sit on it. James does not move. I wait another minute: no movement.

Chet bobs, a pleasant, curious look on his face. He nods to the canvas to suggest he will take it if James will not. I wish he could. I would love to see what a painting would look like if it were made with his ballistic energy. I told Suzanne the technique would only work for the many students with power wheelchairs. Chet's chair is manual and, more than that, his arms are strapped so he cannot reach the wheels to propel himself. Imagining my arms strapped down like this makes my nerves fritz. Chet bobs high, up and down, flicking his head to the canvas.

"Chet," a woman calls to the teen. Stern, wearing a white lab coat; her words are clipped. "We need to have you come down for a fitting."

I move to stand between Chet and the clinician.

"This is Chet's painting class," I say.

"Chet," she calls, stepping to her right.

Moving over, I block her view. Arching up on her toes, she calls to him over my shoulder, "We need you to come down for a fitting. We need you down there."

"No," an odd little voice announces from behind me.

"Wow," I say, my nose a few inches from hers. "He can talk."

Giving me dagger-eyes, she storms out of the room, warm air moving in her wake. Looking over my shoulder, Chet pops his eyes wide open in this hilarious look of amazement at his own audacity.

"Hey, Chet," I smile. "Thanks for hanging out."

He gives me a nice bow.

"So you can talk," I say.

He strains to form a word. Nothing comes out but little flecks of spit.

"Yes," he says, his body twisting violently, as if he had to physically "catch" the word inside him and wrest it up into his mouth.

"You give me directions, I'll push your chair that way," I say

quietly. "Give it a try?" I ask, wavering inside at our ability to use his voice as effective communication, especially if he wants to move quickly, which it appears clear he will.

Chet fires up into the air. "Ah-ooo!" he yelps with joy.

Taking the black foam-padded handles on the back of his chair, I wheel him to the edge of the canvas.

"Ready?" I ask.

Lowering his head, his chin digging in to his chest, he shouts, "Go!" Flailing like he has been scalded, he leaps out over the left armrest, the chair jerking off the right side wheels, Chet gasping as it bangs down, his body sent over the right armrest.

"Ri ri, ri ri," he cries out.

I wheel the chair right. He leaps again, tries to shout. Overanxious, I push him left when he has given no directive.

Oh, no, I think.

Unable to make out his yelping, I push the chair this way, then that. If this were one of the institution's recreation classes, this might look like fun. It might look funny. For me, it is not. I came up here to try to bring them some real control and now *this*. More frustration.

Panting, Chet lets his head fall back against the neck brace. "No mo'," he says.

Drawing him off the painting, I feel shame so sharp it moistens my eyes with angry tears. When I am able to face him, he meets my look with one keen with concern.

"Are you okay?" his eyes ask. Looking back at the floor, I feel him waiting.

I look up. "Yes," my nod tells him, "I'm okay."

The plastic sheeting carefully peeled up, the class breathes in an audible "Oh . . ."

"Wow!" Tammy shouts. "Wow!"

His classmates look from the painting to the wild teen. He bows to each of them, Eric having woken up with all the noise.

"It worked," I say. And technically speaking, it had. Black grooves gleam where his wheels had run. James's eyes are wide, trained on the painting.

"Wow!" Tammy shouts again. "Wow."

It does look good, but as an image it has little to do with who Chet is or what he was after. Just the same he went for it, the painting, this first painting a tracer of his attempt.

"Here," a tubby young man wearing a white alligator shirt, khakis, and white running shoes says. "These are your attendance sheets. You need to fill them out each class. Well, hello there, Mr. Lane," he says, placing his hand on James's head. "You been staying out of trouble there? Haven't been chasing the skirts, have you?"

James glares up at him.

The tubby young man laughs, then turns back to me. "You need to fill these out each class. Leave them with the front desk. Okay then, James,"—he pats James's head—"You stay out of trouble. You hear me?" He laughs, "Ha ho ha. That goes for you too, Cheeseburger." He points at Chester Cheesman. With this, he leaves the room. In response to my angry look, Chet bobs, then gives a little shrug.

Prepping the second canvas, I look up at Eric, who is listing again, his head beginning to lower toward his right shoulder. There is such weight to his sadness. Sadness this marked could only come from disappointment or yearnings that are just as deep. His eyelashes bat. He is trying to get them to stay open. They bat again.

"Eric?" I ask quietly. "Do you want to paint?"

His head lowers. "Yup," he says.

Bringing his hand to the pressure switches he rolls very slowly past me. The front end of the wheelchair swivels to face the canvas, but his fingers are not able to lift up in time, the chair continues around. Then, very slowly, it comes back. With a soft

click, he rolls up to the edge of the painting, his back to me. He remains like this for so long I think he may have fallen asleep. I look to Chet, who from where he sits can see Eric's face. When Chet catches my eye, he checks Eric out, gives a little shrug, then looks my way, nods. I make a gesture with forefinger and thumb placed by each of my eyes, like scissors opening, to ask "are his eyes open?" Chet checks Eric again, then nods. I show Chet a thumbs-up and wait with the rest as Eric contemplates the canvas.

The still image of him looking down at the white square strikes me. It is a singular, critical, decisive moment in Eric's life. In the practical world, he cannot get at things. He cannot roll over in bed at night, much less get up to get a glass of water if he is thirsty. The open world of the painting he can enter. This world, he can change.

With a soft click of a solenoid, his chair inches forward onto the painting. Running off the far edge of the canvas he gets the wheels to come around. As his chair runs over the clear plastic, he cranes his neck over the side to see. When he backs off and stops, I move to take up the plastic.

"Whoa," he says. He is not done.

With grave deliberation and painful straining, he gets his chair to drive around the canvas. Making this one last mark, he once again backs away. His chair stops. His eyes close. His upper body wavers, then topples sideways over the right armrest. His head hangs limp. The walls and all the crap around him fade back and away so all I see is Eric, fainted in his chair, his first painting on the floor in front of him. Looking away, I rein in the emotion, then look to the other three. Chet is not making any funny faces. James and Tammy look to their classmate.

"Tammy," I ask, "is he all right?"

"Eric?" she calls to him. His body remains as still as someone who has been shot.

"Eric?" Tammy calls again.

Eric's head moves a little. His eyes open. I move to the painting; lowering to my knees, I detach the tape, peel the plastic carefully back. Eric's eyes fix to the painting in a way that sends a shudder through me. You do not see a look like this in everyday life. The harsh tread pattern of his rear wheels left marks like curving vertebrae, shining black and gray.

The third canvas prepped, I glance at James, then nod toward the painting. Eric's effort having swept away his aloofness, James rolls away from the wall. Stopping at the edge of the canvas, he looks down at it. Nudging one of the directional switches, he adjusts the angle of approach, then sweeps his smooth small front wheels across the plastic.

"Yes," I smile and close my eyes. Stopping, he considers the mark, adjusts his angle of approach by an inch, then sweeps another arc. A series of eight or more passes completed, he backs away.

"Done?" I ask.

He nods.

The plastic peeled up, the room fills with a common gasp from his classmates.

"Holy shit," I whisper. The smooth arcs James has drawn emanate from one point at the bottom right. They curve together in a bundle upward toward the center of the painting, then as they curve around they begin to separate, fanning out to exit the upper edge at various points more than a foot apart. The lines rise up and out, like a plume or a flume, appearing to be blown back, as if by the wind. The greater part of the thick white paint that covered the canvas remains untouched, this large untouched area held in tension and balance by its greater area and the contrast of its blankness to the determination of the drawing. Excitement runs like electricity between the students, bonding them as the first in the school to have made their marks.

"Is everything all right in here?" a staff person asks after the loud flurry of sounds that came with the revelation of James's painting.

"Check it out!" I gesture with my hand to the painting.

"What is it?" he asks.

"A painting."

"Of what?" he asks.

When I do not answer, he looks down at the canvas, shakes his head "No," then steps out of the room.

"Wow," Tammy shouts, unable to take her eyes off James's painting.

"Not much time, Tammy," I call, crouched above the final canvas. "You ready to rock?"

Jetting onto the plastic, she cranks her chair hard to the right, accelerating back onto the painting so fast the chair skids.

"Whoa." Eric calls for caution, James and Chet whooping it up.

Jacking her joystick back, Tammy's head flies forward. Jamming it forward, her head flies back. Stopping dead in the center of the painting, she takes in a big breath. Her face, red, damp with perspiration, her thick glasses fogged, she and her chrome wheelchair begin slowly to revolve in place. Around she goes, a little faster each revolution. Round and round, faster, faster, faster, she spins on top of her painting; her head falling back so now she faces the ceiling, ceiling tiles pinwheeling. Around and around. Faster, faster, faster.

"Take me away!" she cries out. "Take me away!"

*T*he class period over, James, Eric, and Tammy maneuver for the open door.

"Good work," I say. "See you next Monday."

Tammy whizzes out, as if bolting to bring someone the news. James and Eric bump chairs. Chet's PCA waits for them to clear the passage, then wheels Chet out of the room.

"See you, Chet," I call after him. "Next Monday."

Alone in the room, I blow out air. "Whew! That was so intense. That was awesome!" I figured they were alive in there, but I had not imagined just how alive. I thought it might take time for them to grasp the concept; instead, like fish in water, they were at home with the core idea of painting. In an hour and a half, they had leapt from passivity to creative self-expression. I know how big this is. I can see what this could mean for them, how it could change their lives.

And then, unexpectedly, as a lone cloud moves in front of the sun, the expanding sense of all things being possible checked itself: the staff person who had seen James's painting.

"What is it?" he had asked. He could not see it. He did not understand the language the students had used. The language of Abstraction.

As a little kid, the smell, the sound, the feel of sharpening a pencil got me crazy with a peculiar kind of pleasure. The touch of its point to paper filled me with joy. When I drew, I was king. The paper was my world. I loved drawing. At the same time, I was oddly indifferent to the things I chose to draw. It was not the representation of any particular thing that was exciting, but the act of drawing itself, seeing the lines appear out of nowhere, watching them run, feeling them connect. This was the language of Abstraction, the way of making art that looked more to the life we sense inside ourselves than that which we see in the surface appearance of things. Little kids understand this. Their innocent eyes see the magic. Dancing in the hissing ocean that runs up the beach around their feet, they shriek with joy, at one with the streaking gulls, free as the wind. This is how I felt when I drew with my pen-

cil. Pure and free, my imagination able to fly in any direction, for any distance, to any place.

I had no idea this magic was something the practical world would teach us to replace with more realistic ways of seeing and feeling. I promised myself that as I grew older, I would never let go of the magic. I had seen it. I had felt it. I knew it was real, no matter what anyone said. I was a bit of a discipline problem.

I drew my teachers. For these drawings, I got detention. I felt reined in. In spite of adults' admonishments and the muffling effect they had on my dreaming, I remained determined to find my way back to the bliss.

In high school, I got some art books out of the library. Manet, Cézanne, Picasso. Their quest to push their paintings to the frontier of Art read to me like a story of adventure. Their work lifted me high. In time, I pictured painting that would go even further; painting that would connect more directly with the flash of raw energy I experienced being alive. I longed for the moments when everything, with a big bang, became one thing.

This is the power of pure abstraction. I must have seen examples of purely abstract paintings back then, but was unable to "see" them. The deeper unlearning this required was yet to come.

The same year I discovered all the art books, I met the famous painter Roy Lichtenstein. He is my friend Dave's dad. Not having our driver's licenses yet, Roy was our chauffeur to the beach, the Jersey shore.

I paddled up the glassy face of the wave, the tip of my board knifing through the arcing lip of water, followed by my face, then my body. Joy, excitement, fear and refreshment, everything in full flux, life became one thing: glistening, sparkling, the body of the ocean rising, the blue sky above limitless. This was the feeling I was after. "But how," I asked myself, "could I make a painting of this?" How would painting a picture of a pier with barnacled pil-

ings embody the fury of joy? Painting a picture of a pier would not cut it. Not even close. I knew this. I had tried it.

Confused with undisciplined inspiration, it was a time in life where a guide, an older person's experience and encouragement could help set my course. Luckily, I had found that person.

The next two summers, I got to hang out at Roy's house in Southampton, Long Island. There was the undivided third floor where the surfing buddies wrestled, the third-floor deck where we slept, and a hundred feet from the house Roy's studio, a white building with a long, raked roof. At high tide, the surfing amigos siesta'd on the third floor with its guitars, floor fan, Ping-Pong table, Dave's eight-millimeter projector with a couple of reels of us surfing. In the midst of this perfect scene, uncertainty gnawed at me. Art was calling, but somehow, it seemed dreamy, something people did not see as "real" compared to other jobs, and jobs were coming. High school was over.

I tapped on the screen door of Roy's studio.

"Well, hello there," Roy greeted me, his wry eyes pleased with my visit, confident in his domain filled with light and all his new paintings. He believed in his art, when no one else had. The first of his canvases, now worth millions of dollars, were carried into Manhattan strapped to the top of his Volkswagen Beetle.

"Come in," Roy said, placing the pencil he had in his hand on a counter top. With calm, balanced graciousness, he walked with me from one huge work in progress to another. Then with me, sunburned, perched on a high red stool, Roy drew out finished paintings from the racks one at a time for my inspection.

Dawn, the other surf rats still comatose in their dew-soaked sleeping bags, I stand at the wooden rail of the third-floor deck. Stretching, hands high above my head, fingers separated as far apart as they will go, I see the line of first sunlight over the top of the dune.

The lawn still like night, nebulae of fog hovering above the grass. I try to picture the life ahead of me, practical life and a full commitment to Art weighed on the balance scale; twinges of doubt holding back the "realness," the solidity and sureness of pursuing the dream that called to me.

Down below, a screen door slams. It's Roy. In blue jeans, denim work shirt, and white canvas boat shoes, he walks briskly across the grass, then breaks into a trot, making a beeline for his studio.

I chose to go to school out West. I did very little painting while I was out there. I wanted to paint, but there was nothing in particular of all the things I saw around me that I was drawn to make a painting of.

Why should I paint the mountains? A painting would make them small. It would tame their power. I needed to find a way to paint that would not be tame, but sheer as the way I felt inside.

I needed to get clear on this. To do my best thinking I had to spend some time alone.

High above the canyon road, I stirred the fire with a stick. Although it was late, around one in the morning, and very cold, I was too agitated to get into the sleeping bag. Pulling on my parka and gloves, I hiked out through the deep snow, away from the light of the fire. Lying back into the compressed support of the snow, I looked up into the night sky. I was struck with force by the awesome display. There were millions more stars than I had ever seen before. It was a cosmic flood, loaded with exploding sprays, glowing eddies, and effervescent cascades. It had an awesome majesty that bordered on chaos, all of its extravagant power arrayed in perfect silence.

Tender, a freshman far from home with a mind full of unanswerable questions, the unbelievable scale filled me with a feeling like fear. In an attempt to control the impact of this limitlessness,

I searched for the constellations I was familiar with back in New Jersey. This added to my disorientation. The figures I was used to drawing in tamer night skies were gone: lost in the infinite ocean of winking lights. Swept by this loss of formerly reliable markers, I felt small, and smaller still. I did not like this feeling. I wanted to feel big, and strong. Unwilling to surrender myself, struggling, refusing to let go, I writhed inside. This is when it happened. From the cage of my body, my spirit made its break. Disregarding my fears, it abandoned me to race upward to join the sheerness, the beauty of the borderless sky.

The next day I hiked down the mountain. In the sun-bright snow, among the rugged limestone outcroppings, the wild moment I had experienced looking at the stars was put away. The solid life of the physical world had once again taken charge. The experience had not left me with any simple axiom to carry away. The letting go required by pure abstraction would have to be found afresh.

My first ride took me to Salt Lake, then next to Ogden. By nightfall, I still had forty or fifty miles to go before Logan and school. My thumb out to the occasional set of headlights, I waited beneath the stars.

Wham wham wham wham wham, an old Ford Falcon pulled over a hundred yards down the highway. I jogged for the taillights, knapsack slapping, flannel shirt warmed from running, smells of dried sweat and wood smoke radiating up out the front of my collar. The guy who had gotten out to hold open the passenger door slid in, crushing me between him and the driver. He pulled the door shut, the driver tromped on the gas, and off we went.

The five men had long dark ponytails. They wore jeans, cowboy boots, heavy navy blue pea coats, and drank from longneck bottles of Lucky Lager. The heater of the beat-up car blew full blast. Still stirred up by my fearsome freshman existential experience

in the mountains, I sat scrunched between the two men without speaking for a number of miles. To break the silence, as nervous college boys are known to do, I pointed to a section of the sky.

"That's Cassiopeia," I said. "It makes a chair." The driver looked over at me, then back at the road. He took a long easy drag on his cigarette then blew the smoke into the windshield.

"My people tell a story," he said, his voice smooth and low. "The Fox stole some diamonds. When he saw the other animals coming to his home to accuse him, he took the box and . . ." The driver's hands released the steering wheel in a sharp upward toss. The car filled with laughter, appreciative of the magic that happens with letting go. The snow-covered mountains floated luminous above the dark earth, the starry sky ranging above the mountains and the six of us in the banging Falcon.

Held by my excitement, I walked across the campus. I would spend part of the morning in the library looking at art books. The book I chose from the shelf of giant coffee-table art books was the journals and journal drawings of Leonardo da Vinci.

A few students near me were browsing along the stacks. Then as I began to read they disappeared. One of the sections of da Vinci's text I read stated that the body and spirit lived together against their wills, that the two had different agendas: the body longing for the earth, the spirit for the sky. Things got suddenly very clear. I saw the physical world and all the things I lacked inspiration to paint as the body, the elusive thing I had been searching to find a way to paint as the spirit. The illumination I sought to capture was not the light that fell on things, but the one we feel inside.

"But how," I asked myself later in a professorial tone, "did one go about painting this thing one could not see?"

Although the artistic path I was on would lead to pure abstraction, all the paintings I looked at were done by European artists, all using realistic imagery. In the work of Cézanne, I saw the ele-

ments of pure abstraction, but still there were the apples or the clock on the mantel, the landscape or the seated figure. To reach the essence I sought directly I would have to let these things go.

I saw the interim step an artist can take to reach abstraction in a photograph, in a clipping from the New York Times, Section Two, Arts and Leisure, my mother had mailed me. It showed four slender leafless tree branches, a fine ridge of snow running the length of each. The image had the feel of a Japanese drawing, a spaceless, timeless, silence.

The ground was covered with snow, so it read as an uninflected vertical plane of white. No connection to the earth. He had cropped away the tree's trunk so the delicate branches stood alone. Freed from the literal, they were no longer wood, but could be read as traceries of something that registers in the heart. I absorbed the lesson: The artist transforms: literal to poetic, object to essence.

I was getting closer.

The following semester in a class called Survey of Contemporary Painting, I saw the work of purely abstract painters: Jackson Pollock, Barnett Newman, Willem de Kooning, Mark Rothko. In the dark, the projected images of these paintings stood bright and clear. Their effects ranged from unbridled fields of energy to silent single lines; from luscious sensualities to saintly sadness; each reaching singular states of purity, totally free of any trace of the superficial appearance of objects.

"Yes," I said under my breath.

I did not have to copy the way things looked! I did not even have to use physical objects as my starting point. There was a visual language I could use to go directly to the life I sensed inside.

"Shee-it," a husky guy from the rodeo team said in his twangy voice, "my baby sister could'a done better."

I quit school.

In the jet on the runway at Salt Lake, my cheek pressed against

the cold glass, I looked out at the mountains. The engines revved to maximum thrust, the brakes released, we blasted down the runway, then lifted up into the air.

After Utah, I worked hard to find the most intense art program on the East Coast, one sympathetic to Abstraction. The faculty of the school I selected was powerfully committed to the tenets of nonrepresentational art.

The city itself seemed ideal, at once genteel and urbane. From the second-floor window of the room I was assigned, gentrified row houses, house painters on their ladders, students gliding on their bikes past the magnolias and the cars parked along the street. In the sun two girls in torn denim skirts carried stretched canvases nearly twice their size, braced as sails against the gentle breeze.

Walking around the town, I felt an excitement much like that I had experienced when I was little. Shadows appeared as interesting as the objects that cast them; riffling patterns on windblown puddles by the curb sparked ideas for painting; objects as they faded with the night or diffused in early-morning fog whispered the word "abstraction." It was one thing thinking about making a purely abstract painting. It would be another actually making one.

The next morning, the day of my first studio classes, I ran down the back stairs of the hundred-year-old brick building. He sat on a chair in the middle of the giant studio, his hands on his thighs, his hair black. It was slicked straight back. His piercing eyes watched us filter into the room. Salvatore Federico. When the class appeared to be complete, he took attendance in a drawling voice, part humor, part disdain.

Without instruction, he invited us to begin our work. In the first few weeks, Federico said nothing to me. One day toward the end of a session, walking from painting to painting, he stopped to look at mine.

"What are you trying to do?" he asked.

I winced at there being no good answer, at least not any that would relate to the pastiche of realistic images I had on the canvas. Federico stood patiently, his hands on his hips.

"Do you really need all this imagery?" he asked.

"He wants me to go abstract!" I told myself the obvious. This was the whole reason I had come here, but I found that letting go of the imagery that tethered my work to the "real" world was not that easy.

That night I dreamed of swirling colors. With them, as with the sea of stars I had seen free of constellations, there were no divisions, no sense of limit. This was actually quite scary. I had myself real worked up. I knew how close I was, but it was hard in my art to let go of the body, to turn away from it completely, to see past it as if it were not there, its corpse on the ground, my spirit flying around in the storm.

Unable to sleep, I pulled on my jeans, T-shirt, socks, and sneakers, and headed down the back stairs.

1:00 A.M. I entered the giant studio. Shoving the army of iron easels up against the walls I placed the large canvas I had stretched in the center of the floor, supported above the polished concrete at each corner by an empty metal gallon can.

"Hey there," I said to the canvas. I laughed, but inside I was nervous. "It's only canvas," I told myself. But it was not. It was the letting go. The "letting go."

In my right hand, a stick, a viscous string of tinted liquid acrylic polymer running off the end into the can I had filled. Hesitating, I closed my eyes, breathed in through my nose, then snapped the stick away from my body, the paint sent flying.

Allowing one eye to open, I inspected the results. The mark flew free on the canvas as it had through the air.

"Oh yeah!" I said aloud, mopping my forehead with the back of my arm, electricity running up my spine, up the back of my neck. "This is it," I said aloud.

Outside the sense of time passing, I worked into the night. Mark after mark after translucent flying mark, the painting transformed inert material into a gleaming field of energy. The whipping lines dancing in and out of chaos, pushing outward against the limits of the frame, the spirit of the painting appeared, the twin of my own, both humming with life.

"All right," I said, raising open the large window above the street. "All right. All right!"

The coop, my painting studio, is a long, low, red, barn-sided building with a slightly raking metal roof. Against the wall in the far end is my desk; a deer jawbone, a small broken clay pot, chalk and pencils, espresso cup and crusted brushes. Sitting on the chair, I can rest my elbow out the glassless, framed opening that is my window onto the extensive lawns, precolonial white brick and clapboard house on its field stone foundation, big barn, and outbuildings set around the circle of the gravel driveway. The coop, like the barn, can have the feel of a church, narrow shafts of light falling between the siding through the cooler darkness. The warm wood and lightly musty smells I feel so at home with here in the coop are smells not associated with homes and family life, but, for me, with quiet, with calm, with work. It is a place where thoughts have the silence that lets them link in long, unbroken chains, for days, weeks, months, and years. Sitting at my desk, looking at my painting, elbow out the window, offers a balance I savor. On one side of the coop, the gentleman farmer and his wife there to drop in on when I feel like talking to someone; on the other side, the fields and woods.

Bright green as a Kodachrome shot in *National Geographic*, the soya bean fields lay carved into broad, irregular shapes, each slightly tipped with the mild lay of the land, divided by scruffy hedgerows of cedar, barberry, red sumac, sweetbriar, and honey-

suckle. The field furthest back is corn, as bright yellow as the soy is green. These fields that flank the house on three sides have probably been the way they are since before the Revolutionary War. All the fields are bordered by packed dirt tractor paths, the best kind of path there is for walking on a summer day, head-high weeds wagging, white butterflies flitting along the flowering tops. I walk this set of paths as a break from staring at my paintings, so often that the family of foxes that live off one of the tractor paths no longer dash for their den when they see me but continue to play, the parent watching both me and the kids.

"Suzanne?" I speak into my acrylic-coated studio phone.

"Yes?"

"We need to keep the staff, other than the PCAs, out of the studio. They cannot be allowed to wander in without knocking. We don't need their comments. There is not enough time. There is not enough room. We need the sink drained and all that other stuff, the desk, the piano, out of there. We need air. We need to get rid of those projects."

"Good idea," she says.

"I need a new assistant."

"I think that would be a good idea as well."

My first assistant had talked as James painted. I ignored her, but still she chatted on, full of ideas on how to improve the class. The way she stood made me furious, her rear end an inch from Eric's tray as if he had not been there. No one would stand this way, with their butt in someone's face, if they were in a living room and the person sitting on the couch was able-bodied.

"I can bring in some magazines," she informed me. "I'll cut out images for them, you know, since they can't paint realistic. I can paste them on their paintings."

I fired her.

My next assistant labeled the back of Tammy's canvas. "See?" he asked. "This is your name. Tammy. T A M M Y."

"She can spell her own name," I told him. "Your job is to tape down the canvases."

He quit.

My bad behavior did not scare or worry the painters. During my outbursts, I caught glimpses of Eric, his stern expression clearly showing how pleased he was with the level of intensity that surrounded his and his classmates' work. Admonishing one particularly casual assistant for his lack of seriousness, his lack of respect for the artists, I could see Chet behind the assistant bobbing and nodding the adamancy of his approval. It was really hard not to bust up laughing.

"How much can I offer this new assistant?" I ask Suzanne.

"Oh," Suzanne clicks her tongue. "No more than twenty-five." The same they were paying me.

"Close to an hour ride driving there, an hour and a half in that hot, little room, an hour ride back, twenty-five bucks," I say. "You know how hard it is to find someone who can take Mondays off for something like this?"

"I can imagine." Suzanne's voice holds back a smile.

"It's not funny, Suzanne." I laugh. "I gotta get someone good this time."

"I agree."

"Where am I going to find someone like this?"

"I don't know. I'm sure you can dig up someone somewhere."

With the screech of tires, then the crunch of stone, he blasts up the farm's long driveway. From the cool tunnel created by the canopy of ash leaves, the 1978 Oldsmobile, white like a police car, with its 403-cubic-inch V8 motor, disconnected muffler, and one missing wheel-cover, emerges into the sunlight with menace at some outrageous speed, the horn blaring twice as the car thunders past the house. No sign of any hesitation, he

crosses the lawns to swerve around the coop, parking abruptly next to the woods, steam geysering up from the hood and front grill.

The crude sliding door of Angel's partitioned end of the coop rattles open. From the little radio he has hanging from a nail, tinny salsa.

"Yo, pato!" he bellows. "Pato" is the current Puerto Rican slang for "faggot." When I do not answer, he steps outside, launches a rock or a walnut so it will bang into the metal roof above my head. It is hard to concentrate, not knowing the arrival time of the next bomb. The third incoming missile, I put my brush in a can of water, kick open the back door, and march over to confront him.

"Yo yo yo, pato," he greets me, his big arms folded over his barrel belly, buzz haircut, red bandanna tied just above his eyes. "Got any cigarettes?"

"You know I don't smoke cigarettes, you idiot."

"Jeez," he says with a hurt look, "you don't have to get so angry. I thought I might have left some in your studio."

"What were you doing in my studio?" I ask.

He gives the stubble on his chin a thoughtful scratch. "Making a painting?"

"I do not want you in my studio," I say.

"Chill, man," he says. "I got food. Chicherones y arroz con pollo." Taking two foil-covered china bowls from the passenger seat, he lays them on the trunk.

"Which one you want? I gotta bring one inside." He nods in the direction of the gentleman farmer's house.

Angel always brought food after his disappearances, half-finished carpentry projects on the property awaiting his return: dead broke. Angel usually showed up around two or three in the afternoon. After a wild night, a long slumber, a big meal, he would make a couple of dishes for whoever it was, at whichever

job, who might be upset with him disappearing the way he always did. It was an irresistible combination: the warm food smelling so good, accompanied by streams of words that took the listener this way and that, far off the trail of his having let anyone down by not completing a job that both parties knew would get done . . . eventually, when Angel felt like it.

A bowl of delicious steaming Puerto Rican food in my hand, I listen to tales that start with shark fishing and end with a block party with Rastafarians, something about a spotlight, an M-16 aimed at him, rides in police cars. Always he manages to talk his way out. I have seen him do it.

"I cannot walk the line," he tells the officer standing with him in the glare of the headlights, the cruiser's purple-red strobes popping, police radio crackling. "I am a medically profiled veteran. Got my eardrum punctured from some bombs. So my balance is . . . and I have a bad knee." It does not matter that any one part of his story does not wash. He goes on and on with such gusto, touches on so many reasons, sidebars, engages the officer with so many comradely questions, that by the end, the officer and his partner work to restrain their smiles.

Angel rummages through a bucket of tools.

"Hey," I say.

"What do you want?" he asks without looking up.

"What are you doing this Monday?"

"Why?"

"I need some help up at the school."

"What happened to your helper?"

"He quit."

"I don't know," he grumbles, the guide to his table saw now in his hand.

"Don't know what?"

"What would I do up there with a bunch of cripples anyway?"

I consider walking away, then reconsider. It is hard to find

someone who does not work nine-to-five. Monday is coming and I need the help.

"It's easy," I tell him, "all you gotta do is tape down canvases."

The following Monday, Angel picks me up. He powers the Olds backward across the lawn to the chicken coop. I crawl in through the opening of the glassless window, hand out the supplies: canvas, plastic, freshly blended gallons of color.

We head north. It is already in the high eighties. Both of us wear paint-splattered pants and T-shirts with the sleeves torn off. Angel is hung over.

Veering around and blasting past a slower car, the Olds roars, not as a junk car, but with a great breathy banging purr of Detroit metal with power to spare.

"Hey, Angel," I shout over the wind.

"What now, pato?" he groans with the ring of my words in his ears.

The car blows around a line of stopped cars, crossing the intersection as the light turns green.

"Yo, Angel!" I shout, loose papers whipping violently in the torrents of air that blast in both windows. "I'm not paying for any speeding tickets."

"You want to drive?" he asks.

"I want to get there."

"I asked you if you wanted to drive." He turns to show me his bloodshot eyes.

"You know what, Angel? Screw you."

"One thing you better get straight," he shouts. "I don't take shit from gringos."

"You," I laugh, "are a gringo." He winces. He had told me he was not accepted by the whites because he was Puerto Rican and was not fully accepted by his own people because his skin was pale and he had no accent.

"I am a man without a country," he states with a mix of pain and pride. "You ever read that book?"

"No," I laugh.

"Me neither." The car roars past exit 18A.

"We want 18B, Angel." I wave both hands to the right. "18B."

Angel looks straight ahead, lost in thought. At the last second, he snaps out of it.

"18B, pato," he roars. "Hang on." As we scream around the tightening curve, one of the remaining wheel covers sails into the cement curb then leaps into the air, saucering into the high grass. "Woo-hoooo!" he sings out. "Thought we were gonna miss it, pato!" The car blasts over a train crossing, the red lights blinking, the striped arm of the crossing gate quivering before it lowers.

"Jesus, Angel!" I grip the dashboard.

"Seen any trains?" he asks flatly, the car continuing to thunder. Climbing the hill to the school, he looks at me.

"So," he asks, "are they retards?"

"What?"

"Are they retards?"

"What do you mean, retards?"

"You know"—he makes a face—"like 'daaawww,' retarded."

"You're an asshole."

"Are they retarded? Are they retarded? I'm asking you seriously."

"I don't know. They are intense. They're into it."

"Are they," Angel repeats his question slower and louder, "retarded?"

"They're making great paintings."

"So they're not retarded."

"What difference does it make?" I shout.

"Don't wet your panties." He stares dully at me.

Coming to a stop in front of the main entrance, the Olds is

seized with a fit of dieseling. The motor hisses, then with four or five loud clanks, dies. A cloud of steam rises from the front grill. "Son of a bitch!" Angel shouts.

Walking with him past the students in the main hall, I feel him tense.

"Pretty radical, huh?" I say.

"Jesus," he says under his breath.

I have the first fresh canvas taped down when Chet is rolled in. Angel pays little attention to the job he is supposed to be learning. Sullen, two-day beard, eyes closed, he slumps in a pink molded plastic chair. Eyes held wide open, Chet flares me his excited greeting. His thin red lips purse into a scrunched-up shape with his effort to form a word. Lighted with mischief, ready for fun, I can see him in the role of Puck. If he could talk. If he could walk.

"Hi, Chet," I say.

He does a corkscrew straight up. "This is our new helper. His name is Angel."

As Chet bows to the big Puerto Rican, Angel looks out one half-open eye, then the eye shuts again.

"Boop, boop, boop. Tim," a synthetic voice declares.

Chet has a little computer set up on his laptray, his fingers stretching at the limits of the Velcro to tap at the keys.

"Chet, was that you?" I ask, with a look of amazement.

His eyes wide, he nods.

"Nice computer you got there."

"Thank you." Chet's finger slipping, the computer declares, "How are you thank you how are you?"

"I'm okay, Chet. How are you?"

He nods that he is fine.

"That's good."

James, the cool and self-contained young black guy with the Nation of Islam glasses, rolls into the room. James rarely speaks.

When he does, it is with difficulty. The uncooperative muscles of his throat and tongue pronounce the word "Yes" as "Yee," "No" as "Nee." He does not use any other words, at least none I have heard.

"Ready to paint?"

"Yee."

"Good. This is our new helper. Angel, this is James Lane."

James gives Angel the sneer he had given me before the breakthrough of his first wheel painting.

"Angel's okay," I say.

Eric, the oldest, most serious of my four students, runs into the doorframe. His expression is always one of determination and the melancholy of its frustration. He looks tired, the young professor with a receding chin who has not gotten any sleep, concentrating hard to remember something.

"Tim."

"Yeah, Tammy."

"What . . ."—she throws her head back, gulps in air—"are we"—she takes another big breath—"going to be doing today?"

"We have new colors," I say. "And a new chart of design options. It should be good. Lots of new possibilities. Tammy, this is Angel. Angel, this is Tammy."

"Hello, Angel."

"Hey," Angel says.

"Before we get started," I say, "maybe we should take a look at your paintings from last week."

I had taped the four canvases on the open sections of wall. "Awesome, aren't they? I've been thinking about them all week."

"So," Tammy says, "have we."

The new and far more extensive color and design menus offered to Chet, he looks them over.

Boop. Boop, boop. "Silver," Chet's computer declares.

"This is for your ground-coat?" I verify the directive before applying the paint. "Over the whole thing?"

Chet nods.

His plan includes a single, diagonal division, black on one side, blue on the other, over the silver ground. Making choices was the key. It was the option they had not had. Walking the halls, I have caught bits of what was going on in a few of the classes they attend. They have the feel of a mom kissing a boo-boo, a baby-sitter giving the birdie mobile a spin above the infant's crib. It is light, not dark. Light, sunny, soft and cheery. In here, in 333, I never talk slow for them, never loud or singsong, as the teachers do.

"Like I keep saying," — I stand up from prepping Chet's canvas — " 'no' is as powerful as 'yes.' Get it exactly the way you want it. In here, you are in charge. You're the boss. It's your painting so get it the way you want it. We'll work on it till it's exactly what you're after. So, Chet, is this looking the way you want it?" Chet inspects the canvas. He nods.

"You're sure?"

He nods again.

"It's exactly right?"

Looking it over again he nods.

"Okay, then."

"Yo, Angel. Grab Chet's chair." The weakest link in this whole epic was my inability to figure out a solution for Chet. It was painful, pushing him around on his painting without really knowing what he was saying. His new computer-talker device would allow him to announce exact directives. But it was far too slow to have any chance of being any good with Chet's wild attacks of expressionistic abandon.

"Angel," I say. "Time to get to work. You push Chet's chair wherever he tells you."

"What?" Angel asks.

"Go for it." I jerk my head toward Chet.

Angel does not move. The classroom is quiet. With the passing seconds, the feel in the room gets more uncomfortable. Chet waits hopefully, sensitive to the possibility of his being rejected. James, Tammy, and Eric have their eyes fixed on the guy I had brought up.

"Come on, Angel," Eric says. Angel groans, stands, then lumbers over to the wild teen.

Boop, boop. "How are you?" Chet's new computer voice asks.

"I'm tired, Chet," Angel grumbles. "If you really want to know, I'm beat."

Chet's expression changes, from elation to confusion, sadness so pointed it looks like he might begin to cry. No one says anything.

"Okay, okay, okay," Angel moans, "what do I do?"

"Everywhere Chet directs you, that's where you go."

Hesitating for a moment, he takes hold of the handles on the back of Chet's wheelchair, rolls the boy forward to the edge of the tape and plastic. The big man stands dully, the boy quakes with ferocious enthusiasm.

Unable to get his lips to work, Chet pants like a dog. One second too many for the ballistic boy, he lets loose a yelp and dives head first out over his tray. His body snapping back upright, he throws himself over the left armrest. The whole time he yelps, gasps, his head and body twisting violently to the right and left. Angel glares over his shoulder at me, then swivels the chair counterclockwise.

Five minutes of all-out flailing and Chet gasps, "No mo'."

"Let's check it out."

"Let's forget about it," Angel snarls. He looks angry, I mean *really* angry.

He moves for the door.

"Yo, yo, yo." I step to cut him off. "What's the big problem?"

"This is bullshit," he says, stepping around me and out the door.

"I'll be back in a second," I tell the class, then turn to pursue him down the hall. "Yo, Angel. Give it another try."

"No way." He sweeps his mental path clean with a sharp sideways chop of his right arm. "You do it."

"Just come back," I coax him, both of us striding full speed for the front doors. "The rest of them have motors," I explain. "They can do their own thing."

Angel stops, folds his arms. "That was such bullshit."

I look away, then back. "I know. He's totally ballistic, isn't he?"

"Yeah," he says, "and you got us doing the hokey-pokey."

When we reenter the room, the students look a little scared—all of them except James, who is smiling, entertained by our little drama.

"Let's take up Chet's painting," I suggest.

"Let's not, and say we did." Angel says in his surly voice. "You want to paint?" Angel asks, lowering his face to Chet's. "You want to really paint?" Chet's eyes widen, full of fresh sparks. He draws his chin into his chest.

"Okay then, this time," Angel lowers his voice, "no more of that right left bullshit. You move your head, that's where you go. You got it?"

"You ready?" Angel asks, taking the handles of Chet's chair.

I crouch between Tammy and Eric.

With a sudden dive head first over his tray, Chet's chair leaps onto the painting. He throws himself over the left armrest, Angel torques his chair that way. A scream, then Chet's wild laughter. He dives to his right, the chair wrenched violently with the direction of his will. Pausing for a second, dizzy with disbelief in

the joy of cutting loose, he lets loose a coyote howl, then does his forward kamikaze head-dive. He and his chair race full speed across the painting. Chet yanks his head back hard, the chair pulling up an inch short of striking James; James's eyebrows shoot up, his eyes wide. Chet's head cranes backward over his headrest. Angel drags him fast in reverse, the room getting crazy with his classmates' shouts.

"Oh, my Lord!" Eric calls out.

"Go, Chet, go!" Tammy shouts.

With quick flicks from Chet's head, his chair slashes right, then left. Left, right, left, the teen's head held fast to his shoulder, the chair spins, Angel's feet dancing to avoid stepping on the painting.

In the middle of this set of high-speed revolutions, Chet cries out, "No mo'!" The chair comes to a stop, both he and Angel red-faced, both huffing for air, both soaked with sweat. Angel draws Chet off the painting. Chet pants, his shoulders heaving, facedown close to his tray. When he catches his breath, he sits up straight, his expression shining with knife-like satisfaction, mixed with relief so acute it brings tears to his eyes. "Now you've seen the real me," his look declares.

Breathing hard, Angel helps me peel up the plastic. The dark blue and black triangles of Chet's design are torn by flashing silver snakes that blend blue into black and black into blue. Carrying the painting out into the hall, Angel and I place it carefully on the floor by the fire doors. "That was genius," I say, punching him in the shoulder with the palm of my hand. He looks away. "You're a genius." I hit him again.

The artists are electric with excitement.

"Find somewhere to plug in the fan," I tell my assistant. "It's stifling in here."

"What's with the window?" he asks.

"I can't get to it with all that Styrofoam crap."

With one swipe from his big arm, he sweeps the projects from the sill. The class gasps. With a big grunt, he shoves the window open. It is hot outside, but at least now the air in the room is moving. It smells fresh.

When James has chosen his colors and design elements, and his painting is prepped, he moves up to the edge of the canvas. There is a small band of blue along the bottom edge. The rest is black. Beneath the whole thing, silver. He must have liked the effect he had seen in Chet's painting. With care and precision, he guides the small front wheels of his chair to press out a series of semicircles the length of the blue band.

"Wow!" I say when the plastic is lifted off. "It's a breaking wave."

"Nee," the artist informs me.

"It's not?"

"Nee."

As I stuff the plastic in the trashcan, it appears Angel has retired, sitting once again, slumped, eyes closed, in his pink molded plastic chair. Lifting the painting up, I show it to James the way I think it goes.

"Nee," he gives his head a light shake.

"It doesn't go this way?"

"Nee."

"This isn't the way it goes?"

"Nee."

I show it to him sideways.

"Nee."

I show it to him the way I definitely consider upside down.

"Yee."

"This is it?"

James smiles.

"Let's," I suggest, "do it again."

"That's the way he wants it," Angel says flatly.

"Who asked you, fatso?" I say. Chet whoops with delight. James gives a little snort. Tammy laughs, then stops short, seeing the darkening menace of Angel's expression. Eric watches without speaking.

"This way?" I ask James.

"Nee."

"This way?"

"Nee."

"This way?"

"Nee."

"This way?"

"Yee."

"This way, you're sure?"

"Yee."

"You like it this way best?"

"Yee."

"All right, then. You're the artist."

I stand over James's painting in the hall. The way I had it, it looked like a seascape. The way he wanted it, it reads like a curtain raised to reveal nothing but black.

"I," Tammy decrees, "will need fire-red. I will also need fire-orange and fire-yellow. And one more thing: I will need a lot of room." When I have finished placing the colors on her canvas, Tammy instructs me "much more red."

"Where do you want it?" I ask.

"All over."

Inside, I smile. "All over"—that's how art critic Clement Greenberg described the paintings of Mark Tobey and Jackson Pollock.

"Much more red, Tim." Tammy looks down at me through her thick glasses.

The field of red applied, the plastic taped down, Tammy jets forward onto the painting. As she performs a high-speed spinning maneuver, the plastic tears. A ridge of brilliant shining red squishes up through the rip. Coming to a sudden dead stop, Tammy stares down at the rip.

"Blood!" she cries hysterically, loud enough for anyone in the main hall to hear. "Blood! Blood!"

James snorts at her dramatics.

"Easy, Tammy," Eric advises her.

A second sheet of plastic laid over the tear, I stomp the taped edge down, then jump back as Tammy resumes her attack, her chair darting this way and that, back and forth, back and forth, and over and over. Her chair stops. Her face red, wet with perspiration, she pulls for air to breathe. She backs slowly off the painting.

Tape removed, plastic peeled off, everyone checks it out. It is the first painting without a discernible set of tracks. It has been blended into a single field, a glistening sea of swirling crimson accented by filaments of orange and yellow.

"What do you think?" I ask.

Peering down through her glasses at the firestorm, she blinks. "I like it," she says quietly.

All of Eric's moves are so slow, so painstakingly deliberate. I am used to the effort it takes him to get his hand to the pressure switches. Angel is not. He watches Eric's twisted fingers, then looks down at the floor. When Eric has finished, and I peel off the plastic, the artist says nothing. The painting does not remind me, as the others have, of the artist who had made it.

"I guess that's it for today," I say, looking at my watch. "Good work, you guys. We'll see you all next Monday." The three motorized students pull away from the wall. Maneuvering for the door, their chairs bump together. Eric slowly backs up to un-

snarl the jam. James, closest to the door, drives slowly out of the room. Chet, sitting in the corner exhausted from his wild session, is asleep. "See you at the car," Angel says.

"You're not going to help clean up?" I call after him.

"For twenty-five bucks," he calls back, "I've done enough."

When I finish the cleanup, I sit down on one of the five-gallon pails, wait for the oscillating fan to blow on me. With his smooth face and slender, cleanly defined features, Chet, asleep, looks more like an angel than a maniac. He is missing one of his shoes, the toe of his sock hangs off the end of his foot. Not a poor and piteous cripple. Just a handsome kid sleeping in a chair, one shoe on and one shoe off. "Hi," I say into the phone. "Chet's PCA hasn't shown up."

When the PCA appears, she looks Chet over, then starts looking around the room for his missing shoe. She locates it in the far corner behind some of the pails. It must have flown off while he was working on his painting. When she tries to wedge it on his foot, his eyes pop open. He kicks the shoe from her hand and it sails across the room as it had before.

"Chill, boy," she tells him. "You can't be walkin' around the place with no shoe."

As she continues her wrestling match with the wild sock puppet, Chet kicking away, he stretches out his finger to the key of his talking computer. Boop. Boop. He ignites the voice. "Free. Free. Free," it declares.

The shoe on, she pushes him out of the room.

"See you next Monday, Chet."

He turns his long neck to look back at me, his lips twisting to form a word, then he is gone. I look around the studio, turn off the lights, pull the door closed, head down the main hall, walking slowly behind slow-moving wheelchairs, easing around others.

*

"You fill the radiator?" I ask the big man at the wheel of the roaring car.

"I don't know, man." Angel shakes his head.

"Don't know what?"

"I don't think I'm cut out for this."

"Your thing with Chet was awesome," I say.

"I don't know."

"Think about it. Chet got to go off for the first time in his life. You should have seen him, seen the two of you. It was really great."

Angel looks straight ahead.

"Belle Mead Inn," I say, sensing he might actually be about to cry. "I'm buying."

"I don't have time to stop." He gets his surly voice back. "I got a roof job to look at."

When, close to home, the Belle Mead Inn, an old clapboard house with neon beer signs in the windows, appears, I shout, "Pull over." The Olds veers onto the rutted gravel parking lot.

"You're buying," Angel says.

"I said I was buying."

"Just one, then we're out of here."

"Right," I say sarcastically.

Walking together, parallel to the two-lane highway traffic, I hold the door open, and wait for Angel to go in. Dimly lighted by a few lamps the beer companies had provided, his cold can of beer untouched, he sits quiet, his face turned away from me.

"What happened up there?" I ask, feeling his tears welling up.

"I don't know," he says, wiping the back of his arm across his eyes. "Maybe I can tell you tomorrow."

"Have a shot, you big sissy," I say.

"I don't want a shot."

"Then have a bar pie."

"You buying?"

"I told you I was buying."

When we leave the bar, it is evening. The air has cooled. A floodlight plays on a billboard for a company that builds swimming pools. A woman, emerging from the water, holds a brightly colored beach ball above her head. The moon is up in the dark blue sky: champagne, china, linen, and white.

*E*ric's lone figure sits motionless in the center of the intersection. His head hangs low over his laptray, pointing the direction he had been willing himself to go. I should go over there and straighten out those glasses. I should go over and put my arm around him, and tell him how much I admire him for trying, week after week, in the months since we met, to get at something he cannot yet reach.

"Hi, Eric," I say.

No movement.

"You okay?" I ask.

His head comes up. He looks at me. He looks at his right hand, then brings the fingers to the green pressure switch, which will signal his chair to roll forward.

I wait for him to get his chair settled in, against the wall, next to James.

"What's up with Tammy?" I ask.

"I don't know, Tim," Eric says.

When Tammy started missing classes, I went to talk with her teachers. They said it was typical of her, with new classes, to come on strong, then to quit.

"How come you guys didn't rotate into new classes?"

The two eye each other.

"Your teachers know you're down here?"

"We talked with Suzanne."

"And she said you can stay with us?"

"Yup."

"Hmmm," I muse, encouraged by Suzanne's circumvention of the rules. "That's good."

"Fat, fucking bitch," Angel shouts. Chet, wheeled ahead of the angry man, bobs and shakes his head in adamant agreement.

"She's a fat fucking bitch?" I ask Chet.

"Absolutely," he nods, eyes glinting with fires of fun, solidarity, and real support for Angel's outrage.

Eric watches Angel, then gives me a glance to ask if we should be worried for our safety. With a little shake of my head I signal him that everything's cool.

"What happened?" I ask.

"Ahh!" Angel spits into the trashcan.

"What happened?"

"I found Chet down in the cafeteria. Just sitting on his ass, no one doing shit about getting him down here. This other kid was trying to get something to drink and this fat bitch starts yelling at him. 'Make up your mind!' she's yelling. 'You can't have white milk and chocolate, too. Make up your mind!' she's yelling. All the kid wants is something to drink. I woulda' decked her if she was a man." Angel holds up a clenched fist for the painters to see. James smiles blandly, as he always does with the dramatics of the able-bodied.

"Wassup, Lane?" Angel asks in his gangster voice.

James continues to smile, but there is a slight shift in his eyes. The three young men look up at the big, gruff, angry, Puerto Rican man. They have never seen anyone get this angry on their

behalf. You can imagine what it might mean to them if they were to have someone like Angel, a crazy person with muscle, who could step in when they got pushed around.

A student I have never seen before sits in the doorway. He wears a tight black T-shirt and a bright orange baseball cap that reads "Harley-Davidson."

"There he is!" Angel shouts, his scarred finger pointing at the young man. "Dude!" he laughs. "Wassup with that fat bitch? What you ever do to her? Huh? Nothing, right? Fuck her. You know what I'm saying? Fuck her. In fact, fuck this whole place."

Chet bobs, and nods, his eyes showing a hilarious joy for all things extreme. Like a rabbit on the front lawn, the boy with the bright orange Harley-Davidson hat sits perfectly still — as if, if he does not move, he will not be seen. I say nothing to him. During the rest of the class, without my noticing his movement, he has maneuvered closer to the paintings being made. At the end of the class, he sits with his front wheels an inch from the edge of the last painting to have been worked on. At 2:30, the painters on their way to their next class and my assistant nowhere to be seen, the young man with the orange Harley-Davidson hat remains. He looks down at the painting Eric has made.

His head, in fact his whole body, leans forward, his elbows resting on his Plexiglas laptray, his hands one over the other, cupped on a joystick mounted at the center of the tray. The two of us sit silent, me looking at him, him looking down at Eric's painting. His wheelchair and paralysis aside, he reminds me of the guys I see in shot-and-beer bars. Banged-pickup driving, black T-shirt with rock-band logo wearing kind of young guys. He has this look and feel about him, like a young guy who would work a farm, or be a mechanic at a gas station. The type that does not talk that much. It is clear he cannot talk at all. Nonetheless he looks — unlike Chet, who would rap a mile a minute if he could — like someone who keeps himself to himself. It

must be real hard for a kid like him to be up here. I can picture where he would rather be: on his Harley, its big V-twin rudely farting through some little town, or down along some river.

"What do you think?" I ask.

No response.

Returning from the alcove where I placed Eric's painting, I sit on the five-gallon pail. The young man has not moved. He stares down at the square of floor where Eric's painting had been.

"So," I say, "you're not here to check out Eric's painting."

The boy holds himself perfectly still. I feel something from him, a pride, shielding a shyness, or embarrassment. He wants something, something he cannot easily ask for, so he will not ask for it.

I wait another minute.

"You want to paint?" I ask. "Wanna paint?"

His eyes focus hard on the floor in front of him. I get up from my pail, take the roll of canvas, cut into it with the Buck knife, rip the large square off, and snap the canvas out like a tablecloth.

"Let's paint," I say.

The canvas prepped, plastic adhered to the floor, the boy glides forward onto the painting. He cuts smooth, looping arcs. As his chair turns hard, his body remains perfectly still, all the chair's motion controlled by the slight movement of his finger-tips on the joystick. Shifting in midstream into reverse, he arcs backward and away, then over the painting again with a quick loop to the left. He drives backward off the painting, and stops.

The plastic peeled up, the two of us inspect his work.

"Not bad," I say. The boy—the young man, maybe nineteen or twenty—makes no move to leave.

"I have to go," I say.

His chair revolves without a sound, and he glides out of the room.

Eric sits in the hall parked against the wall.

"Hey, Eric. You know who that guy was? The guy with the Harley-Davidson hat, the orange baseball cap?"

"That is Michael," he says. "His name is Michael Young."

Suzanne and I stand together at the mouth of the unlit corridor.

"Michael has been sitting out here, by the door, every day since your last class," Suzanne says.

This means that Tuesday, Wednesday, Thursday, Friday, as I worked in my studio, as Angel banged nails, as waiters poured ice water in fancy restaurants, Michael Young stared at the studio door.

"Couldn't we add him to the class?" Suzanne asks.

"There isn't enough room or time for Chet, James, and Eric. An hour and a half gives them each half an hour. It was too tight with four students."

Suzanne rests an elbow in her palm, a finger pressed into her chin. As we speak about possible arrangements for extending the class period, Michael hovers nearby. He makes a slow pass behind us. Both Suzanne and I track him over our shoulders.

Suzanne smiles, then whispers loudly, "There he is."

Michael feigns interest in the view beyond the fire doors. Returning to our conversation, I see him loop around and head for the entrance to the unlit corridor. Shifting the way I stand, I let him know I could grab him if he tries to slip by. He stops short. I look to Suzanne. She shrugs, her hands turn palms up. Michael makes the dash.

Mike had not been to more than a couple of studio sessions when I notice a lull in the anticipation to paint. Not in Mike,

but in the others. "What's up?" I ask. Something is definitely wrong and it seems clear that it is something they are hesitant to tell me.

"Eric. What's up?" I ask.

Eric looks down and away. "Well," his voice drags. "Well . . ."

"Has it got anything to do with this class?" I ask.

"Yup."

"Like what? It's your class, right? What's up?"

"The wheel painting," Eric moans apologetically, "is good, but . . ."

"But what, you're sick of it?"

"Not really sick."

"Bored?"

"Kind of bored."

"Yes!" I throw a punch in the air. "That's excellent! I'm sick of it too."

Pleased with the success of his coup, Eric throws back his head, the happiest I have ever seen him.

"What," he asks, almost beside himself, "will we be, you know, doing next?"

I run my fingers through my hair.

"To tell you the truth, Eric, I haven't got the slightest idea."

*T*he calico barn cat stretches out on my desk. Butterflies flit outside the glassless window. The gentleman farmer rumbles over the lawns on his gray Ferguson tractor with its big mower attachment. Swallows dive from the blue sky, down on the bugs the mowers scare up.

The coop is a good place for thinking. The big question for the day is what is lacking in the wheel technique. What do the painters need to move on? A breakthrough when we began,

wheel-painting seems primitive now. The limits of the technique frustrate Eric's attempts to translate his deeper thoughts and feelings to the canvas. Driving slowly over his paintings, he cranes his head and upper body, hard, over the armrest of his wheelchair. He stares, unblinking, down through his glasses at the marks he has made. When the plastic is peeled up, he shows no signs of pleasure, as he has for the revelation of his classmates' work.

The wheel-painting technique has some bad limitations. The artist cannot stop and start a line in the center of the painting. All the wheel tracks come from the outer edge, inward. Another bad thing is that the plastic that covers the painting may appear full of reflected light from the overhead fluorescents. Another bad thing is that the technique favors those with power chairs. It would be best to find something that worked equally well for all the students.

Marks the wheelchair makes are very slow compared to the way you can move a pencil. One thing Eric might need is something that would let him get past the ponderous motion of his chair; some speed. Speed.

"Speed," I repeat the word aloud like a mantra meant to push away all other thoughts. "What is really fast?" A narrow shaft of sun entering from an opening in the barn siding crosses the darker space, to rest on a gallon-pail of brushes in water.

"Light," I say.

"I need a laser," I tell the guy behind the counter at the gun store. He smiles like a lizard, his eyes close to slits. "What kind of range are we talking about?" he asks.

I check to my right, then left, then narrow my eyes the way he has his.

"Close up," I whisper.

He comes from around the counter with a key, opens the glass case, and takes out a short, narrow black metal tube. Drawing it up to his shoulder the way you would throw a dart, he aims the beam.

"Got you," he says.

A color photograph of Bill and Hillary Clinton; the ruby bead rests on the president's chest.

I give a low whistle.

Back at the coop, I remove the shield from a welder's helmet, put the plastic liner with its adjustable tighteners on my head, and twist the knobs to snug the fit. A length of aluminum flashing inserted into the plastic headband, I run it down, out around, and back up to reflect the shape of my jaw line, like the face mask on a football helmet. The laser is Velcroed to the thin aluminum armature so that it sits dead center between my mouth and nose, three inches from my face, pointing straight ahead.

The laser switched on, a ruby bead appears on my painting. The bright red bead moves smoothly with the slight motion of my head. I draw a circle of light on the canvas, fifteen feet away. I draw a triangle. With a slight "no" motion, the bead etches an expressionistic set of tracers.

This suggests that a person with physical challenges like those of my class could use the head-mounted laser to reach out far beyond the limits of their bodies to draw, to paint, with speed and fluidity. It will be simple. Wherever the artist draws the light, Angel will apply their chosen colors.

Mike waits at the door to Room 333. His orange Harley-Davidson hat hangs on one of the push handles on the back of his wheelchair. I have never seen him without his hat on. He has a crew cut.

"Hat on or off?" I ask. "Off?" I wait for his eye signal.

His lashes do not lower.

"On?" I ask.

His lashes come down.

"Okay, dude." I place the Harley hat down snug so the bill rests just above his eyes the way he likes it.

"That right?"

Lashes down.

"Good," I say. "Got some serious stuff here, Mike. Got a laser. Hey, Chet."

I shove open the recessed window. A steady stream of fresh air moves into the studio.

"You guys ever seen a laser?"

I hold it out for inspection. Mike and Chet eye the black tube.

"Laser," I say. "Light amplification through stimulated emission of radiation. That's what the letters in laser stand for, I think. It's really cool. It shoots a beam of light. It's jacked up, intensified, so it stays tightly packed, just going straight ahead, way brighter than normal light. So, you can see the dot it makes, hundreds of yards away. I got this baby in a gun store. They use it for aiming at stuff. Pretty cool, huh?"

Mike's eyes are fixed to the black cylinder.

I doubt anyone up here would think of explaining the workings of anything to him. They think he would not understand. To me, it does not matter if he gets it all. What he gets is that I do not hold back on how I talk to him.

The button pressed, the little ruby dot dances on Mike's tray,

then leaps to the wall, races up the ceiling to reappear back on the tray. I had never seen his head move until now.

I pull the headgear from my little canvas pack. Mike eyes the contraption. "It's homemade," I say, fumbling to attach the laser to the rig.

"Gimme that thing," Angel barks.

In my twisting the rig from his grip, the laser hits the floor, battery lid rolling one way, the tiny battery another. I jump to my feet. Angel takes a half-step back.

"Don't look at me, fag boy!" He waves his arms to dispel any responsibility.

Mike, who we have never heard make the slightest sound, moans. His head comes all the way up, then over, back, until it rests on the padded neck brace. His chair revolves in place, once around, twice, three times, then out comes a gusher of sound. Around he goes again, his body rocked with laughter.

"Check it out, Lefens," Angel says. "We really cracked him up."

Exhausted from laughing, Mike exhales. His chair stops. His head falls forward, then out comes another wave of laughter.

"Now what?" Angel asks when neither of us can locate the battery lid.

"Go find a coat hanger."

"What for?"

"We'll straighten it out, attach it to the jaw mount of the headgear, so it sticks out, as a pointer; like the laser would have before you wrecked it."

A length of wire clipped from the coat hanger, then duct-taped to the jaw-mount, I turn to Chet and Mike. "Who was here first?"

Shooting up into the air, Chet lets go a coyote yelp. Wedging the headgear unceremoniously onto his head, Angel cranks the

tighteners; the wild teen's eyes flare with excitement. The not-perfectly-straight coat hanger extends out away two feet from his face. It wags up and down, in a way that would make me laugh if I was not so anxious to see the technique succeed. "You look like goddamn Frankenstein," Angel says, his hands on his hips.

In Chet's quick move to look my way, the wire whips around, jabbing Angel in the stomach.

"I've been stabbed," the big man roars. His shirt hoisted to inspect the wound, Chet stares in awe at the barrel of flesh. Then, in prime demon form, he lunges forward to run Angel through.

"See that, Lefens?" Angel shouts, jumping back to avoid the thrust. "He's a maniac! I told you he was a maniac."

Chet and Mike give each other "Do you believe this shit?" looks, then with the joy of juvenile delinquents, bust up laughing. Chet hops up and down, the wire pointer going boing, boing, boing, up and down.

To blunt Chet's rapier, Angel takes a big wad of masking tape from the garbage can and skewers it on the end of the wire.

"Angel," Chet says. "You're weird."

"Look who's talking," Angel blinks, startled at hearing the voice of a normal teenager. In the rarest of rare moments, Chet's throat muscles cooperated, and out had come the words.

Chet hoots at Angel's expression, thrilled with having so thoroughly shocked him.

Angel grabs a wide roll of masking tape.

"There you go, wise guy!" he says, sticking a strip of the tape over Chet's mouth, Chet still talking the best he can with his lips sealed shut.

"Get that off him, you idiot!" I say, picturing one of the staff witnessing this. All the same, Chet's eyes flash with joy. "Take it off, Angel," I say.

With one brutal yank, he tears the tape from Chet's mouth. The wild boys gagging with laughter, Angel stalks around the

room like a pro wrestler, threatening one, then the other, with a big closed fist.

Eric, in the doorway, looks concerned. He had to have heard our little party from way down the hall.

"There's the freaking top," Angel says.

"Where?"

"Over there, over there." He points with his chin.

The battery reinstalled, the cap to the laser screwed in with a dime, Angel tears the coat hanger off the headgear. The last of the duct tape picked away, I press the strips of Velcro together, flick the tiny toggle.

"Laser on," I announce. "Let's get serious."

"You can be the test pilot, Mikey," I say, lowering the rig onto his head.

Pinning a canvas to the sheet of plywood, leaning against the wall, I instruct Angel: "Go with the black liquid paint in the squeeze bottle."

"Wherever the light goes, that's where the paint goes. Got it?" I ask. "Everybody ready?"

Angel drags over a five-gallon pail, hunkering down to sit close to Mike and the raw canvas.

Mike trains the ruby bead on the center of the painting, Angel brings the nozzle of the squirt bottle to the point of light.

"Well?" Angel looks to Mike.

The light darts away and back to hover next to Angel's hand.

"Okay, Mikey," Angel says under his breath. "Let's try that again."

The same quick move, away and back.

"Oh yeah, Mikey boy." Angel leans closer to the canvas. "Think you're fast?"

The dot whips away. This time Angel lunges after it, the black paint streaking in hot pursuit.

Mike stops, exhales, totally stoned from his first game of tag.

Laughter wells up inside him; then, with his head falling back, it gushes out. The ruby bead goes straight up, Angel and the black squirt tube in tow, and off the canvas; the black line squirts onto the classroom wall.

Chet screams.

"Oh, my Lord," Eric moans.

The ruby bead fixed on the acoustical tiles of the ceiling, Angel gets up on the five-gallon pail, reaches up to the point of light, and with a loud farting sound blows paint onto the ceiling.

Mayhem. Pandemonium. Mike's head drops, the black line tracking back down the wall, down the canvas, then with Mike's next laugh, up it goes again. Shouts, gasps, and yelling.

"Check it out, Lefens," Angel calls over the noise. "A painting of Mikey laughing!"

When Mike can't take anymore, his head falls forward. It does not come back up.

"He okay?" I ask.

"Who knows." Angel eyes Mike.

"You think he's okay, Eric?"

"Michael?" Eric asks. "Are you okay?"

Mike rights himself, a new wave of laughter welling back up.

In spite of the wild boy's joy, I want to test the laser for a more careful articulation.

"Eric, you ready?" I ask.

"Yup." His serious look meets mine.

Fresh canvas reeled from the roll, Eric concentrates on the finger I run slowly along the upper edge.

"Stop," he says.

"This right?" I ask, bringing the blade of the Buck knife to the point he has directed the cut to be made.

"Yup."

"Exactly right?"

"Yup."

He directs the second cut.

"Horizontal?" I ask, displaying the rectangle. "Or vertical?" I turn the canvas.

"Vertical."

His chair adjusted to face the canvas, I lower the laser rig onto his head. Eric's expression is grave. He stares at the canvas without speaking for a few seconds.

The canvas is pinned to the four-by-four sheet of plywood we have propped against the wall. Eric looks at the brilliant point of light. He moves his head a few inches, back and forth. Angel takes the cylindrical squeeze bottle of liquid black paint, pulls up a five-gallon pail, and sits next to the board.

"Ready to begin?" I ask.

"Yes."

Eric draws the laser back and forth, slow and steady, its movement traced with a narrow line of black paint. The ruby point plays in the lower corner until it forms a dense lozenge-shaped area soaked wet with glistening black paint. The level of control Eric has over the paint sends a thrill through me. It is the same as if you were sketching, carefully, with a pencil or a brush.

When no raw canvas remains in the lozenge-shaped area he is working, the light continues to move, slowly, slowly, inside the black shape. Angel looks back at me.

"Wherever the light goes," I say, "that's where the paint goes."

"It's already painted," he protests.

"Go with it."

"I don't get it."

"Go with it!"

Eric's head sways an inch or two from side to side, the red bead running bright through the black bog. Very slowly, back and forth, he takes the tip of the squeeze bottle through the black, then suddenly, straight up; the point of light disappears off the top edge of the canvas.

Angel was caught off guard and has not tracked the move. The bead returns to the black shape. Eric leans forward, his elbows rising with the severity of his concentration: lost again in his sadness, he continues to draw. Then again, without warning, he takes the line straight up. This time Angel has it. A series of ten or twelve of this same set of moves: etching inside the shape, followed by a fresh, vertical "breakout," Eric's head falls. The red bead rests on the splattered floor.

"Done?" I ask quietly.

No answer.

"Eric. Done?"

"Yup."

The trees outside sway with a gust of air.

Eric's eyes close. I promised I would not involve myself, in any way, in the artist's creative process. I promised I would stay clear, ask no questions. But I cannot help myself now, drawn as hard as I am to the critical depth of Eric's purpose.

"Is there any way you can tell me, if you feel like it, what your painting is about?" I ask.

Eric brings his head up but does not speak. The room is quiet.

"The bottom part is the earth," he whispers. "The lines are my arms, reaching up to the sky, saying, 'God, please don't let the earth take me.'"

Angel's eyebrows go up. "Whoa," he says.

"This is the art room," Tubby Tuna tells a visitor.

"What are they making?" the visitor asks.

"What are the kids making today, other than a mess?" Tubby chuckles, smiling easily to me then to the visitor, in her tweed jacket with its black velvet collar.

"The kids?" I ask.

"Yes," Tubby says. "What are they making today?"

"This is Eric Corbin's painting," I say.

Looking directly at the canvas, the visitor squints; then she squints harder. The flesh on the bridge of her nose puckers into wrinkles, her lip draws up to expose the tips of her small teeth. Giving up, she turns to her guide. "Do they know about real things?" she asks.

With Tubby's friendly shrug, the two turn to continue their tour.

Eric rests his head back against his neck brace. He sighs. His eyelashes bat twice.

*A*utumn now, a dried oak leaf moves on point, on the outer sill of the recessed window. A gust of cold wind makes it leap into the air. Eric continues to work with the drawing style he developed in the first laser class. He is so dogged. He concentrates so hard, giving each effort everything he has. It pleases me that he has a handle on what he was after for so long.

Today, he sits quietly waiting his turn to paint. Angel clowns around. He blows up a surgical glove, so huge it pops; the air in the room fills with the smells of his Burger King breakfast.

"Oooo!" Chet makes a face.

When the surgical glove exploded, Eric flinched, yet his eyes remained stern. It takes a while for the rowdy boys to settle down. When Eric comes up to the board and gets his chair arranged, makes his color and brush selections, and finally gets down to work, the feel in the studio has changed. His classmates sit quietly. They watch with an interest in the absolute seriousness he brings to his painting. He leans into it. As he works, the only sound in the room is that of the brush running over his canvas.

The others shift their styles more freely. Chet attacks his canvases with a flurry of flying violence. It is not anger. He has a lot

of youthful male energy he wants to let loose. He paints with a brightness of fun and reckless, devilish abandon. His work does not look juvenile. There is so much energy in it and it is done with such bravura that his latest laser paintings put more cautious professional abstractions to shame.

Mike acts cavalier, like he does not care. Yet when he paints, the placement of his sophisticated blended colors is controlled with a precise touch that is visually lyrical. His paintings feel clean and free. He leaves lots of wide open space in the center: an open field.

James uses the laser to create paintings that reflect the secret of his unique sensibility. He carefully drew two graceful spirals, each placed symmetrically, side by side, perfectly equidistant from the outer edges as from each other, their hypnotic nautilus orbits opening. Twins spinning, different and the same. James is the first to direct that passages of paint be brushed over and over. Angel, tracking for him, did not get what James was after in directing the brush back and forth like this. Being a painter myself, I was thrilled. He was after the smooth gleam you can create with this technique. No one taught him this. No one has taught them anything. It is all coming from them. What they learn from outside themselves, they pick up from watching each other.

Their new work is really very good. If some of the paintings are a little crude, the honesty, the necessity, the drive of the work takes up the slack.

In making this leap they have leapt over the staff.

"Have you seen what Mike has been doing?" I ask his social worker, a small woman in her mid-thirties—pointed nose, pile of curly hair pinned on top of her head. By her voice a native of urban north Jersey or Staten Island, she holds her clipboard to her chest. She eyes the painting I point to.

"Very nice," she says.

"You like it?" I ask.

"Oh, yes," she says. "It's very nice."

"What does it say to you?" I ask.

She peers through the door at the abstraction. Mike is now using a wide range of subtly blended colors and sophisticatedly spare drawing. "Oh . . . ," she says, vague with discomfort, "I don't really go for modern art."

"But what do you feel when you look at it?" I ask.

"We were wondering if there is any way he could do it himself?"

"What do you mean?" I ask. "With his hands?"

"I think it would be important if he could handle the materials."

"His hands don't work," I remind her.

"Have you considered HOH?"

"What is HOH?"

"Hand Over Hand," she says. "Recreational therapists use it now. They feel it has real benefits."

"What exactly is it?" I ask.

"The therapist holds the crayon or a brush in the client's hand," she explains. "The therapist draws, the client gets the direct sensation of making the drawing."

"What?" I ask, my face screwed up.

"What do you mean 'what'?"

"I mean you're kidding me, right? You're joking, right? This thing you're talking about is insane. What chance could one of my students have of creating Art with you holding their hand, you driving the crayon around where you want it to go? No chance, right?"

"They get the sensation." The social worker fixes her eyes on mine.

"Sensation of what?" I ask.

"Their body," she says with conviction.

"Their bodies are what does not work so well," I say. "It is not their strong suit. Their power comes from inside."

"The client is in direct contact with the process," she says.

"The process is a nice part of making art, but it is not the point. The point is to make Art."

"And you know what Art is?"

"Yes," I say, "as a matter of fact, I do. Art is the creation of an object that transcends its materiality. You know, when the paint is no longer just paint, or something that is used to make a picture of something else. It is art when the paint is transformed into a true reflection of the spirit. That's when it's Art. That's what Art is."

I look at Mike's painting, then back to the social worker.

"The critical thing," I tell her, "is that they find a way to say what they need to say clearly, unambiguously, uncompromised by the control of those who work with them." Seeing how much this last statement angers her, I change the subject.

"Mike seems very bright."

"You know he is severely retarded?" she says. "He can't make change for a dollar."

"Why would he know or care about making change for a dollar?" I ask.

"I let you know," she says, "in case you are tempted to impose values on him that are not there."

"I have to get back to my class," I say. "Thanks for stopping by."

Angel sits next to Mike. Both have overheard the conversation with the social worker.

"This place sucks," Angel says.

By dismissing the paintings, they dismiss the students. The opinions of the staff concerning the paintings ranged from bland to blank, from dubious to derisive. The paintings—the student's achievements—brushed aside week after week left a film over the gleam I felt for pure abstraction. I knew their opinions did, and did not, count. They did not make any difference to my own art work. But they were the ones who controlled the student's lives. They were the ones the students had to deal with, day in, day out. Their attitude colored everything in the student's lives. So their opinions did matter. The paintings were proof that the students had deep, vibrant interior lives. If the staff were not going to be able to see this, the students would never break the spell of misperception that held them back. If the sum total of opinion—as in an ideal democracy—counted, we were in trouble. There were a whole lot more of them than there were of us. If a hundred people tell you that you are stupid and one tells you that you are smart, who do you believe? I guess it would depend on who that one person was.

Clement Greenberg is among the most influential art critics of the twentieth century. His collection of writings, Art and Culture, *is a cornerstone for modernist painting. He championed the work of Jackson Pollock when next to no one saw its importance, when* Time *magazine lampooned the purely abstract Pollock as "Jack the Dripper." In spite of the snickering, Pollock's paintings rose to international preeminence, Paris and the Old World art world making way for Pollock, New York, and the new.*

It is highly fashionable in the art world today to hate Greenberg. In the sixties, when art shifted to a more glib, ironic, sociopolitically-driven market place, Greenberg became the lightning rod for all those who held judgments of good and bad as passé. Glib and ironic professors, emptied of the classical dream

of aesthetic excellence, force-fed armies of impressionable young art students the same line. For most of them, the worst person in the history of art is Clement Greenberg. Yet when I looked at the painters he picked as his favorites, I could see in them the drive to transcend the material. Three decades of attacks did not seem to faze him. He just said what he felt. He did not let them drag him down. This is one of the reasons I needed to go see him.

Clem's apartment is on the seventeenth floor of a building off Central Park West in New York City. The building has an awning, and a doorman who will not let me in.

"Send him up," Clem's raspy voice crackles over the intercom.

Eighty years old, bald head, hooked nose, thick lips, his eyes owl-like behind his large glasses. In spite of his appearing significantly smaller than he looked in the photographs I had seen of him with Pollock in the forties, he has the air of his hard-baked Brooklyn youth. He had been a bit of a terror when he was younger, thrown a few famous punches in his day, back when Art was felt with unrestricted fire.

In one of our phone conversations, Clem quoted someone as saying that the eye is the most intellectual of the organs, and went on to suggest that to see Art we had to trick the eye, to get past the intellect. This is what he is doing as he looks at me now. Judgment suspended, just looking, taking me in, with the pleasure he gets from looking at things.

"Put the paintings in there." He nods to a long, sunny, airy, living room that overlooks the park.

Khaki pants, chamois shirt, slippers, vodka on the rocks in one hand, burning Camel in the other, Clem stands looking at me. Dropping the dead weight of the roll on the carpet, I look around at the paintings on the walls, work by famous painters I revere.

"Fix yourself a drink," he says. "The booze is in the kitchen."

With my own vodka on the rocks, I take a seat on the couch, beneath a painting by Morris Louis. Clem stands by a low, round-

backed armchair. His knees bending to bring him within a foot of
the seat, he free-falls to rest. A sip from his drink, his face lights
with satisfaction.

"This," I tell myself, "is the guy." Because I had chosen to live
in rural New Jersey rather than Manhattan, I had worked alone,
receiving very little qualified criticism. Now, after all these years,
I was about to get it. My anxiousness apparent, Clem looks me
over, carefully, then turns his gaze to rest toward the back of the
apartment. Minutes pass, he saying nothing; me, on the edge of
my seat. Sweat forms on the outside of my glass. Ice cubes settle.
Clink.

"Should," I ask, "we look at the work?"

"In a bit," he says, a slight irritation in his voice, before he re-
turns to the pleasure of his perfect calm. As the silent minutes
pass, my anxiousness turns to frustration, then to anger; my work,
my paintings, my life on the line, and this guy sitting there like
Alice's hookah-smoking caterpillar. Finally, thoroughly disgusted
with my fretting: I simply let go, mentally tossing my hands in
the air.

In the quiet, sunny living room, surrounded by paintings,
Clem, puffing on his cigarette; sounds from a school playground
far below. A car horn honks. Birds chatter in the park. I take a sip
from my drink, place it on the glass coffee table, then sit back
against the couch, rest a boot on my knee, lace my fingers behind
my neck, breathe in, then out.

"Okay." Clem smiles my way, "Let's look at the work."

Getting up from his low chair with some effort, he scuffs in
his leather slippers over to the large windows that face the park.
He stands there, perfectly still, his back to me. I take the first un-
stretched canvas from the roll and hold it up for inspection. The
painting is big enough to hide my whole body. I peer around it, to
see what Clem is up to.

"Ready?" he asks, his back still to me.

"Yes," I say.

With a flash of movement, the eighty-year-old man spins to face the painting. The spin blurs the world away, so my painting will be the only thing he sees. "Look at those eyes," I tell myself, startled by their childlike intensity. "I was trying to get the top to lift off the square in the bottom," I say.

"Oh, for Christ's sake," he grimaces. "Please. No soundtrack."

"I was just trying to say that, I wanted to get your take on . . ."

"You know," he interrupts me, "the French have a saying, 'dumb as a painter.' Let's see the next picture."

His eyes are serious, but twinkle with his teasing me, and my smiling back at him.

Each new canvas I hold up, Clem, his back to me, asks, "Ready?" Each time I say "Yes," he spins. "You're on fire," he growls, looking hard at one of the paintings.

When he has seen the last of the canvases and the paintings have been rolled up, he makes no move to usher me on my way.

"Fix yourself another drink," he says. He gives his cigarette pack a shake, a fresh Camel popping into view.

With the breath of evening, the windows of the buildings across the park light up, one by one.

"Clem," I nod to the roll of paintings. "You think a couple of these are good. Does that mean they're not great?"

The critic snorts, then offers me a Camel. "You're hot," he waves me away. "Don't worry about it."

"Clem?" I ask. "When is a painting great?"

"When it's good," he says, "that's enough."

"When you say 'good,' what do you mean?"

"I mean good." He thumbs his lighter to flame.

"What does good mean?" I ask.

"It means good."

"Come on," I laugh. "What makes a painting good?"

"When it works," he says in a plain voice, not displeased with my perseverance.

"When does it work?"

"When it's good."

"When do you know when it's good?" I ask.

"You just do."

Sullen, red bandanna tied around his head, his big forearms on his thighs, resigned and agitated, Angel sits in the cramped, messy studio.

The smell of the disinfectant the buffer machines apply to the floors. The slight buzz of the fluorescent lights, rising and falling. The receptionist is saying something over the public address system. Her voice fills the main hall, but reaches this forgotten end of the school as if from a separate building—some busy company at work, unaware that we are here. The minute Angel drops me off after we get back from being up here, he heads for the world where he belongs. In the Trenton barrio, life is robust, crazy, rich, and raw. Police cruisers prowl the alleys. Rickety fences, broken back porches, laundry on the lines. Excited voices, sweet as singing, kids swarm to greet an older couple as they pull their car to the broken curb. In the dusk, the bar windows glow with neon letters: red, orange, green, yellow, white. Night, beneath a street lamp, teenage girls gather around a boom box on the sidewalk, salsa music pulsing the soundtrack of the film that is the neighborhood, everyone part of it: drama, romance, and comedy.

Here a man of stormy energy could shout, shove, his senses flush with the unpredictable cast of untamed characters appearing and disappearing in and out of the here and now. He could lose himself in this world where people did what they want. Here he was free.

Angel has been late to pick me up for our ride to the school the last three Mondays. Each week he has shown up later than the week before. In the staff, Angel saw a level of conformity, disingenuousness, and disrespect for the powerless that made him ill. Making the walk down the main hall, instead of quietly absorbing the patronizing treatment of the students, Angel would bark at the staff. Dressed as he was, unshaven, big, he scared them plenty. He was out to "pop their bubble." But as it turns out, the staff of the school, from the protection of their institutional citadel, ended up popping his. Looking at him sitting here in 333, all that seems to be left of his rage is exhaustion. The dark disturbance that emanates from him is so strong it voids the usual give and take of greeting between the artists and us. The painters—Chet, Mike, James, and Eric—have their eyes trained on him. He looks at the floor, then closes his eyes. On top of this hill, he, champion of the underdog, sits with the ultimate underdogs. Although he and they have grown close, his hope that we could rock the school, and free them, is played out.

"Face it," he told me on the ride up, "we can't be here all day, every day to stand up for them when they get fucked over. We're just torturing them." The studio sessions were giving them a taste of freedom that made the limits they lived with starker and harder to bear.

"Let's go, Chester," the staff person says. As he reaches to take the handles of Chet's wheelchair, Angel gets to his feet.

"I wouldn't do that if I were you," he whispers.

"He has an appointment," the young man in preppie clothes, says, surprised, then piqued with the questioning of his authority.

"His appointment is here," Angel says.

"He is already late," the man says, moving to take the black, foam-padded handles.

"Don't touch him," Angel says.

"He has a scheduled appointment." The young man's smile forms to express our need to cooperate.

"This class is important to Chet," I say. "It's his only chance to do anything all week."

"That's the way it goes sometimes," the man says, moving again to take the handles of Chet's chair.

"Back off." Angel holds up one finger, wagging it in a final warning, his body squared to face the man, transformed to radiate physical power, and the violence it could deliver. "It's up to him whether he comes or goes," Angel says.

"We'll see about that," the man hisses.

Angel makes a gross sound, clearing his throat, then hockers the gob of phlegm, loud, into the trash barrel.

"I guess we will," he says, wiping the back of his arm across his mouth.

"Thanks for coming by," I say, taking a step to stand with Chet.

"And next time," I suggest, "could you remember to knock first?"

Chet laughs, and makes a crazy face at the staff person.

When the man has turned and all but flounced from the studio Angel sits down in the pink molded plastic chair. His eyes shut.

"Chet's up first," I say.

Angel's eyes remain closed.

"Let's get it on," I say.

His eyes opening, he looks at me for a few seconds, then gets up. He looks at Chet. He stands there, dully, then moves to take the handles of the wheelchair.

The teenager, crazy with the fun of the big confrontation, rockets up into the air, his face snapping to a stop an inch shy of striking Angel's.

"Cool it!" the man barks with savage harshness at the boy.

Stunned, Chet holds himself perfectly still, then, eyes wide, he lowers, very slowly, down the back of his chair. Settled on his seat, his mouth open, he blinks. Tears fill his eyes. He looks down at his tray. His head lowers, his shoulders quake, and he begins to weep. Unable to leave the room, unable to bring his hands to his face, all of us looking at him, his face lowers further, until his nose is close to the surface of his laptray. Shoulders shuddering, his tears free-fall onto the Plexiglas.

"You better leave," I say.

"Who, me?" Angel asks.

"Yeah, you."

"And go where?"

"Doesn't matter. Just not here."

"I leave and I'm out of here," he says.

"Whatever," I say, flicking my head to the door.

"You," he snarls, "can get yourself a fucking taxi."

I nod again to the door. Gone, I hear him walk to the main hall, then stop. Reentering the studio, he rests on one knee next to Chet.

"I'm sorry," he says. "I'm sorry I shouted at you."

The past swept instantly away, eyes bright, Chet bows to his friend, willing and ready for good times to begin again.

I can see that Angel is touched by Chet's graciousness. Touched, but maybe not enough.

Class over, the fresh paintings placed in the alcove, I move to the center of the room.

"You all remember your show is tonight," I say. "Right?"

"Bullshit," Angel says.

"You are all set for the show, right?" I ask the painters.

"Bullshit," Angel says again.

The artists look from him to me: "What's up?" their eyes ask.

"What Angel is saying, is that the show is bullshit." I laugh, the way you do with the pathetic and the ridiculous, and give

Angel a look to acknowledge his being right to put the facts on the table.

"What he wants to let you know is that the gallery took only the wheel paintings. They didn't want any of these." I draft my hand past the sophisticated paintings taped to the walls, the ones that had been made with the laser. They only wanted the wheel paintings. They were into the treadmarks. The ones that show it was made with a wheelchair. The ones that say they were made by handicapped people. I close my eyes with the prick of shame, then go on.

"When I found out, I tried to call the whole thing off. It was too late. They already had the paintings."

The look I get from Chet, Mike, and James swirls a light wind of laughter inside me. They could not care less. The concept of anyone outside of this room wanting to come see their work is something they have no reason to have imagined, or hoped for. Being here working together, pushing further, seeing what they will come up with, is what is real. Life outside the school is vague.

Eric, on the other hand, looks stern as he considers what has been said.

"We'll see you tonight," I say.

In the parking lot of the Papermill Playhouse, Angel and I stand in the dark. Although it is only six, the sky is black. It is cold, and Angel is unhappy.

"This sucks," he grouses, seeing how few cars there are.

"Cool it," I tell him.

The gallery is the lobby of the theater. A few fairly well dressed people sip champagne.

"This blows," Angel says in a loud voice. All heads turn our way.

"Tim," Suzanne greets me, in a cheerful voice. Her hair

flowing, she wears a simple, bright red pullover dress. "This is the director of the gallery."

"Where are the students?" I ask Suzanne.

"They are here," she says after a sip from her champagne.

"Where?"

"James is over there," she points. "And I don't see Eric."

"What about the others?" I ask.

"We had a problem with Transportation, could only get one van."

"How many students is that?"

"Four, at the most, if they use manual chairs."

"So where's Mike? Where's Chet?"

"Richie and Wendy are here."

"Who are they?" I ask. "I don't understand, really. Why are they here instead of the painters?"

"They signed up for the trip."

"So," I say, "it's James and Eric, and the rest were left behind. That's the story?"

"It's not easy dealing with Transportation." Suzanne gives me a look.

"Excuse me," I say, and move across the lobby to where James is parked.

"Lane, what's up?"

He gives me a big, warm, Cheshire cat smile, then lowers his face to draw on a straw in a giant cup Angel has prepared for him. He sips the drink with pleasure. As he draws on the straw, his eyes track people that pass by.

Across the room, a young couple stands with Suzanne. Good-looking, neatly dressed, healthy, comfortable with each other, they listen as Suzanne speaks, her free hand gesturing with the brightness of her enthusiasm.

The couple turns to take in one wall of paintings, then the next. As they come around to the third wall, they see James.

Their eyes catch on the barb of his appearance: twisted fingers, crooked arms, oddly pointing shoes. Their faces twist, one interior directive making both of them stare, another making them blink, and one ordering, but unable to make them look away. Both attempt to smile and then, in embarrassment, their eyes tear away—not to look over any more of the paintings but to return to Suzanne, smooth and optimistic in her bright red pullover dress.

James's easy, self-contained pleasure is unaffected. It is not that he did not see the looks on their faces when the young couple saw him. He saw them. He smiles, warm as before, his lips then creating a fresh strong seal around the plastic straw he pulls on.

"Where's Eric?" I ask.

James shrugs.

When the elevator opens, Angel steps off. With one hand he holds open the door, with the other he draws Eric out of the elevator and into the gallery. Eric looks dazed, his face blank, like someone who has been clubbed.

"Hey, Eric. You okay?" I ask.

"You okay?" I ask again, then look to Angel. "Where'd you find him?"

"He was in the freaking parking lot. This whole freakin' time," Angel tells James and me. "It's freezing out there."

"How'd you find him?"

"I asked around. I went out to the van and there he was next to it, sitting there, no jacket or nothing, for the last half-hour. They got him in that, look, not his own chair, but that thing with no motor and he's sitting out there. Look at him."

Resting on one knee, I bring my face close to Eric's.

"Eric," I say.

When his eyelids raise enough for me to see his eyes, I can see his anger, and his disappointment. But there is something

else. Eric. Eric the determined one. Eric, the one who never gives up, no matter what. Weakened, glazed, the look is still there. His eyes bat once.

"Thanks, Angel," I say.

Angel shakes his head, dismissing everything but his disgust.

"This is really quite remarkable," a portly woman bubbles. "Suzanne told me you are their teacher. You must have such patience to work with them. I know I, well, it would be difficult for me to be around them. It's too . . . sad. But what you're doing," —she perks up— "it must be so rewarding, make you feel like a million dollars. I was wondering one thing, though. Do they understand what you are saying, really? It must be such a challenge working with them, you know, them not, you know, thinking the way we do?"

"Will you excuse me?" I say, giving my elbow a light tug to break her grip on the sleeve of my sport coat. James smiles. No doubt he heard everything, seeing as how she stands next to him.

The woman takes a fresh grip on my sleeve. "Suzanne tells me you are developing a new technique using a laser. How does that work?"

"The artist points the light and that's where the paint goes."

"But how does it get the paint on the canvas?" she asks.

"The artist points the light and an able-bodied assistant tracks the light with a loaded brush."

The woman narrows her eyes. "Oh," she considers, "then they don't really do it themselves."

"If an author dictates his book to a secretary, did the secretary write the book?" I ask. "Will you excuse me?" I turn away, and lower to hunker down next to James.

"Hello, James," the Matheny staff person Angel had had words with in the studio earlier today greets the artist, then eyes James's cup.

"Is that champagne?" he asks.

"Salud!" Angel raises his glass to the man.

"Not a wise idea," the man says.

"Merry Christmas," Angel says.

"It could conflict with his medication," the man says.

"Relax," Angel says.

James's eyes, sparkling with the entertainment, flick back and forth between Angel and the man as they speak, all the time his lips pulling strong and steady at his jumbo champagne.

"This is not good," the man says.

"Chill," Angel says. "He's twenty-one, isn't he?"

"What's your name?" the man says.

"Angel, what's yours?"

"You need to learn a few things about these people," the man says.

"Salud."

"Suzanne," the man calls over to the program director.

With a long, noisy slurping sound, James vacuums up the last of his drink. "Ahhhhhh!" He smacks his lips.

"Too late." Angel smiles at the man.

The reception coming to its end, the attendees move to get their winter coats.

A PCA takes the handles of Eric's chair, another takes James's, and both are wheeled backward onto the elevator. The door closes.

The gallery now all but empty, I see Angel slip an unopened bottle of champagne inside his coat. The gallery director is walking in his direction.

"Excuse me!" I call to her. "I just wanted to tell you what a beautiful job you did curating the students' work."

Seeing Angel has stepped into the elevator, I turn back to her. "Gotta go."

Beneath the building in a walkway that leads to the parking

lots, Angel walks along with the students. He raises his fluted champagne glass to them, downs the contents, then hurls the glass into a brick wall. The students start in their chairs.

"Merry Christmas!" he bellows.

He stands in the cold by the van as each of the students is loaded onto the hydraulic lift gate, raised up with a whining sound, then drawn backward into the van. When they have been strapped to the walls, the driver pulls the sliding door, then slams it shut. Angel leans to place his face close to the tinted side window, his hands held like blinders, a circle of mist from his breath forming on the dark glass.

"Ciao," he says.

The Olds roars past the warmth, safety, and familial comfort of lighted windows in gracious old houses far back from the river road. The face of the house illuminated, a wreath on the door, an electric candle in every window. A last home moves by, then bare trees, barely visible in the dark. The headlights charge the snow-edged road. Still early, we pull into the farm and park behind the coop, both Angel and I intent on working, me in my studio, him in his wood shop. I throw my pants, shirt, jacket, and tie on the back of the chair, pull on my jeans, boots, and a ripped up sweatshirt. The track lights and stereo on, I light a fire in the woodstove.

"Hoooooooooohoo-hoo, hooooo." An owl hoots in the cold air, high in the branches of the big ash tree that grows next to the coop. I feel its thick coat of feathers and the cavity of its body in its powerful call.

Angel shoots staples from an electric staple gun. Pop. Pop pop. Through the interior door to the studio, I can see across the long dark section I use for storage to his shop. The partition wall at his end was never completed. The missing sections along the

slanting roofline let me see Angel's droplight, which is on, and once in a while his head.

I wonder what he is stapling. He always overbuilds. He uses oversized screws, two where someone else would use a single nail. He drives them home with force, as if he were taking out his disappointment with the flimsiness of the world — as if, if he could join things with enough gusto, it might make things right. When he puts things together, it is with an industrial power drill. For nails he uses long-handled framing hammers, not staple guns. Pop, pop. Pop.

Pushing the heavy backdoor on my side of the coop open, I step out into the night. Snowflakes blow sideways over tire tracks frozen in the mud. Fast-moving clouds rake past the moon.

Angel's door rolls, rattling open. I step into his shop.

"What are you working on?" I ask.

"Nothing." He says this without turning to face me, no wisecracks, no insults.

Each time I move, he moves the same way, his bearish body backlit by the bulb in the droplight.

"What are you making?" I ask.

"Nothing," he says. "You work on your side. I work on mine."

I push in between his body and the workbench. A small canvas on a frame. Pop. Pop.

"What's that?"

"A painting," he snorts. "What's it look like?"

"What are you doing with it?"

"What's it look like?"

"Is that one of the students' paintings?"

"Yup."

"What are you doing with it?"

"What," he asks, "are you blind?"

"That's one of the students' paintings."

"No shit." Pop, pop. Pop.

"What are you doing with it?"

"Stretching it, pato."

"What are you planning on doing with it?"

Pop. "Sell it," he says.

"Sell it?" I ask.

"You better get your ears checked."

"Sell it to who?" I ask.

"People."

"What people?"

"People in Trenton."

"People in Trenton" meant his crowd in the barrio at Zooky's bar.

"You're selling them in Trenton? How many you sold?"

"A few."

"They actually buying abstract art?"

"Yup."

I picture a "Mike" or an "Eric" hanging in a room in one of the dilapidated urban row houses.

He cocks his middle finger into his palm with his thumb, and fires it into the canvas. Boink. "Tight as a drum," he says. "Which way you like it better? This way?" He turns the painting, "Or this way?"

"You're taking the students' paintings and selling them?" I see the orange glow between the iron gratings of his wood stove, the bench with his tools, the shape of the unfinished section of the partition wall, the concrete floor, the toes of my boots. I look through the open door at the night.

"This is not going to work out," I say.

Angel places the little painting down on the sheet of plywood, and claps his hands free of sawdust. "Good," he says.

Snow falls thick and steady. Covering the hilltop with a deepening blanket, it absorbs all sounds from the world outside our studio. Simple, singular, the quiet imbues our little room with calm.

"You guys know Angel's gone," I say. "You know, probably for good."

They are not as affected by the news as I thought they would be. Eric's eyes say, "I know." Mike's, "Who cares?" Chet's, light as a sigh, "Oh well." They had seen it coming. In their lives, people come, and people go. Employees. Volunteers. They get tired, then take off. The students are each other's only constant. Hardened to abandonment, they live together, taking what pleasure they can with the things at hand. They sit poised, relaxed, interested in how intensely I weigh the situation. Chet bobs lightly.

"Tim."

"Yeah, Eric?"

"Angel was a good guy. He just needed a different job." The tray of Mike's chair nudges me. When I do not look up, he directs it to bump me a little harder, then throws his head back to say: "Let's get going."

"Give me a break, Mike," I say.

"Hello, everybody," Suzanne chimes from the doorway. "I wanted to say good-bye."

With a grant she raised, Suzanne had operated our program outside the direct control of the school. Her husband's position as medical director freed her from the rules and regulations that constrained the full-time staff. This created bad blood between them and us. They had to wear a certain style of clothing. We did not.

They had seen the radical change in students like Eric. Where once he had listed, now he sat up straight. Where he had been silent, he now talked all the time—about his paintings.

People like Mike who refused to take their classes took ours. They heard the laughter and shouting from 333. Our successes irritated and threatened them. Instead of coming down to learn, they stayed away. They banded together to maintain the status quo.

Suzanne, after pushing for all these months in the face of such odd disregard and open resistance, was worn out. In recent weeks, she had hinted to me that she was thinking of moving on. A playwright, she had mentioned her desire to focus again on her own work.

Without her, without Angel, I would have no buffer between me and the forces that had drawn themselves into opposition to us.

"See you around, I hope," I say. I extend my hand to her.

"I'll stay in touch," Suzanne smiles. "Don't you worry."

"It's been quite the little adventure." I smile.

"That it has." Suzanne smiles back. "I'll see you all at your next show, right?" she asks the students.

They look at her.

Alone with the class, I stand for a few seconds.

"Tim?"

"Yeah, Eric?"

"Are you okay?"

I look into his eyes. The determination I see in them shores me up against the tide of resignation creeping through my system. From the looks each of the others give me, all of them take it for granted that we will be carrying on as if nothing has changed. Close ranks. Push on. This moment with them touches my heart in a way I cannot properly describe. I had pulled the cart, and now, when I would flounder, they pulled me along in theirs. Their confidence encourages me to sweep the refuse from the gem.

"Ready to get started?" I ask. I get up from Angel's pink, plas-

tic molded chair, and move to face them from the board. "You maxed out the wheel technique a long time ago. You've made awesome work with the laser. Now, if you're ready, it's time to move on. Ready? We have a new technique. It's going to open up a whole new world of possibilities for you. It's going to give you control that is so exact, it'll blow your minds. When I say exact, I mean exact. I mean, down to the millimeter." I show them a tiny gap between thumb and forefinger. "The laser is good for expressionistic drawing, for organic drawing, but it's not so great for drawing straight lines. Not good enough for perfectly straight lines. Let's look at this painting."

From a roll of recent unstretched canvases, I remove the one James Lane had done, a loose net of open diamond shapes, chevrons. The putty clay ground-coat, purely material as the earth itself; the carefully stroked lines in the delicate floating net of diamonds hovering above the crude and random field below. "The thing I saw in James's diamond painting here," I say, "is that he created two things I had not seen any of you make before. One is closed geometric shapes, diamonds. Geometric shapes are things like triangles, circles, squares. The second thing I saw in this painting that I had not seen anyone do yet is to create a painting that was symmetrical. Anyone know what symmetry is?"

Boop. Boop, boopboop. "Same," Chet's computer voice states.

"That's right." I smile inside with the serious look he gives me. "This painting made me think you all might like being able to make straight lines and clean, hard-edged shapes."

James looks at his canvas, eyes narrowed behind his Malcolm X glasses.

"On to the new technique," I announce. "It isn't fancy. In fact all you need is a stick, a big straightedge, like this." I hold up a yardstick I had painted black.

"First, you picture the shape or the line you want. Picture where you want it on your canvas. Let's start with something simple. Let's say it's a square. A regular square, where the sides are parallel to the edges of the painting."

"Tim."

"Yeah, Eric?"

"What is parallel?"

"Lines that run the same direction. This edge"—I run a finger down one side of the canvas—"is parallel to this one."

Eric leans forward with his concentration. "The tracker will lower the stick over your canvas, like this." I lower the black straight edge horizontally over the big raw piece of canvas pinned to the board. "When it touches the edge of the square you have imagined, you signal the tracker to stop the stick. She will ask if it is positioned exactly right; then, if it is right, and I mean exactly right, she will run a piece of tape across the whole canvas to cordon it off. You have the first side of your square. Then all you have to do is to come in with the stick from the other three sides. Like this—" I draw the stick slowly inward from each side of the painting. "You can see how easy it will be to get any square or rectangle, any size, placed anywhere on the canvas you want it. Once you have it taped off, you go right into your color blending and all the other variations with transparencies and textures and all the stuff you already know all about. Want a circle? It's easy. Draw the stick down from the top. Stop it, say, here. Draw the stick in, from the side. Stop it here. The coordinate point is the center of your circle. The tracker marks it, then draws her finger slowly away, like a balloon blowing up. You signal 'stop' when it is the size you want, and that's the circumference."

"Circumference?" Eric asks.

"Yeah. Circumference." I run my finger to trace a circle on

the canvas. "The outside edge of the circle. And there is lots, lots more you guys can do with this system, lots more. You can create curved lines. Using the coordinate points you can place single brushstrokes, like the Impressionists."

"What are the Impressionists?" Eric asks.

"They're a group of painters who placed pure color in single brush strokes. Before then, the idea was to make things look as realistic as possible, to create illusion."

"Illusion?" Eric asks.

"Illusion is something that looks real, but isn't. Anyway, we'll have lots of time to talk about all this if you want. You seeing the possibilities? The control you'll have?"

Moved by the total seriousness of their attention to the new technique, a set of information no one in the school has ever dreamed them capable of grasping, the moment holds in my mind as a black-and-white photograph. Artists, in a small room, forearms on their trays, snow falling outside the window.

"The rehearsal for the Bell Choir will start in fifteen minutes," the receptionist announces over the public address system. "All students in the Bell Choir please report to the Medical Dayroom." "James? Chet? Eric?" the music therapist calls from our doorway. "See you down there?" She gives them a pointed glance, then disappears into the unlit corridor.

I look at Eric.

"We have to go," he says apologetically.

"You do?" I ask.

"It's our rehearsal, for the Christmas concert."

He sees the look on my face.

"Guess if you gotta go, you gotta go," I say, lacing my fingers behind my neck.

"You're not in the Bell Choir, Mike?"

Mike makes a face.

"I didn't think so."

I look to the young woman I talked into coming up to fill in for Angel. She appears a little overwhelmed with the whole scene.

"How 'bout you go with the laser today?" I ask Mike as his three classmates make their way out of the room. "It'll be better for her." I nod to the young woman. "And it will be better if all of you are here when we kick in with the new technique."

The class period over, paint pails sealed from Mike's session, brushes cleaned, I sit with him and the young woman, still clearly fired up from her painting session with Mike.

"I want to check out the Bell Choir. Do you mind?" I ask.

After our long walk down the various shining, white-walled halls to the Medical Dayroom, I look around.

"What happened to Mike?" I ask.

"He went thataway." The young woman points to the right, where we had turned left.

Inside the Medical Dayroom, the therapist has a dozen students lined up, side by side.

"Everybody ready?" she sings out.

Satisfied, she steps to stand in front of one of the students. It is Eric. She chops the edge of her hand in front of his face. He twists his head, torso, and arm to bring the little metal rod clutched in his fingers to the brass bell on his laptray.

"Ding," it rings.

One, two, three times she chops her hand. Three times he hits the bell. Three more times, she chops. Three more times, he strikes the bell. Then, once more. The therapist steps to stand in front of a different student; she brings the edge of her hand down. In this way, she plays them as if they were keys on a xylophone. Ding, ding, ding. Ding, ding, ding. Ding, dang, ding, ding, dong.

"'Jingle Bells'?"

Home, I stand at the kitchen sink, looking out the window. Sipping from a glass of ice water, thinking about the school. They are absolutely clueless. How else could Eric live there all these years and be able to talk, and have no one know shit about who he is? How could this be?

I place the glass down, breathe in, then out. It is surreal up there. All the energetic activity. The teachers' happy chatter. The brisk walking down the halls. Running televisions. It is eerie. All these people, unable to see the fervent life in front of them, so obvious when you take two seconds to look into the student's eyes. They bring them pity instead of respect. Without respect, a person is humiliated. The staff, paid to pave the road to freedom, act instead as keepers of the students' cages.

My spirit dull, totally washed out, I am bitterly ashamed of my naïveté in thinking that once the staff saw what the class had achieved they would do a festive dance of joy and everything would be different. Awkward, jagged thoughts slow, then stop. As at an intersection car wreck, seen in silence, void of urgency, void of meaning, I stare without feeling. The world: insensate; its dumb weight always pulls down everything that dares to fly.

To break the grip of these suffocating feelings I yank open the front door. A rush of cold sharp air, clean with the smell of snow, hits me. With an excited flutter, a tiny bird flies out of the Christmas wreath. Soft, breathy, purring little wings, it flies once, twice, around my head, close to one ear then the other, before it finds the open door. In the last strip of light along the horizon, between the silhouettes of the neighbors' houses, I catch sight of it. It rises and falls along its straight flight path; the rise, its sprint, the fall, the glide to catch its breath.

Christmas Day, the house is quiet. The sun flashes off the little stream behind the house. The water moves too fast for it to have

frozen yet. I think over the dilemma the class and I face. There was no doubt the painters would continue to rise. Every week their work was more amazing than the last. But what good was it, in the bigger picture, for them to soar and soar and soar, if no one around them could see what they had done? The painters could use the class to transcend their physical limitations, while they painted. But they did not paint all day. The moment they left the studio they became part of the school. If their work did not bring them to the basic respect they were due, their time in the studio would be like a drug they took to escape, rather than a means to join in communion with fellow human beings.

It being Christmas and all, I feel bad about my feelings concerning the staff. There have to be people there who see the students as whole. There have to be. But where are they? We have talked to none. Heard no talk in the halls of any who see them this way.

It is as if the staff of the school acts as a single animal, strictly conformed to a single way of seeing: physical rehabilitation, health maintenance. The undilutable, indivisible, indestructible fire of the students' spirits remains outside the parameters of their consciousness. Who among the staff sees the possibility that their charges have more power than they?

I put my dish in the sink, run water over my hands, dry them with a paper towel, look out at the fast black water of the stream, then pick up the phone, and punch out the numbers for Angel.

"Feliz Navidad," I say.

"Is thees Teem?"

"Yeah. Can I talk to your son?"

"Merry Christmas to you, Teem. Let me get Angel." The background noise is wild with kids running around, loud Spanish, laughter, the clatter of plates.

"Yo?"

"Angel."

"Yeah, what's up?"

"Let's go see James."

James is the only one in our class who has no family. In spite of Angel's crimes and misdemeanors, he is a person who gives his all. I know he misses the class. Although most of the painters will not be there, he would enjoy seeing James.

Angel waits a second. "Hang on," he says.

I hear his voice speak rapidly over the sounds of the family dinner. "Okay," he says into the phone, "I got my mother's car, so no paint on you."

"What happened to the Olds?"

"Blew the trani. You got gas money?"

"I'll be here."

"You ready, fag boy?" Angel shouts, barging into the kitchen. "Here are some shrimp. They're jumbo, jumbo, and there are some platanos. You're not going up like that are you?" he grimaces.

"What's the problem?" I ask. "Just because you're all duded up doesn't mean I have to be, too."

"Get real, Lefens." He bats at an imaginary gnat. "It's Christmas."

Angel's mother's car has no pickup. A few cars actually pass us, something I had never experienced riding with Angel. The sun bright, the pavement black, there are few cars on the road.

"Sir!" the receptionist leans out over her counter to call to Angel. "You'll need to sign in."

"I work here," he says. "Or," he gives me a look, "I used to."

"You'll still need to sign in."

Angel writes the large letters M E on the ID badge.

"What's that supposed to mean?" the receptionist asks.

"When they see it, they'll know it's me." Angel makes a face at her. "Get it? Guess not. Where's James Lane at?" he shouts back to her from the main hall. The halls are empty.

James sits alone in a triangular room next to the employee's cafeteria. He sits, looking out a plate glass window, basking in the illumination of sunlight reflecting off the snow. Perfectly placid.

"Yo, James!" Angel rumbles up to him. James's eyes widen. He wears a new shirt, black-and-white checkered chest with black sleeves, that looks like it is made of velour, a pair of dress pants, and polished black dress shoes.

"You eat fudge?" Angel rips the green foil off a box. "My sister made it." I pull up a chair. Angel drags over another. "James," he asks, "you want some?"

"Yee."

Angel picks out a piece, and holds it to James's lips. "Good, huh?" he asks, his big body hunkered in close to the young black man. "You want more?"

"Yee." James smacks his lips.

"Need some water, Lane?" he asks.

"Yee." James nods.

"Be right back."

Angel gone, James and I sit together in the quiet. I look at the floor, then out the window the same direction he is. Looking at him out the corner of my eye, I take in his smile, his easy breathing. Sensing my eyes on him, he turns to look at me. His smile widens as his eyes narrow.

"This new?" I nod to the boom box on the table.

"Yee."

"Cool. Mighty Clouds of Joy." I read the title of one of the CDs. "You like Mighty Clouds of Joy?"

"Yee."

"So do I. They're good."

James smiles.

"May I?" I ask.

"Yee."

A toggle flipped, an FM station plays Nat "King" Cole's "Christmas Song": "Chestnuts roasting on an open fire," he sings.

With James's gaze returned to the winter scene, I look down at the floor. We never said that much to each other outside of 333, and now we are not in 333, and there is not that much to say. I want to tell him how much I have enjoyed knowing him, or something, something like that.

"You know it's been said many times, many ways, Merry Christmas, Merry Christmas to you." I sing quietly along with the song.

James hums, the notes atonal but close enough to catch the tune. "I know it's been said many times, many ways, Merry Christmas to you."

"I didn't know you could sing, James."

"Yee." James nods. "Here comes your water," I say.

"How about champagne?" Angel suggests, pulling his chair up next to James. Getting the reference to their wild time at the last show, James smiles as Angel holds the water to his lips.

"That's what got me banned from the school," Angel growls. "Those bastards. Right, Lane?"

James looks at him, opinion reserved.

"Babes." Angel nods to a set of swinging doors. "In the kitchen. Dark meat. Gotta check 'em out." He makes a maniacal face, then bounds for the doors. Shrill screams of laughter, a radio is turned up loud, the stations blur then settle on sexy, driving salsa. Loud. When he reappears, he has a brown woman in white uniform by her wrist. Her fellow workers peek out the open door. The sensuous music pours throbbing into the bigger room. I flick off James's boom box, widen my eyes to him, then turn as he does to watch the fun.

Angel releases the woman in the center of the floor, takes a

step back, then commands her: "Come to your papacita." Her coworkers hold their sides with laughter. She covers her face with both hands, but does not run away.

"Come to me," Angel says in a firm, but far more gentle tone.

She takes a little step toward him. He slides his big arm around her waist, takes her hand in his. She knows how to do it, and the two move, hips flicking, across the room, her coworkers shrieking with laughter.

"Rosalita! Rosalita! You go, girl!" they call out to her.

When the song ends, the woman escapes Angel's romantic grip and runs back into the kitchen.

"They love me!" Angel shouts to James. James turns to me, eyes bulging: he lets out a whoop, fudge all over his lips.

When things quiet down, we sit without speaking. Angel pulls up his chair.

"I told you, Lane." He gives James a wink.

"Feel like painting?" I ask. James considers, then, laconically, says "Yee."

"Okay," I say. "Then, let's hit it."

The three of us move down the empty halls, past the empty bedrooms, Angel and I walking one-quarter-speed to keep pace with James's electric wheelchair.

Hearing my name called, I stop in the intersection of the main hall and the unlit corridor, Angel and James continuing on to the studio. The setting winter sun, perfectly aligned with the windows at the end of the main hall, floods the channel of the hallway with a luminous fog of gold, rose, amber light. I cannot see the person who has called me.

"Eric," I ask. "Is that you?"

As I walk in the direction of the voice, the figure appears. I crouch at Eric's side, maintain my balance with two fingers pressed to the chrome tubing of his wheelchair.

"What are you doing here?" I ask quietly.

"People say Eric works his butt off," he moans. "But they don't really get it." Eric skips the holiday greetings to go right at the thing that preys on his mind. "Why, Tim? Why don't they get it?"

"Get exactly what?" I ask.

"The paintings."

"Some people get it," I say.

Eric shakes his head. "Some people, Tim, don't get it."

"I guess it's because they're abstract, Eric."

"Why?"

"People are too busy to look sometimes. They look at things for different reasons than you do."

"What reasons?"

"I don't know. Practical reasons like where did I park my car, where is this and where is that, you know, practical stuff."

"But they don't get it, then, do they, Tim?"

"Probably not, Eric."

"Why?"

"You making your paintings for them?"

"For them, and for me and my family and . . ."

James and Angel are headed our way.

"Corbin," Angel roars, "cheer up. Want a Christmas cookie?" He offers the artist his choice from a full box.

"Where'd you get them?" I ask.

"What difference does it make?"

Angel holds an iced Christmas tree to Eric's lips, the cookie remaining close as the artist chews.

"Thanks, Angel," Eric says.

"De nada." He waves away the favor.

"Where did you get them?" I ask.

"In one of the classrooms," he says.

"You can't," I say, "just go into other people's classrooms and take stuff."

Angel heads down the hall, opens one of the classroom doors, and goes in.

James snickers, that big Cheshire cat grin widening on his face.

A roll of duct tape in his hand, Angel inspects Eric's chair.

"For God's sake, Angel," I groan, "could you do me a favor and put that back? I still work here."

He pulls Eric's headrest to its upright position from where it had fallen against the back of the chair, and lashes the duct tape around and around the chrome stem. Without his headrest, Eric's head was a weight that wanted to fall. It meant he was fighting to keep it upright every minute he was in his chair, which was all day. The tech guys were gone for the holiday. It might be days before they were back at the school and could fix it. Eric had not complained about it. He never complained about anything, never asked for anything—that is, except one thing: to be understood.

Angel tears off another long strip of the tape, and wraps it around and around the chrome stem of the headrest.

"There." He steps back to admire his work. "That ain't going nowhere."

Eric lays his head back against the padding. He breathes out. "Thanks, Angel."

James smiles. "You guys feel like painting?" I ask.

"No way," Angel announces. "I'm out of here."

"Come on," I say.

"Outta here."

He stalks off toward the front doors. His body turns black in the luminous fog. A corona flares around the black form, and he is gone.

I look at the two young men. James faces into the flood of amber light. His brown skin glows warm, his eyes bright behind

the light on the lens of his glasses. Eric faces the end of the hall with the fire doors.

"So," I ask, "How we ever going to get these people to, as Eric says, 'get' it?"

"What about New York?" Eric says.

"What do you mean?"

I look to James, whose eyes direct my attention back to Eric.

"You two been talking?" I ask.

Eric's eyebrows go up.

"Yee." James nods.

"Really? About New York? What about New York?"

"A show," Eric says.

"A show?"

"Yup."

"A show in New York? Of your paintings?"

"Yup."

"Really?"

The two artists give a short laugh. "Yup." Eric takes an exaggerated inhale.

"You think you're ready for New York?" I ask.

"Yup."

"You're sure?"

"Yup."

"You know New York's the art capital of the whole world. It's the acca-lacca-Mecca of painting."

"Yup, yup, yup, we know all that, Tim." Eric's eyes sparkle merrily with the boldness of his plan.

*W*inter drawing to a close, life goes on in the valley. In spite of the flat dark-gray ceiling that hangs low, impenetrable, over the quaint little town, the counterman of the Copper Penny luncheonette greets the locals with a loud, happy voice. He calls them all by name, taking pleasure in calling out their names, Mister so-and-so, Missus so-and-so, lined up as they are, waiting to order their coffees, their breakfast sandwiches. Music from the Big Band era plays from a radio back in the kitchen. Racks of newspapers. Racks of snack foods, a few round tables, the town's colorful characters seated, the others having jobs they need to get to. A refrigerated glass case full of soft drinks. A cardboard cylinder on the counter by the cash register, slot in the top accepting change for a charity.

From the table closest to the window, I look up at the hill, its top plunged into an inverted sea of motionless gray. As we climb the hill, the car enters a wall of fog. Dark, cold, wet air. The latest tracker and I cross the parking lot.

"They must pay pretty good here," the trainee comments as we pass the spaces reserved for top administrators. Mercedes. Lexus. Jaguar.

Mike's waiting for me at the front doors has gotten him trapped by the authorities. The president of the school, Bob, and his top lieutenant, the director of student services, stand by the receptionist's workstation, still as statues. It looks like they had been speaking until they saw me and my shabby tracker.

I move around them, turn the corner into the main hall, then stop to wait for Mike.

"What are you up to, Michael Young?" I hear the big, white-haired man in the business suit ask. "No good, I bet," he says, then laughs. I picture Mike: cornered, doing his motionless attempt at invisibility.

"Aren't you supposed to be in class, Mr. Young?" Bob says, his voice now gruff.

Mike zips into view, then slows to roll along at my side.

"Aren't we supposed to sign in?" the tracker calls from the receptionist's counter.

Someone has ripped up part of the floor in 333: a pile of shattered linoleum in the middle of the floor, sticky, striated, black tile cement exposed. Taking inventory of our supplies, I turn to Mike. "Looks like they took a bunch of our stuff. I'll be back in a bit."

I head back down the main hall, turn right up the administrative wing. Men and women in sharp business suits greet each other as they pass. Turning right again, I walk the length of the children's wing, past the bedrooms of the little kids, the nurse's station. Right again at the entrance to the cafeteria, I look, without luck, for the maintenance guys. A three-foot high iron gate opened, I descend a set of stairs into the dark. The stairs turn left, then lower again. To the left an industrial whorl of washers and dryers. Further down, the hall jogs to the left and then straightens out. One room is a technician's workshop. A chrome wheelchair on the workbench, a radio playing. Retracing my steps, I climb the dark stairwell. In the hall, at the top of the stairs, two men stand as a third, on a stepladder, drills into the wall.

"Excuse me," I say. "You with Maintenance?"

They look at me without speaking.

"You tearing up the floor in 333?"

No answer. "We're missing some supplies," I say.

When they make no response, I sense reality become dreamlike, a wall of glass now between myself and the scene of the three men. "Know where I might find them?" I ask.

The man on the ladder turns back to his work. The trigger of the drill pulled, the motor moans, round and round the bit spins, extruded filaments corkscrew from the borehole. The two standing men return to the conversation I had interrupted.

On the way back to 333, I poke my head into empty rooms, squinting to see if any of the boxes I locate look like they might hold the missing supplies.

"No luck, Michael," I say. With his ball cap on sideways, tight black T-shirt, and hard look on his face, he could be one of the Deadend Kids, one of the Bowery Boys, from those movies they made in the thirties and forties. A kid in a tough neighborhood, left on his own.

"Bob?" I say into the studio phone. "This is Tim Lefens down here in 333. Looks like the maintenance guys have thrown out some of our supplies."

"Take it up with Suzanne," he says.

"Suzanne is not here any more," I say.

Bob exhales.

"I'll look into it," he says, then hangs up.

"Thanks," I say.

Tonight, the sky wet, carbon black, I wait for the painters to arrive.

We have four new studio classes, many new students, and a new arts director. Before she left, Suzanne had used her clout to get the okay for this expansion of the program. As much as they did not like us, the administration did not mind taking credit for an art program when they gave progress reports to the board of trustees. Teachers did not mind dumping students they could do nothing with down at 333. No matter. I had my classes. Five of them. One in the morning, then the original slot after lunch, another later that afternoon and two after dinner.

The night classes have a very different feel from the others. The teachers home with their families and the administrators home with their families, we work in the studio. Most of the painters who work with us during the day come down to join us

for the night classes. The last session goes until nine-thirty. By then, most of the other students are in bed. Not the artists of 333. Some of them show up in their pajamas.

Boop. Boop, boop, boop. "How are you?" Natalia's computer-voice asks.

"Okay. How about you?"

The tilt of her head, the look in her eyes, lets me know the transparency of my unhappiness.

Natalia joined our class last month. Brown skin, seventeen, Natalia has large, almond-shaped eyes, her hair in rows of slender braids, white beads at the ends. She wears a fluorescent pink sleeveless nylon shirt and tight, abstract-patterned pants that stop above her calves. Her fingernails are painted black; she radiates the sharp charm of a sassy, streetwise teenager, good enough looking to be a model. She could be a model, except for her being in this tiny wheelchair, with its batteries, joystick controller, and the computer voice synthesizer they call the Liberator. She weighs no more than seventy pounds, her arms at taut angles, a trace of saliva on her lower lip.

Lowering my hand into the black water, I jab the tip of the knife at the drain, clogged as usual.

"You say they used to call this place a home?" I ask the teenager with the beaded braids.

Natalia told me Matheny used to be named The Matheny Home. Faced with financial troubles, the Home was reorganized. They hired Bob. Bob was all business. He reshaped the dynamic of the place to run with greater efficiency. He grew new programs. Improved the medical care as well as the technical support for things like Natalia's impressive wheelchair and computer-talker. But with Bob, there came a coolness. The name Home was dropped in favor of School and Hospital.

"It used to be our home," Natalia types out with the extended middle knuckle of her right hand. "We went to sleep when we wanted."

"Doesn't feel much like a home, sometimes," I say, continuing to stick at the clot with the point of the knife.

"I hate it here," she declares.

"Don't blame you. You ready to paint, Natalia?"

Boop boop. "You can call me Nat."

"All right, Nat. You can call me Tim."

Getting my dopey joke, she smiles, then nods toward the new tracker, who stands, uncomfortably, in the corner.

"Okay," I say. "Let's get started. Do you remember all the techniques we worked with last week?" I ask the tracker.

He nods a "yes" that looks more like an "I think so." In the subtlest change, Natalia lets me see her eyes go dull for less than a second, before the fire returns.

"I know what you mean, Nat," I breathe out.

The white beads that hang at the end of her braids click with the movement of her head. Stilled, they rest against the brown skin of her face.

Without hesitation, Nat directs the tracker to apply thick colored gel over the entire area of the small, square canvas. She aims the laser at an industrial pot-scrubber that lies among the application tools. She directs the tracker to draw the jagged plastic wreath horizontally across the bottom half, a broad spackle knife across the top half.

In these two extremely bold moves, the painting reads as a landscape: ocean and sky or wild scruffy fields beneath a slick and gleaming sky. Not satisfied with this raw piece of sophisticated painting, Nat orders the pot-scrubber back into action. The laser trained on the center of the upper edge, she signals the tracker to rake the scrubber straight down with violence.

"You sure?" I ask.

"Grrrrr," she growls, her big brown eyes lighting with sparks.

"Sorry," I say.

The decisive move made, the wide-raking, vertical passage blows away the landscape, the remnants, along the right and left edges, lorded over by the singular power mark. It bristles in re-flection of Natalia's untamed spirit. "*I am here,*" it says so clearly. "*I am here.*"

The painting placed carefully on the floor by the fire doors, I stand above it.

From the administration wing, a floor buffer the size of a ven-dor's cart emerges at the far end of the main hall. Slow and steady, it makes its way up the polished floor. Whining, moan-ing, it grows louder as it nears, a great mechanical hound with its nose to the ground. Forcing me to step back as it passes, it makes its turn in the alcove.

Whoop. Whap. The painting is sucked up into the spinning pads. Agh, the buffer chokes. The machine turned off, the mo-tor whines down.

"Sorry about that," the man says, as he tugs the painting out from between the pads.

"It was an accident. An accident," he says again when I say nothing.

"Sure," I say, a thumb from each hand slipped into my front pockets. When the machine rolls away, I rest my forehead against the glossy cinder block wall of the unlit corridor. I bang my head lightly three times, then go back into the room.

"You forgot your meds," a nurse informs Eric. She places a pill on his tongue, holds a paper cup to his lips. As the tracker works with Chet, Eric begins to sway. His eyes close. His body leans further and further over. When it gets to the point where he will topple over, his eyes pop open and he rights himself, but

the eyes stay open only a few seconds before the lids lower and he slowly begins to tip to one side.

"You okay?" I ask quietly.

His eyes closed, he says nothing.

The painters have all passed out at one time or another. They do not let it bother them. They want to stay to work, not to be wheeled away. So I let Eric be. There is nothing to do about it. The "meds" are strong and it is hard enough for him to concentrate on staying upright without my asking if he is all right all the time.

"Tim," Eric says, his words slurred, slow and low, his eyes closed.

"Yeah, Eric?"

"I want my paintings on my grave."

"What?"

The huge heating units, located outside our room, kick on. A loud moaning vibration pulses the air, "ah ya ah ya, ah ya ya ya ya ya ya ya ya ah. Ah ya, ah ya ya ya ya, ya," it moans. When it shuts off, the room seems hushed.

"You want them on your grave?" I ask.

"Yes." He exhales a sigh. "So," he murmurs, "my family can pick them up and read them. The truth is in the paint."

I had found someone who believes as strongly in painting as I do. Eric has found a certain real satisfaction through his work on canvas, but it becomes clearer and clearer that this will not be sufficient to satisfy him. His paintings are not for his artistic needs alone. They are hands he intends to use to reach out to others.

"Your family doesn't get your paintings yet?" I ask. I draw the five-gallon pail I sit on closer to him.

"You see your dad often? I mean, does he come up to see you?"

"My father is not in my life so much, Tim."

"He used to be?"

"Yup."

"How long ago was that?"

"I was eighteen."

Freezing rain pelts the recessed window, early spring thunder rumbles overhead. A student in the main hall is crying.

"I'm getting out of here," Natalia's Liberator declares. With the sound of a puppy that has been locked in a room, Natalia makes a high, soft whimpering. Her eyes moisten with tears. Boop, boop. Boop boop boop. "This place is a prison," she declares.

"How long you been here anyway?" I ask.

"Three."

"You been here three years?"

"Three."

"You've been here since you were three?"

The pretty features of her face distort. A sob shakes her body. Bringing her little hand, crimped at the wrist, up to her face, she dabs at the tears that run from her eyes.

"Is there anything I can do?" I ask.

"Yes." She snuffs once. "Find me a home."

"**W**here's that little brush James was using? Anyone seen that little freaking brush?" I ask.

On my knees, I rummage through our supplies. "Anyone seen it?" I ask again.

Chet launches himself out over his laptray, his eyes held as wide as he can make them, unblinking, his head held still, in an emphatic "point" at a section of the floor. I look at the section, then reach to sweep my hand over the splattered linoleum. The

tiny brush rolls away. I snatch it, sit up, knees on the floor, my
butt resting on the heels of my boots. My eyes holding Chet's, I
toss the brush up in the air and catch it.

"Why?" Chet's computer voice asks.

"Why what?" I ask.

"Why?" Chet nods to the section of floor where the brush
had been.

"What are you asking?"

I hold up the tiny brush. "Why I didn't see it?"

Boop. "Yes."

"Hmm," I muse. The artists sit extra still. Mike's eyes narrow.
Eric's eyebrows rise. Nat tilts her head. They are so observant.
They already know, have probably known for a long time; their
eyes unified in serious, calm encouragement that it is cool for
me to confide in them. I do not feel like talking about it. The
depth of trust and respect that has grown from the intense expe-
riences we have shared together here in 333 calls for me to level
with them. I look at each of them, then turn back to Chet.

"I have this thing," I say in a quiet voice. "They say I have
this thing. It's called RP, retinitis pigmentosa. There are some
patches in my eyes, in the retina, that don't pick up signals.
When I move my head, the thing that was in the missing section
shows up. So, I can see everything, see well enough to do most
anything, except a few things, like drive. The missing patches let
small things disappear, like a car, coming fast from way off." I
make a moving car with one fingertip. "That's one of the things
I can't always see."

I had made a quick turn on my Kawasaki 900, across a high-
way. This move sent a car full of kids into a set of screaming,
tire-smoking fishtails, the rear end of the car swinging hard to
the right, then the left. Right, left, right, left, on and on down
the highway. A couple hundred yards down the road, the car

straightened out and went on its way. If the rear end had come around another foot or two the car would have rolled for sure, probably hit a phone pole. Back at the coop, I dropped the ignition key on the desk, looked at the painting I was working on, no tears forming.

The room quiet, the class perfectly still, I close my eyes. "I've known about it for a long time," I say. "It's just recently I let it get me down. There's nothing to do about it, so there's nothing to worry about, right?"

Chet works at his keyboard, tap tap tap, boop boop, boop boop boop boop.

"Glasses."

"Glasses don't work." I close, then open my eyes.

"How are you?" Natalia asks.

"Fabulous, Nat. How 'bout you?" She watches me. The university student, our latest tracker trainee, standing in the corner, looks anxious. Going over the now somewhat complex systems the class use is the last thing I feel like doing.

"Guess I am going to be doing the tracking today," I announce. "What do you all think of that?"

"Wheel," Nat declares.

"What?" I ask. "You want to do a wheel painting?"

She nods. I give her a look. The old wheel painting technique did not need the visual acuity required to track the darting laser.

"Wheel painting, huh?" I smile.

Natalia nods an affirmative, her matter-of-fact look tempered with tenderness.

"Did I get it all?" I ask from my hands and knees above the slathered canvas. As I ask the question, I catch a glimpse of a little spot I have missed. "Got it all?" I ask.

"Yes," she says.

"You sure?" I tilt my head. "You sure you're not just saying that because I'm handicapped?"

She guffaws. Tap tap, boop, boop. "No way." She laughs. Scooting forward, she takes a look at the bright red square, then glides around to run over it with quick, graceful little arcs, twirling carefree: this way and that. The message of comfort imbued in this lightness touches me.

"Tim?"

"Yeah, Eric?"

"I feel bad for you."

"Thanks, but you know what, Eric? Don't."

"Tim."

"Yeah, Eric?"

"I feel bad for you."

"Thank you, Eric."

"Maybe," he says, "we don't have too much time, Tim."

"I'm aware of that, Eric."

I brush my hand through the air at him, to break the beam of his concern.

One of the little kids I have gotten to know wheels herself into the studio. When she has seen me walking down the main hall, she races in hot pursuit. Banging her hands down to propel her wheels, she shoots them up into the air, fingers splayed for me to stop and let her hug me. When she gets ahold of me, she does not let go, gliding in tow as I make my way for the studio, her teacher calling for her return. Eyes crazy-bright on having discovered the studio and her buddy, she takes hold of the collar of my T-shirt. Pulling hard, she gets it to stretch way out, and coos for me to play.

"No games today," I smile at her. "Okay?"

With a crack of metal striking metal, the twelve-year-old rolls backward, Mike's chair now where hers had been.

"Easy, dude," I tell him. "She's cool."

When the little girl wheels back to grab a fresh hold of my collar, Nat plows into her. Driving the youngster backward, out the door, Nat stops short, the little girl continuing backward into the hallway. Mike moves to block the entrance.

"Good work, Michael," Eric tells him.

I came out of art school wildly naive with dreams concerning the power of painting. I thought painting, in its purest form, would give its viewers wings to fly, as I had, up, out, and away from the clutches of the mundane. Fired with a child-like excitement, I showed my paintings to everyone who came by the coop. One visitor was a friend, a guy my age.

"I definitely made the right move, getting into real estate when I did," he said. "Being broke sucks. Been there, done that." He made a face. "I got sick of driving a rust bucket." He said this, leaning to glance out the coop window where his new white Volvo station wagon was parked on the circle of the driveway. "Got my wife one, too. Same color. Is that cool, or what?"

I said something in response, then asked if he would like to check out the new painting. It was a large, heavily built-up acrylic canvas, weighing at least fifty pounds. The idea that drove its creation was an attempt to transcend the material, not by making a pretty image to seduce the eye, but to tell it like it is, putting the materiality "in your face," crude, thick roilings of darkly tinted acrylic gel; then, with two intuitively placed lines, trumping the grosser power with the finer. With this, the latest, most ardent of my efforts, hefted onto the single horseshoe nail, I stepped back.

When my friend said nothing, I looked his way. Sensing I was looking at him, he looked at me then back to the painting, harder this time, his eyes narrowing.

"It reminds me of guacamole," he said.

The white Volvo crushing carefully down the gravel driveway, I stepped out of the coop.

"What do you think about all this, Rock?" I asked the farm's Belgian shepherd who accompanied me down the tractor path, woods to our right, fields to our left. "I mean, really. Guacamole?" He gave me a dopey, confident look like, "Don't know what you're saying, but I'm cool with it."

I was not cool with it. It was becoming apparent that the people I had chosen to live among, in the rural beginnings of suburbia, did not care much either way about pure abstraction. This was bad. I was pissed.

My rent overdue, I sat at the bar.

"Wanna do some tree work?" the guy sitting next to me asked.

"What's it like?"

"Crash, and smash," he said in a very laid-back, tough-guy kind of way.

"Crash and smash?" I asked.

"Crash 'em, and smash 'em, my man."

Draining off the last of the tall-neck Bud, I placed it on the bar. "Sounds good."

In our lumbering old truck, loaded with chainsaws and climbing gear, we invaded the yuppie's world, avatars from some earlier, more primitive time, back when things were still physical. Climbing, things were real. Every move you made forty, sixty, eighty feet above the ground had consequence. A climber, tired at five o'clock but still moving quick, diced his own line, free-falling backward out of the tree, onto a tall wrought-iron fence with lance-like points. Scenes like this did not put me off. They were part of the deal. The stiletto voltage of adrenaline was worth it. It obliterated the timid world I was determined to elude.

Piecing down massive sections of an oak trunk, four feet wide, many stories above the ground, I cut away a section I knew was

way too big. Its tonnage toppling over, it pulled the crane I had leashed it to up off its outriggers, the oak cylinder dancing crazily away from me then back to pound the trunk I was tied to, an inch from my head. It was great. Nothing had happened to me. Nothing. I brushed the sawdust from the flat circular face atop the giant column, and pulled myself up to take a seat. Surveying the world below, the tops of all the smaller trees, a green sea, the spires of Princeton University poking up, no higher than me, I sensed my seat: a throne; me: the king of the world. I was the man! I had it going on.

In these years of total freedom, I grabbed the gusto. My paintings appreciated by a group of recognized abstractionist heavyweights, I savored my hours in the coop. My work had been shown in New York galleries, in solo exhibitions: a famous art critic among the buzzing crowd. I surfed the monster waves at Tres Palmas, followed Giotto's paintings through northern Italy, swaggered reeling, with my buddy JJ, through the most dangerous parts of lower Manhattan; artists' loft parties, beautiful girlfriend: Fike, dancing like mad to the Fabulous Thunderbirds. Anything I wanted to do, I did; the future rolled out before me in all directions as an endless expanding landscape of intense sensational highs. Little did I know that, running full speed, a trip wire, unseen, would bring me, "the man," to the ground.

"Retinitis pigmentosa," the eye doctor said.

Having come in to see if I might need glasses, I froze in the examination chair.

"I'll be blind?" I asked.

"Maybe not blind . . . as a bat."

"You have two years, five at the outside, of usable vision left," one of the specialists said. "There is no cure, much less any treatment, and none on the horizon."

In spite of this, he put me through batteries of tests. These tests

taught me how to see the areas of retinal damage. Once I could see them, I could not "unsee" them, could not stop looking at them.

That night, at the Belle Mead Inn, where I, in the past, had shouted rowdy, ready to fight, I sat alone, looking at the beat-up bar, eyes unfocused, thinking of my demise. I pushed my beer away, intending to get up and leave, but could not move, trapped by my review of losses to come.

I told no one about my eyes, the rotten crab clawing listless at my stomach — the life I had felt in the trees, on the bike, replaced with fear. I wanted to do something about it, but there was nothing much to do. Regular glasses might improve the field of vision that was still working fine, but I could not go to the doctors. I had made a vow. I would never put myself in the hands of another eye doctor unless he was an artist as well. This sounds pretty crazy to me now, but that was the vow. It was dead serious then. I figured it would assure I dealt with a human being, and not the priggish clinicians who had sniggered that it was lucky I was an abstract painter, as opposed to a realist, who would need his eyes. Many months later, by asking around, I actually found an ophthalmologist who was a sculptor. In his office, I showed him reproductions of my paintings. He leafed through the binder, taking his time to consider each of the images. When he was done, he closed it, handed it back, and looked at me for a second without speaking.

"I'd like you to come up to the school where I am teaching," he said. "They're starting an art program. I'd like you to show slides of your work to my students."

I went up the hill to the school. There, in 333, from the cloistered depths of morbid self-absorption, I got slapped awake, the full power of life I thought was gone for good reappearing with startling intensity. The vanity of their bodies ripped away from them, the singular driver of the human spirit stood clear, intact, burning with a curious fire. I could see it. The students could see

*that I could see it, and signaled back to me with their eyes. My
heart was hammered, not with pity, but with awe. They lived so
much further outside the world than I had, enduring unimagin-
ably greater punishment than I, and still they had kept the fire
alive. The foundation of my arrogance, already eroded, wavered,
cracked, then crashed into deep water.*

*When James Lane drew that arc on his first painting, my whole
life, past and present, came together: longings, questions, mean-
ing, and purpose. Everything had been training for this moment,
this place, these people.*

*Although in the months that followed I maintained a fairly
martial tone of voice with the artists of 333, refraining from ex-
pressions of tenderness, they knew where I was at, and moved close
to me, joining me for what was to come. Not for them, or for me,
but for us. Now that I am down, it is they who hold me up.*

His orange Harley hat on backward, Mike eyes me with disgust.
Where in the last few weeks the rest of the class had been, and
continue to be, very sensitive to my despair, very patient with
me, careful with me, Mike had had it. I sit on a five-gallon pail,
eyes on the floor. My eye thing remains stable for long periods.
Sometimes, it seems, as long as a year or two. Then, without
warning or apparent cause, it drops. I am aware of Mike's eyes
on me.

Before Angel and me, Mike had refused to engage the world.
Suzanne told me Mike did not go to his classes, that he never
took part in any school activities. In our class, he had driven to
the head of the pack. His drawing and his color sense were com-
mented on by all the different trackers.

His control with the laser was very, very good. He created
beautiful effects for his handsome paintings, such as a set of
huge vertical metallic colored bars in the shape of an L. From
the open corner of the L, he directed washes of iridescent colors

to be sponged outward, upward, into the open field of the un-primed canvas. The effect was striking. The slightly tipping metallic L, strong; the iridescent wash, expansive, breathed out as if from the "mouth" of the L: as a mist. The raw canvas above, and to the right, creates its own shape, clean, taut, edges sharp. The three elements, each very clear, very different from each other, perfectly tuned to complement and accentuate each other in the lyrical poetry of their balanced asymmetry. Some of his paintings were as good as any I had ever made. His range and his control drew the painters to gather in a semicircle behind him, to watch, to learn.

Mike is a complex guy. His paintings stand in contrast to the more obvious aspects of his tough-guy character. His family runs a towing service. When they take him out of the school, it is to a stock car race down at the Flemington Speedway. This is the life he would probably live if he could walk, if he could talk, if he could flex his fingers. He hates the school. He hates the staff, especially the teachers who talk baby talk to him. He loved Angel and me with our ripped-up clothes, our unshaven faces. He loved our arguing, Angel's cursing. He likes people who are tough, not sissies lost in self-pity. Without Angel around, I am Mike's link to the world of men, at least up here at the school, which is where he lives all but a few days of his life.

With my fade into weakness, I am abandoning him. "What's up with you?" his eyes poke me. His turn to paint, he wheels around fast, stopping sharp next to me, waiting for me to look up. When I do, he gives me a hard look, then accelerates away in a fast curve to another sudden stop in front of the board.

"Okay, Michael," I say to myself. "You have something to show me?"

He directs the cutting of a large canvas; indicates that it be pinned up horizontally. He fixes the ruby bead of the laser on the gel bucket, then the gallon of black paint, then to a three-

inch house-painting brush, then to the canvas pinned to the board in front of him. The speed of his pointing shows the intensity of his impatience with me.

I have watched Mike paint many times. His attitude usually appears quite casual. This time, he is all business, like a man who overturns a dinner table, standing to challenge the person who has offended him.

The tracker applies big blobs of black gel on the canvas at the points Mike targets with the laser. Satisfied with the gruesome field of clinging blobs, Mike aims the light at the brush, directing it into and over one black blob, then another, forcing the pigment into the now random bits of raw canvas, dragging it, pulling it, smearing it.

When he has all but a small island of raw canvas at the bottom center edge, I hold my breath. The painting looks very, very good like this: the pristine little island managing somehow to hold out against the dark and brutal storm that rages all around it. Mike directs the clotted brush to plow back and forth over this last area of untouched canvas.

"Ooph," I say under my breath. Out go the lights.

Now that there is only black, Mike presses on; drawing, turning back, dragging, plodding, his brush rides over the surface. Finally, the laser slows, then stops.

"Anything more?" the tracker asks.

Mike takes an audible breath, then goes back to his work.

Skating, looping slowly around, running back and forth; the blobs worked down, and out, the black blended into one perfectly even hue. The brush glides now with little resistance over the smooth black plane, the only effect the glistening tracery of its movement. He continues to work inside the black, calling for no new color, no change of brush. On, and on, he drives the brush. On and on, and on, and on. On, and on, and on.

A standard session is half an hour. Mike has been up at the

board for fifty minutes. The other painters are aware, if this keeps up, they may not get a chance to paint this class. They show no signs of anxiousness, they, like me, having been drawn into the spell of his determination to keep working the painting.

"Done?" the tracker asks when the ruby bead stops.

Mike does not signal for a moment, then looks to the tracker. The laser removed, Mike does not back away from the board but remains still, facing it.

The tracker, at the sink, cleaning the brush; I see Mike alone, the back of his wheelchair, the back of his hat, the large black rectangle that frames the lone figure. I get the feeling he is waiting for me. I pull the five-gallon pail up next to him, and sit. I look at him, the side of his face not moving, his skin damp from the straining of the muscles of his back and neck. He looks without blinking at the painting, aware, I am sure, of my looking at him. I turn to face the painting. We sit like this, close together: looking into the shining sea of nothing.

He pulls back on his joystick and accelerates backward—to stop short, inches before he hits the wall.

Eric rolls up to the board. When he is settled in to his work, I look to the painter of the black monochrome: Michael Young. When I catch his eye, I give him a look to tell him, "I get it." He smiles a tired smile, then turns my attention back to Eric's painting.

*T*he lesson of Mike's monochrome being as heavy-duty as the worrying that had dragged me down, I needed relief. This for me has always meant the ocean.

One of my old surfing buddies lives on the beach in North Carolina. He works for a little newspaper. The three days I am

down there, while he is at work, I swim among the waves. White noise of the ocean runs up the sand. The fresh salt air blows steady. Seagulls screech, speeding white in the bright blue sky. Cold, wet, refreshed, I settle back into a low canvas beach chair. My brain is free of thoughts, for a minute, or a half hour. But there is only so much of this alert "not thinking" you can do. After a while, thoughts come forward: reasonable, interesting, offering themselves for consideration.

The paintings deemed most radical in the history of art are the monochromes. Malevich, of the Russian avant-garde, painted a number of purely black paintings. The ones I have seen were done on shaped canvases. Artists like Bryce Marden painted single colored fields. Marden would leave a small area of raw and splattered canvas at the bottom edge. Ad Reinhardt painted what appear to be monochromes. Looking carefully, the viewer can pick up a blocky bar or crossed form set in the black. Michael Young's monochrome has no parallelogram shape like Malevich. It has no raw edge like Marden, no hidden geometry like Reinhardt. Mike's was all one thing, the thing itself.

My eyes closed, I sense the quick fly-by of a gull between me and the sun. The next shadow does not move.

"I'm William!" the big man shouts over the wind. He extends his hand, takes mine, and hoists me to my feet.

"We gotta talk," he says.

At the beach road, he climbs over a fence, waiting impatiently for me to do the same. "Come on." He gestures with his arm.

"Where we going?" I laugh.

"Green Swamp. Let's go."

My surfing buddy had told me about William. One of twenty-four kids his father spawned with various wives, in rural Illinois. Teenage runaway, running wild and free in Haight-Ashbury dur-

ing the halcyon days of psychedelia. Vietnam. Master pressman for the local paper. It appears my buddy had told William about me.

"I cut out early," he says without my having asked the question, then slams the truck door and twists the ignition key.

A long tire-humming drive on a deserted road; scrub pines in sandy soil, the smell of the creeks and streams, a hint of the briny salt air blown in from the ocean, no other cars, no houses, no billboards; we fly down the road. The brakes come on for a turnoff, then again for the turn into William's rutted earth driveway. A small one-story house, packed dirt front yard, a parked Cadillac. A skinny hunting dog ambles out to greet us.

William leads the way through the house, stopping for two seconds to pull cans of beer from the refrigerator. He shoves open the back screen door, hands me one of the cold cans, and nods to a weathered wooden chair on the weathered wooden back porch. Satisfied I am comfortable, he drops onto a rickety chair, placing his big hands on his thighs so the fingers of the two hands point at each other. He stares at me, then looks out over the narrow, scruffy strip of lawn that separates the house from the swamp. Insects drone on then off like the guts of a great electrical transformer. Ooooo-wah oooo-wah oooooooowah.

"Well?" William says.

"Well what?" I ask back, primed to laugh from the openness of his expression and the flood of energy that radiates from him to me.

"Tell me about this thing you are doing."

I describe the artists, tell William about the laser, the exactness of the new techniques. I tell him about the beauty of the work, and the barriers that block the students' liberation. The last word of description just out of my mouth, William leaps from his seat to his feet. He pulls a checkbook from his back pocket.

"How much do you need?" He waves the checkbook in the air.

"Hey, thanks, really," I say. "But I can't take your money."

"You don't understand, Tim," he pronounces Tee-am. "Me and my wife Barbara, we're in between churches. We're going to make our tithe to your program. Where's a pen?" he shouts.

"I can't take your money," I shake my head. "I really appreciate it."

"Tim?" William's eyes lock mine with intensity.

"Yes?"

"What is it you need most, say, if it wasn't money?"

"Hmmm." I think aloud. "Maybe a camera, a video camera. I've been thinking maybe I should be shooting what's going on in the studio. It might help people get what we're doing."

Barbara home from work, William gets special dishes cooking on the stove: venison he shot, vegetables they raised. Sitting together at the table, William reaches out for his wife's hand then mine. Gripping them firmly, he says, "In Jesus' name, Amen." We lay the hand towels they use for napkins on our laps. The delicious meal finished, we sit in the living room, a little area attached to the kitchen. The coffee table, a trunk with a sheet over it. Late into the night, we talk, warm with lots of laughs.

With the video camera, batteries, charger, tripod, and video dubbing deck William sent, I shot footage of the artists, then made a trip down to see them again, bringing with me the tape.

William, Barbara, and I watch the tape in the living room of the tiny house in the middle of the Green Swamp. Eric, Mike, Nat, the class, the people I knew so well as strong, as funny, appear. Hard at work, you can hear the public address system, the click of solenoids, the boop, boop of Liberators, and laughter; colorful new paintings held up to the camera, one after another. Tears run down Barbara's face.

"You cryin', Barbara?" William asks.

Slender braided lengths of Nat's dark hair, white beads at the ends, hang casually, fashionably, in front of her left eye. The camera draws her slowly, smoothly closer until her face fills the entire screen. She looks out at us.

"I'm a person," she says. "I don't need people feeling sorry for me."

The tape ends, no credits, no music. William watches the static snowfield of the imageless screen, his hands on his thighs.

"Anything else I can do for you, brother?" he asks.

*E*yes closed, white clouds and blue sky overlay the figure behind the glass. Mike dozes, waiting for me to show up, as he does Monday mornings. When he hears the automatic door exhale open, he snaps to, revolves quick, and accelerates to run at my side, down the long main hall.

"What's up, Mike?" I ask.

Taping up the first of the paintings from the week before, I speak to the artists over my shoulder.

"I want to talk to you guys about some things."

"Work," Nat's Liberator fires the single word, a playful suggestion that I not give any speeches.

When I give her a hard look she laughs.

Meeting William had shored me up. It had revived me. The first person from the outside to get from their seat to their feet, he reignited my faith in people, a faith that had faded pretty badly with the lack of interest, lack of proactive passion, for the vital liberation movement that was at hand.

"I know I've been dragging my ass," I tell the painters. "That's over. I went down last week to see William again, the guy who gave us the camera. He is so fired up for you guys. So fired up.

He gets it. Like we do. If there's one person out there like him, there's got to be more, right? He gets it, Eric."

"He does?" Eric asks.

"Big-time."

"I knew someone would get it." Eric smiles, then laughs. "I knew, Tim!"

"They're out there," I say, looking with narrowed eyes at the artists. "But how do we reach them? That's the big question."

"With our paintings," Eric says.

"That's right!" I show Eric two fists. "We need to let the world know what's going on in this stinking little studio of ours."

"We need a show in New York," Eric says.

"When people get what's going on here, things will change. Not just for you guys," I point at them, "but for *all* the people stuck in places like this. And for everyone else, too. It'll open things up. What do you think?"

"Cool." Nat holds her brown almond eyes wide open.

"It's not a dreamy dream," I say. "It's something we can make real. We can make it happen."

"We need a show in New York," Eric says again, his eyebrows held up.

"That's right. Listen to this, you all. Eric has this idea we ought to get a show in New York. What do you all think of that for a plan?"

"Whoo hoo," Eric hoots. "Let's do that."

"Work," Nat's Liberator fires.

"Right as usual." I bow to her. "Let's get to work. Who's up first?"

Both Nat and Mike dart for the board. With the sharp crash of their chairs, Mike's upper body is sent over his armrest. Righting himself, he gasps, then lets loose a gusher of laughter, Nat's eyes sharp with the thrill of the collision. The room fills with hoots, and shouting.

Each having had their turn to paint, the fresh work laid carefully in the fire-door alcove, the class period over, none of the artists make any move to leave. When there is especially good action, when there is a big breakthrough, everyone sticks around, in spite of the classes they are scheduled to be at. Comfortable in the clubhouse atmosphere they have created, Mike looks out the window at some construction equipment doing some digging. Eric speaks with James. Cindy, our newest superstar, takes questions from the tracker. Nat plays DJ. Her little boom box pounds the music current in Manhattan's dance clubs. Chet hops up and down to the beat. It is a moment I savor, everyone in the room so alive, so sure of themselves, relaxed with seeing themselves as part of something good, something new, something big. When we met, it was hard for most of them to think past simple survival of boring days. They have grown to see they could challenge the school. This turned them on. It was daring. It was fun. Today, with our talk, they absorbed the concept of pushing a quantum leap beyond these walls, out into a bigger, wider world, where they might blaze a trail for others by gaining the respect that, as exceptional artists, they were now due. Leaning against the wall, a smile on my face, I drink in the hipster clique, kicked back in their own café society.

Tubby Tuna enters the studio without knocking.

"Hi, kids!" he greets the painters as if he were host of a children's TV show. "How are you kids today?" he asks the seventeen, eighteen, twenty-one, and thirty-seven-year olds, unaware of the looks they give him.

"Here," he hands me a stack of papers. "New attendance sheets. You have to fill them out, each and every week. Ta ta." Tubby scuffs out of the room.

The artists had completely escaped the school. Tubby's silly, patronizing tone had brought them back. Pop, goes the bubble, that bland, restrictive aura displacing their fun.

The ruby bead plays on the stack of papers I hold. When Mike sees I see it, he aims the laser to train on the trash can.

"In here?" I ask, holding the stack above the can.

With his slow nod, the papers drop with a phloomp. The painters whinny. With laughter, the music turned up louder, sounds of the hipster's cafe once again fill the room.

In my first days up here, I asked the doctors and teachers questions about the students. They told me about all the things that were wrong with them: a litany of their various physical, and neurological disabilities, and what they could not do.

I found, after these talks, that I was not interested in what was wrong with them and what they could not do.

What I know about the class comes from what goes on in this room. I have seen them outside of 333, once in a while. Mostly up in the cafeteria, when I had to get a message to one of them. A noisy scene, crowded, bustling. I noticed how Eric, who never used to say that much, talks to the PCA feeding him, in his dragging, heartfelt voice, about his "pain-tins." The feeling I get, slowing to listen, is that the PCA wished Eric would do less talking and more eating. Chet pops up and down. The staff love him. Always bright, always ballistic, it is a pleasure to get him a drink of water—Chet's Liberator calling out "whisky whisky whisky!" Slurping up the water like a madman, he smacks his lips with satisfaction. James's lunch is quite civilized. The yogi-like calm, the cool-cat-who-cares attitude he radiates, draw those around him into his calm. James can pick up small things like a french fry. He can get one into his mouth. To finish a meal on time, his PCA resorts to offering him forkfuls of food. Natalia is a social butterfly. Her speedy chair whirs her in and around areas of cafeteria congestion. She seems more interested in flitting around the room, catching and creating news, than in eating.

"Hey, Nat!" I had called to her. "How's the food?"

Boop boop. Boop. "Dog shit." She snorted at the look of
shock on my face, then accelerated away.

I have never seen Mike at lunch. He is like certain animals
you are sure are in the woods. You know they are right around,
somewhere around nearby, but you cannot see them. Cindy
does not take nourishment through her mouth. She sits with her
back to the cafeteria wall and watches the others eat. Signifi-
cantly larger than any of the other painters, Cindy sits in an
equally larger chrome wheelchair that gives her a physical au-
thority. Eighteen, broad swimmer's shoulders, short hair, raw-
boned, clear-eyed; she reminds me of a cowgirl: confident, wary,
silent. She wears a cheap, oversized yellow sweat suit, and high-
top sneakers.

I see them deal with anger. Cindy is very intense. As you or I
might slam down a phone or call the cops over serious personal
offenses, Cindy uses her big chrome chair. She can swipe with
it to slam a door shut. She can brush a wheelchair and its owner
out of her way. I have seen her with only one shoe, and won-
dered if she has had a problem sometime earlier during the day:
the missing sneaker, launched with her bucking, kicking dem-
onstration of frustration. Someone pushes her the wrong way,
she throws a shit fit. People step back when she "goes off." She,
allied with Nat, got a lousy tracker fired. While she and I spoke,
he, instead of painting a transparent black wash over the net-
work of lines she had drawn, did his own creative thing by paint-
ing in some of the shapes between the lines, with solid black
paint. Seeing this, Cindy shouted, turned, as it were, on her
heels, and blasted out of the studio. Later, she and Nat called me
to a meeting in an empty classroom.

"We cannot paint with him," Natalia stated, Cindy bowing
gravely in solidarity.

"Maybe you can tell him what he is doing wrong," I suggest
halfheartedly, well aware that the guy was incorrigibly intent on

involving himself in the creative process. I asked the women, "You want, to put his head, like a turkey, on the chopping block and . . ." I bring down an invisible axe. "That what you want?"

"Yes." Both fix me with ardent looks, then, glancing at each other, laugh.

The others deal with anger in different ways. Crossed, Nat will cry. At the same time, when the tears are over, being the most sophisticated of the crew, she works to charm whoever needs charming in her campaign to secure a home outside the school.

Eric holds it in. He lets it brew. At home in the peaty loam of long-suffering, his way of dealing with unhappiness is to paint; each new painting, more earth added to the mound he hopes to mount, to see from and be seen. I see Eric spoken to in the most patronizing tones of voice — insulted, in my opinion. He absorbs these affronts with mild submission. This does not mean he is not angry inside. It is just that he does not like to argue. He hates to see things get out of control.

Chet can be quite sarcastic. His temperament is like Natalia's, in that they both see the ridiculousness of things around them. Where Natalia will steam or cry, Chet will shake it off, tap out a rude one-liner on his Liberator, then smile, pleased with his own humor, bob a little, then settle back and stay cool.

Mike is on strike. He dodges away from teachers who track him down. He knows all the alcoves, the unused classrooms, storage areas, good hangouts for someone who does not want to be found. If he is not cruising from one of his less inhabited areas to another, you will find him outside the school's front doors. He likes the sun.

James Lane. Well, James is above it. He can be sarcastic, but most of the time he remains aloof. Most of the time I see him, he has a placid glow as if he is calmly drawing the things around him in, filtering them, filing them. It seems these things he sees,

placidly filters, and files, do not make that much difference to him one way or the other. It is like he already has the secret, knowing everything comes and goes and that it is he that appears most surely to be the center of his universe.

We have grown together, without a lot of words. We have grown close without a lot of facts about the past, about the normal daily stuff, without our dwelling on our problems, our "afflictions." It is through our work that we have come together.

Each of us shows the others that they are trusted members of a family no one has spoken of but each values, more than words can say.

The artists are so energized now, so confident. Their work these past few years has really paid off. Picturing each as a photographic portrait, the images are clear, in sharp focus, high-contrast. As much as this pleases me, seeing the students who have not had the chance to break out bothers me. These students, who still spend a lot of time parked in the halls, remain out of focus. No one can make out who they are.

The idea of "outreach" had begun to take real form. Outreach. Getting the program to others like these people, in other places like this, all over the country. I had thought of it early on, but with problems enough at Matheny, I had put the idea on the back burner.

With the class having reached such a level of achievement, such confidence, with everything so surely on track it feels like the right time to make the move.

I can deal with the art world. But I know nothing about how to connect with all the other places like Matheny. Having no teaching credentials, no professional organization behind me, no business experience, I will need help with this. Who would know more about the other facilities like Matheny than Bob, president of the school?

Expensive tailored suit replete with suspenders, he sits behind his big desk. Well over six feet tall, in his sixties, white hair; he has a look that lets me picture him, in a different get-up, behind the counter of a Brooklyn hardware store. On the wall behind him hangs a large photograph of a flock of sheep. Outside his window, the parking lot and the peaceful valley far below.

"Bob," I say. "We need to get what we have developed in 333 to other schools."

His all but motionless reaction is so intense I stop speaking. He breathes in then out through his nose, then places his hands on his desk, palms down. He stares at me. "What the hell did I say?" I ask myself, tempted in my confusion to laugh at the image of a bull, shot with a tranquilizer: livid, but immobile.

"What did I say?" My brain jumps around as I wait for him to say something. He says nothing. So I go on.

"It takes the students from doing nothing, just sitting around, to creating these phenomenal paintings. It's made a profound difference in their lives. We have to get it to all the rest of them out there."

He says nothing. Seeing him filled with such inexplicable volcanics, about to erupt, I figure I should say something like, "Maybe we can talk about this another time," or "Did I pick a bad time to drop in?" Something. Anything but go on.

"Other schools need it too," I say, pushing the thermonuclear hot button I have identified but cannot stop myself from testing.

His big body leans forward a few inches, like he might leap over his desk.

"Is this real?" I ask myself.

"It's a moral imperative. A moral imperative that we share it," I declare.

"Watch your step, Mister," he says, grinding gravel in his throat. "Watch, your, step."

This is all he says. I wait a few moments more until it becomes clear nothing else will be coming out of his mouth. I get up, walk to the door, look back at him then walk out of his office.

Bewildered by his crazy reaction, angered by the flat-out rejection of the beautiful dream, I stop in on a doctor who has an office down the hall. This man understands what we have achieved down in 333. He leans back in his chair, his hands behind his head, his unbuttoned suit coat drawn away to reveal a white shirt and red tie. In spite of this relaxed body language, he has the air of some discomfort over my overwrought expression, and its connection to his boss, the president, down the hall.

"What did I say that made him so angry?" I ask. "Share what we have with other schools? What's not to like about that?"

"This," the doctor says calmly, "is Bob's show."

"It would be good for the school," I say.

"He looks at it another way."

"What way is that?"

"Your class has benefited the school in many ways."

"What ways? I mean besides the students who use it. Not one person has ever come down to see how it works, so how could it benefit anyone other than the class?"

"You've gotten some press."

"A couple articles."

"That," the doctor says, "is a good thing for the school, for the school's reputation. It is helpful for fund-raising."

"Big enough of one to keep the benefits from everyone else, anyone else not part of the school?"

"This is Bob's show," the doctor says.

I look at my hands. The fingertips of one hand tap the tips of the other.

"That is unbelievable," I say.

The doctor sits quietly, his fingers laced. One of his thumbs taps the other.

"Thank you," I say, then get to my feet.

Making my way down the main hall, I feel a numbness, a vague dark, dull sense of the force that drives the school; a wall, tall and thick enough to quash the light of dreaming. The intense, instinctive reaction is to get free of this place. Working solo in the coop, I pushed ahead with my life, unfettered by the decisions of anyone other than myself. Now, bonded with the painters, unable to leave them, I am trapped here with them, my freedom tied to theirs.

The artists assembled in 333, I pull up a five-gallon pail and sit down. I cannot talk, as my head is pumping with blood meant to cool my brain: extreme, perhaps overly dramatic, images of the crashing edges of two worlds, drawn into a spinning collision course where one would go on and one would be destroyed.

"I just had a talk with Bob," I tell the artists.

Sensing we are going to have a serious meeting, the painters arrange their chairs, solenoids clicking, into a rough semicircle facing me.

"You want in on this?" I ask Chet, parked over by the sink.

He corkscrews straight up. His head twists on his long neck. His eyes flash: "Yes!"

With three quick moves, Natalia directs her chair to open a space for him to join the semicircle. On my pail, I rest forward, elbows on my knees, fingers laced, chin resting on my knuckles, my face even with theirs.

"Bob did not seem real interested in a plan where we break out of here. He does not want us to share what we have, with other places like this. So, it looks to me like, if we're going to do it, we're going to have to do it ourselves." The artists lean forward into the challenge. Their seriousness elevates their appear-

ance. A most unusual band of partisans, they look eager for the freedom fight.

I look at each of them.

"First," I say, "we need to get people to understand what you all have done. To do this we'll need that show in New York. Right, Corbin?"

Eric does not smile. He does not nod his head. An almost imperceptible lowering of his lashes seals the depth of his solidarity.

"How do you think we could get a show like that?" I ask.

"How should we know?" their eyes ask back.

"There are galleries in the city," I say, "that cater to disabled artists. I know we could get a show with one of them. But we don't want that, do we?"

"We need a show, Tim," Eric says, "for our paintings."

"A real gallery."

"Yup." Eric nods.

"It has to be in New York."

"Yup."

"You know it's not easy getting a show in New York."

"We know that, Tim."

"Sometimes, even after a gallery gives you a show, you have to wait a whole year, or more, before the show goes up. Did you know that, Eric?"

"Yup."

"You knew that?"

"I believe you, Tim," Eric nods.

"Okay, then," I say, "That's the plan."

With tonight's classes, Carol will be our new tracker. At least half a head taller than me; her arms and legs are strong. I can picture her as a Wagnerian Valkyrie, horned helmet, her huge strawberry-blond ponytail sticking out the back.

Carol paints every day. If it is not her own work, it is faux painting. She painted a shark on the bottom of Peter Benchley's pool. She has a cat, and a crazy boyfriend, lives in a carriage house on a nice estate in the woods outside of Princeton. She sleeps on a mat of magnets, eats blue-green algae, feeds the same to her beloved cat, drives a little station wagon that reeks of paint, and attends lots of the heavy-duty cultural events that take place on the Princeton University campus. Japanese drummers, Schubert, a reading by Tobias Wolff. She gets the tickets from her clients, say, when one of the wealthy couples has a spouse with a cold. When her boyfriend cannot make it, Carol takes me.

After our dinner at Bernie's Black River Grill, we climb the hill to the school. Deer stand in the fields, their tawniness illuminated by the amber light of the setting sun. The parking lot is all but empty.

My hand palm up, the automatic glass door rolls away, taking with it the reflection of the valley and the pastel sky.

"Having all the teachers and administrators gone makes things much better," I tell Carol. "The painters cut loose. Not just with their paintings but with what they say. Gets fairly rowdy sometimes," I laugh.

"They'll be in there," I point with my chin down the hall toward 333. "They are supposed to rotate out each semester, but none of them will go and new ones just keep coming."

The main hall is all classrooms, no bedrooms, so at night after dinner it is very quiet. Halfway down the hall I stop to place a finger to my lips. I hear Mike laugh, the booping of Liberators,

the thud of a boom box playing some head-banging rock and roll. Three new students wait in line to enter the room.

"Excuse me." I wedge between them, then stop. "Who are you guys, anyway?" I ask. None of them can talk.

"We'll find out in a bit. It will be a while before you can get in. Thanks for coming down. Glad to see you."

"I hate it here." Natalia tells the men sitting with her.

Captivated by the intensity of her expression, Chet and Eric lean into her words.

"I am getting out of here," she declares.

Tap. Boop. "Yes!" Chet says, his body still, his eyes serious, sincere.

"Damn right," Eric says under his breath.

Surprised by Eric's using the word "damn," I hang back until I am sure the discussion has concluded. "This is Carol," I say. "She's our new tracker."

The painters eye her coolly. Unflustered by their reaction, the lady Viking gives them their cool look back, then smiles. She radiates a sureness that comes with high intelligence.

"This," I nod, "is Chet Cheesman. Mike Young, Natalia Manning, James Lane. This is Eric Corbin. And this is Cindy Shanks."

"I am getting out of here," Natalia informs Carol.

"For real?" Carol asks.

"Yes."

"Where will you be going?"

"Apartment."

"A group home?"

"Apartment."

"Solo?"

"Yes."

"Got anywhere in mind?"

"Kind of."

"Have a real plan, anyone helping you with this?"

"Yes."

"What stage is it at?"

"Papers."

"You'll get out." Carol shoots Nat a look of sisterly solidarity. "Of that I have no doubt."

"Thank you," Nat tells her.

The intense rock music that pounds from a boom box on Mike's tray stops.

"Thank you, Michael."

I am impressed with Mike's ability to work the controls for the unit. His fingers are packed tightly together, yet still he is able to bring enough pressure down on the controls to get them to work. He started using his arms and hands more after we got into this thing, this game we played, where he punches me in the face.

The idea was to see if he were tempted with something really fun, he could get his arm to move. "Go ahead, buddy boy," I had baited him by placing my face even with his tray. "Give me your best shot."

When he had gotten the concept of the game, he laughed. I feigned disinterest, my face still close to the edge of his tray. His shoulders quivered in the effort to will the immobile right hand to move. The first time the hand came away a few inches then returned elastically to the joystick where it had resided cupped with the other hand for so many years. A second try brought it to the edge of the tray. In a third arduous, explosive effort, the hand cobra'd out to catch me in the side of the face.

"Ooo-pha!" I shook my head as if to clear the stars.

Mike had laughed so hard he had choked, and still the laughter powered up through his body. Laughter, and more than that: relief. Deep relief, close to joy.

"May I have a word with you?" the little social worker with

the pointed nose, and pile of curly hair on top of her head, calls to me from the doorway to the studio.

"What's up?" I ask.

"Mike is in trouble."

"What kind of trouble?" I ask, a look over at Mike then Carol before I step out of the room.

"He was in cooking class," the social worker says in an ominous tone. "His teachers have seen him pulling you around the school in that cart, or whatever it is."

This was another game Mike and I were into. With a strip of canvas, I tie the wagon we use to haul paint supplies to the back of Mike's power chair. I hop in the wagon, and off we go, Mike whirring full speed up to the cafeteria, down the children's wing, laughing as we zip past Bob's office, and back to the studio.

"And?" I ask the social worker.

"They felt that since he appears to enjoy using his chair, he might participate, in the class, by running errands. You know," she informs me, "that Michael refuses to take part in his classes?"

"I've heard that."

"They asked Michael to go to the cafeteria," the social worker says, "to pick up some eggs. When he returned, they praised him for his cooperation."

"Yeah?"

"Then," she whispers, "he did: this!" She makes a sharp backhand swipe with her right forearm.

"Whoa," I laugh once, try to hold back but bust up.

The social worker's eyes narrow.

"Didn't break the eggs or anything, did he?" I ask in my most serious voice.

"Certainly he broke the eggs. And," she lowers her voice, "this seems a cognizant choice on his part, no accident."

"I better have a talk with him," I say. "Thanks for coming down."

Once again among the painters, I stand with my hands on my hips.

"You guys hear about Mike's little incident with the eggs?"

Low sounds let me know they had. Mike rolls his eyes. "No big deal."

"Michael really did that?" Eric asks.

"That's the word, Eric."

"Whoa," Eric breathes out.

"Whoa is right. He's a rebel, ain't he? All right," I say. "Let's get it going. Carol is a professional painter. She got her degree in Fine Art from Carnegie-Mellon University. She is an expert in color theory and knows more than anyone I know about application tools and techniques."

The painters eye her. They have never heard this tone in my voice concerning any other tracker.

"I almost forgot," I say. "Let's check out our new track lights. They're homemade, but they should do the trick. What do you say?"

I push in the plug, reach over to flick off the fluorescents.

"Oh, my Lord!" Eric gasps.

The new workstation, made from two full sheets of plywood screwed into the wall, an eight-by-eight-foot square, is flooded with incandescent light. The greater part of the room is more gently lighted. The effect is calming for the artists hanging out, more intense for the artist who will be at the board. Push-pinning up Eric's most recent painting, red and blue, the color is much deeper, much richer than it had looked under the cold blue-white light. I step back, to stand with the artist. "Looks a little more like a studio in here now, don't you think? I have an announcement. We are going to have a new show. It is at Rutgers

University, the galleries of the School of Visual Arts. They've given us two big rooms. Each is divided, so there are twelve big sections of white wall twenty-one feet high. I counted up the number of you advanced painters. The number is twelve. Any interest in creating one giant masterpiece each, twelve walls, twelve painters, twelve giant paintings? I mean canvases the size of the roll, six feet or bigger. What do you think?"

"Cool," Nat's Liberator chimes.

"What about the rest of you?" I ask. "Okay. This show is going to be different. This one we will control from start to finish, ourselves. And this time, we will all be there. There will be some reporters coming up to see you guys work. It's not New York, Eric," I say.

"I know, Tim."

"It's a step, toward New York."

"We know."

"That's why you all need to feel free to uncork it. We nail this one, it jacks up our chances for New York."

In spite of the seriousness of their expressions, the painters radiate excitement.

"Uncork it, you guys. Uncork it."

The session now under way, the painters fall into a smooth, rhythmic groove with their new tracker. Carol maintains perfect neutrality, never skipping any of the options, always checking each of the artists' directives for accuracy before she applies tape or paint, and again when the mark has been made. Watching her work is a thrill for me. She is the one who will let the artists push their work to the next level. Without any practical backing from the outside world, the only source of power we have, our only voice, has to be the paintings. The level they reach, the power they radiate, is the key to our breaking out.

"What do you think?" I ask the class, nodding toward Carol.

Bright eyes.

Nine-thirty, and time for us to call it a day; the painters remain. Carol pulls up a chair to sit with us.

Boop. Boop, boop, boop. Boop.

"Why did the dog eat the banana?" Chet asks. His face sweeps around on his long neck, to include us all.

"Why, Chet?" Carol asks. "Why did the dog eat the banana?"

Boop. "No dog food."

"Stupid," Nat comments.

"Mind your own business," Chet instructs her.

Nat dismisses him with a sarcastic shake of her head.

"Are you guys married, or what?" Carol laughs.

"We used to be together," Chet says.

"No more." Nat makes a face at him.

"Bitch," Chet fires his Liberator.

"Oh, my Lord," Eric exclaims. "Oh, my, Lord!"

Natalia's eyes fixed on Chet, she brings an extended knuckle down to her keyboard. "Fork you," she fires.

"Fork me?" Chet asks, his face puckish with delight. "Fork me? Okay." He hoots at his own ingenious word play, turning the insult into an invitation of sex. His crazy face cranked around to see if we get it, Carol and I bust up, Carol holding her sides. Nat gives me a look that suggests I not encourage him. Chet bows to his classmates, triumphant in having clearly topped the savvy Nat.

In the two months that follow, the artists work hard. I did not think it was possible for them to concentrate harder than they had all along, but I was wrong. Maybe it was the massive scale of the work, or that each painter would enter just the one painting. Maybe it was that they really believed they would all be at the show this time. They heard the many phone calls from the spattered studio phone to the gallery, to the press, to people we were inviting to the opening reception.

There was only one thing that could screw us up. In each of the few shows we have had, the school has never allowed more than four of the painters to attend their opening. I submitted a list of the twelve artists to Transportation a month in advance, then went to speak with the arts program director.

"Will all twelve be going?"

"As far as I know," the arts program director says. A bit of a wince in her tone of voice set off an alarm.

"Transportation," a man answers the phone.

"Hi, this is Tim Lefens. I was wondering how many students you have scheduled to go to the Rutgers painting show."

Papers shuffled. "Four."

I call the director of student services.

"Just called Transportation and they tell me they have only four students going to the Rutgers show."

"We can't do everything you want us to," she says.

"All twelve need to be at their opening. Six o'clock sharp, in their power chairs."

"They eat at six."

"Come on," I laugh. "Let them eat early."

"You don't know how things are done around here."

"The trouble is, I do. They need to be there. It will be one of the most important nights of their lives. And besides that, it is important for the school. There will be all kinds of press."

"We'll see what we can do," she says.

"If that means they might not all be there, then that isn't going to be good enough."

"I don't think I like your attitude," her voice turns from flat to sharp.

"Let's get back to my class getting to their show," I speak as calmly as I can. "There are twelve giant masterpieces hanging down there right now. You're not going to leave eight of the artists home that night, are you?"

"If it's possible, we will do it."

"If it's possible?" I ask. "If it's possible? They put a freaking man on the freaking moon, didn't they?"

"I have another call," she says. Click.

"Bob? This is Tim Lefens. Transportation tells me only four of the students are going to be going to their opening at Rutgers."

"You need to take this up with the arts program director," Bob exhales, exasperated with my having called him directly, something I have been instructed not to do.

Dull with rage, I make one last call. A handsome, quiet woman I had met at a picnic for the students. Besides understanding modern art, she is the president of the Matheny board of trustees.

"The school is not going to allow eight out of twelve of the artists of my class to attend their opening reception at the galleries of Rutgers University," I say into the phone. "The ones they will allow to go will not be permitted to use their power chairs. Their power chairs are their mobility. Not letting them use them is like cutting off their legs."

This route I took was not a good way to ingratiate myself with President Bob. But I do not care what Bob or anyone else at the school thinks of me any more. I promised my class they would be there.

The last class before the show, I sit with the painters in Room 333: Nat to my right, Eric to my left, Mike in the corner. Cindy sweeps the small wheels of her chair back and forth in nervous arcs. She looks down at her tray, then at me. Chet bobs lightly, aware, of my brooding.

The night of the opening, I stand in the entrance to the gallery, checking my watch. Five fifty-five. At six o'clock sharp, the door to the main entrance swings open, and in procession roll all twelve of the painters, the women in dresses, the men in suits,

and ties. They are electric with excitement, radiating their thrill to the crowd that has read about them in all the local newspapers. Nat and Cindy blaze from painting to painting. Chet, and the usually cool James Lane, let out whoops. "Tim," Eric calls.

"Awesome, don't you think?" I ask, taking in the huge canvases, stately claiming their twelve separate, giant walls, as strong as any show you could see in Manhattan.

"What do you think, Corbin?" I ask.

"Good, Tim. But where," he asks with concern, "is mine?"

"Behind you."

Arching to look back, the artist starts in his chair.

"Whoa!" he gasps.

It is one thing for him to see the painting in the studio, another to see it stretched taut as a drum, framed sharp and clean, flooded in light.

"Yeah. I think you could say whoa about that baby, Corbin."

At the peak of the opening reception, the din of conversation, rising and falling; a woman touches my arm. It is the president of the board of trustees.

"This is unbelievable," she says evenly, a section of Chet's Day-Glo color visible over her shoulder, Natalia's huge canvas, "Hell," in front of us, its color and drawing asserting itself with power among the sea of people.

"They're good, aren't they?" I ask.

"Yes, they are." Her eyes fixed to one of the paintings, she says, "You know I had a little talk with Bob."

"You did?" I ask. "Thank you."

*M*onday after the opening, I sit with the painters. Brushes in a pail of water. Trash can loaded above its rim with discarded wads of masking tape edged with dried acrylic colors. Canvas rem-

nants, torn away in the relentless creative blitz of work the artists threw themselves into, rest in a heap on the floor by the can. The new paintings, started after the masterworks for the show were finished, hang taped to all the walls. They touch me in the way they look so wan; keys lightly touched by a pianist who, with the concert performance over, sits at the keyboard with nothing left to give.

I am struck by the seriousness of the painters' exhaustion. It moves me to see them so spent. Each time there is an opportunity for them to climb higher, they push further than even I, their biggest fan, think them capable of.

Part of the exhaustion comes from the reception they got at the show. The reaction of the crowd was amazing. There was respect for their work. And them. Then this: the return to the school. Respect, then no respect. In the drive to make the most of the Rutgers show, we attracted stories by two or three newspapers. Various reporters had visited to see the artists paint. We were pleased to get the word out, but it was not the same with strangers hanging around the studio.

"You guys look whipped," I say quietly. "I mean, whipped."

Our tiny black firebrand, Nat, allows her head to lean to one side. Cindy's wide shoulders slump. Her eyes close.

"It was the best work you've ever done," I say. "By far. Did you see them checking out your paintings? You blew their minds."

No reaction.

"How about we chill out for a while?" I suggest. "Maybe say no more visitors. Get it back the way it was. Just us."

The artists remain perfectly still.

"Want to say no more visitors? That a good idea?" I hear one of the artists draw in a breath, then release it; another set of eyes closes.

"Okay then," I say. "That's that."

Eric exhales.

"What's wrong, Eric?" I ask.

"My father was not at the show."

"Did he say he was coming?"

"He came up to the school, Tim."

"Yeah?"

"He looked at my paintings. He said, 'Eric, you did not make these paintings. You could not have made these paintings.'"

"No." I wince. "He said that?"

"Yup."

"What did you say?"

He sits still, staring, for a long time before he breathes out.

"Father, look again," Eric murmurs. "I said, 'Father, look again.'"

The room remains quiet with the weight of Eric's disappointment.

He stares at the painting he has been working on.

"I see his face," Eric whispers. "I see his body. Then I see me in the painting. Father and son, red and blue. Father and son, together, not broken apart." Eric blinks once, twice in the quiet messy room.

"Tim?"

"Yeah, Eric."

"Art is my life."

"You know what, Eric? I kind of got that feeling."

"What are you doing down here?" the PCA scolds from the doorway. "You know you are supposed to be at the cafeteria. You know that, right?"

The students eat in shifts. Getting them to the cafeteria requires the PCAs to hustle, like cowboys on a cattle drive. They come from the far ends of the school, sweeping the students ahead of them, some pushing a student with one hand, pulling one with the other. There are traffic jams in the choke points

when someone with a power chair, like Eric or James, has to concentrate to negotiate turns.

The thing that makes the efficient running of mealtimes so intense for the PCAs is that every student is so different. The size of the pieces of food they cut: different for each student. Some of the students can only take liquid. The PCA mixes a shake, removes paper from a straw. Some of the students, like Cindy, cannot accept liquid through their mouths. A nurse or PCA fills plastic sacks slung to the wheelchair. They make sure the amount is right before they plug the little pump into a wall socket, checking the tube that runs into the student's stomach.

"Now get down there," the man says. "You hear me? Get going. Now."

"I was coming," Eric says apologetically.

"Get going, buddy," the PCA presses. "Don't make me have to come looking for you."

"I was coming."

"Okay then, get going. Go go go go go go go."

It takes restraint not to step in on Eric's behalf. But, knowing him as well as I do now, I know how important it is that he learn to demand the respect he is due himself.

"We'll talk later," I say, as he rolls by. "We'll talk tonight." I get the feeling the attendant is going to put Eric in manual and push him, something Eric did not want anyone to do. I get up, walk after them into the unlit corridor.

Once I see that Eric remains under his own power I return to the room, and sit on one of the five-gallon pails.

A tap tap tap on the open door to 333. It is the Matheny director of public relations, beside her two young women in black business suits.

"May we come in?" one of the young women asks in a cheery voice.

"Actually, you can't," I say, getting up from my pail, moving to ease the visitors a few steps back into the dark hallway. "We have a new policy. No visitors in the studio, for a while."

"Can we come in just for a sec, take a peek at your class? We want to see the laser."

"Sorry," I say, "I don't mean to be rude. It's just that the artists are burned out. They worked very, very hard to get their work for the Rutgers show ready."

"These young women are from a public relations firm in Manhattan," the Matheny director of public relations informs me. "Bob is interested in getting Matheny some national press."

"Sorry. The class and I talked about it and the word is no more visitors for a while."

"Can we come in?"

"No."

"No?"

"Sorry."

"You won't help us do a story on the school?"

Previously naive about social politics and their machinations, I am getting a picture of how things work. We are being used. Dog and pony show. Any press generated by us should do more than put a smiling face on the institution. It should work, directly, to establish new programs at other schools.

"Will you work with us?" the blonde asks.

"Hang on," I say, stepping into the studio to get the little canvas pack.

"Here." I offer her a copy of the videotape. "Show them this."

A few weeks later there is a flurry of excited phone calls to Room 333.

"Stay where you are!" the PR girl tells me in a breathless voice. "You are going to be getting a call from CBS Evening News. Can you stay right there?"

The conference call connection allows the CBS person in Washington and me to hear the PR girls in New York, but it is apparent the girls in New York cannot hear us. The woman from CBS tries to speak, but has a hard time because the girls in New York in a panic keep saying, "Hello? Hello?" When they decide to hang up and redial, I am left one on one with the person from CBS.

"My name is Jill Rosenbaum. We do a piece called 'Eye on America.' We would like to do a piece on you and your class."

"You mean the Evening News with Dan Rather, the national news?"

"That's us," the producer says.

"Sounds good. Our mission is to get this thing understood."

"What was that, Tim?" Eric asks.

"That, Corbin, was a great big hand, coming to help us from the outside world."

"What was it?"

"CBS Evening News. CBS has decided to shoot a piece on you guys. Know how many people watch the CBS Evening News? Corbin? Any idea how many people will see you? Millions, that's how many, Corbin. Freaking millions."

Eric's Irish face tenses with the narrowing of his eyes. His jaw juts out. His fingers draw into fists.

*D*iffused shadows beneath his wheelchair; his eyes dart, his teeth grind, the shrieking sound piercing our ears. The wheelchair reclines back so far he is practically lying down. With large padded wings and a large padded headrest with wings, it looks, on its four wheels, like a baby carriage. This has a scary effect, in that the young man in it is very, very small, but maybe as old as thirty. His body torques violently. Vomit pulses over his lower lip.

If I had seen him that first day I had come up to the school to show my slides, I would have gotten all twisted up inside. Not so now. Seeing this guy, freaking out as he is, is pure pleasure. I feel his energy: blasting power you rarely get a chance to be near. His writhing is not fear, pain, or his being crazy. It is excitement, desperation. He has struggled to get someone to get him down here, and now he is here. No PCA, no teacher, has ever brought a student to us without the student initiating the move. Never. Those who have power chairs get here on their own. Those like Chet who use a Liberator can ask for a lift. This frantic young guy cannot talk, cannot motivate his chair, cannot use a keyboard, his crooked arms draped like broken wings over his little chest. So, having learned of our studio, it may have taken months, day after day, talking with his eyes, no one understanding what he wanted. And, finally, he is here, wild not to be sent away.

"Who's this?" I ask.

"JR," Eric says.

"Hey, JR. This is Carol. I'm Tim. You probably know these guys." I pull up a bucket near him. "What's your 'yes'?"

JR's eyes flash upward. His left knee shoots up.

"That's your 'yes': eyes up, knee up?"

His eyes shoot up.

"Both are 'yes,' the knee and the eyes?"

Eyes up. He gasps, then gags. It takes him a minute to get things straightened out—the gagging, and the getting air to breathe. When he has it together, his face is red, wet with sweat.

"Need a nurse?" I ask.

JR shoots his eyes to the side.

"Is that your 'no'?" I ask.

Eyes up.

"No nurse?"

Eyes sideways.

"How about a PCA?" I ask, sure of his furious answer.

"No," his eyes flash.

"Wanna paint?"

His left knee rockets up with force that makes the cloth of his pant leg snap.

Once he's fitted with the laser, Carol touches each corner of the large canvas with a finger.

"Can you reach, here? Here? He's got it," she reports, her voice hushed with her own seriousness and anticipation.

JR unleashes a furious linear storm; black electric cloud, jamming into the upper left-hand corner. The artist spent, the ruby bead falls away from the canvas. He lies, panting, looking very frail compared to the image he has created. Furious energy. This is the first time in his life he has affected the physical world outside his body. The first time he has directed it to reflect *his* will.

"That was really something," Carol says quietly, her head slightly bowed. She wipes her forehead, looks at the painting, then to the small young man, drenched in sweat.

"I think I know what he's saying," Eric says.

"What's that, Eric?" I ask.

"Get me the heck out of here."

"Is that what you were saying?" I ask JR.

His eyes, once so frantic, glint: stoned, jazzed out of his mind, elfin warmth radiating in a rich beam, from him to me. I had not known he was up here, the whole time I have been here. Desperate. Ready. Waiting. How many more are there like him still to reach? Here in the school. Out there, in the next county. In the next state. In the rest of the country? We need to move now. I have seen the depth of their desire, and the joy that comes with their liberation.

Driven to action, I walk down the main hall and go over what I will say to Bob. "Bob, with the CBS piece coming up we have

a big opportunity. It could launch an outreach program. By bringing it to other schools, it would raise Matheny's standing, nationally. Good for the school."

If he cannot see his way to work with me, that will be that. I will not ask again. If he cannot see his way to help us share the breakthrough, I will put a file in his fancy media cake, so it will not just be a celebration of the institution, but a means of breaking out of it.

I tap first on the outer door.

"Hi." I smile and give a little wave to his secretary. She nods to Bob's inner sanctum. Knock, knock.

"Come in," his gruff voice growls.

A chair pulled over to the middle of the big desk, we sit face to face.

"Timmy Lefens," he greets me. "What can I do for you today?" he asks expansively, having heard from his PR people in New York that his big media coup is a lock.

I wondered what had happened to him. A social worker told me that Bob had been such an ardent fighter for disabilities rights, he had boatloads of people pissed out of their minds at him.

"When was this?" I had asked.

"When he was younger."

On the wall: the big photo of the flock of sheep. Glassed. Framed. Outside the window, in the parking lot reserved for top administrators: the expensive cars.

"The CBS piece they are doing on my class will be a big opportunity for the school." I speak evenly. "I wanted to ask if the school would work with me to develop an outreach program for the techniques we are using."

Bob looks out the window.

"It would be good for the school," I say.

His head turns with his eyes, to stare me down.

"I," he says slowly, threateningly, "do not want you doing any end runs around Matheny."

I can tell this is all he is going to say. So, once again, without pleasantries, I get up from my chair, and step out of his office.

"What is wrong with that guy?" I ask my doctor friend.

"What did he say?"

"Don't do any end runs around Matheny."

"What else?"

"That's it."

"Tell me," the doctor says, "how you see this whole thing working."

"The school has no idea who these people are. We need to let people know, and then we have to . . ."

With a courteous hand signal, the doctor gets up. He pulls his office door shut, then returns to settle back in his seat. His hands folded over his tie, he looks at me.

"Please go on," he says. When I am finished with a long, disorganized, emotional gush of ideas, neither of us speaks.

Despite the closed door, the doctor looks to his left, then his right, before bringing his eyes to mine.

"This thing," he says, "could be freestanding." His words are imbued with encouragement, tempered with caution.

Walking back down the main hall, I ask myself, "What, exactly, does 'freestanding' mean?" In the alcove, by the fire doors, I kick the word around. Freestanding. Freestanding meant that the organization that would coordinate reaching out to other schools could be some organization other than Matheny. And what would this organization be?

Oh no, I think. Something *I* would start up on my own? How could I do something like this? In grade school tests, I got a 13 out of a possible 100 percent in clerical skills. The few attempts I made doing jobs that required paperwork resulted in frustration.

A group of nervous little birds land on the sidewalk outside the fire doors.

"Fly away!" I say.

When they do, I look at the empty sidewalk.

From where I stand I hear Carol's voice, then Mike's chortle, the boop boop boop of Natalia prepping a message. The upbeat mood of the studio drops to silence when they see the look on my face. They knew I was going down to talk to Bob. On my pail, I stare at the floor, and feel them staring at it with me. No one says anything for a long minute.

"Are we going to reach the others?" Eric asks.

"It isn't going to be easy," I say.

"What should we do?" he asks.

"It looks, I think, like we have to form something like, a company. I don't know. I'll have to make some calls."

"Should we call them now?" he asks.

"I guess we could do that, Eric."

Getting to my feet, I walk to the phone and press out the number of a friend who owns his own business.

"What would it take to get the systems we use up here distributed nationally?" I ask. "Yes. Yes, become incorporated. An incorporation. Yes. Yes. How do we . . . where do we get the forms for all this?" I grimace.

The phone hung up, I see my life veering off the clean, simple path of the artist's life.

The painters get my attention without their having moved a muscle. I feel them. They do not want me backing out after all the talking I have done.

"**D**o you need a computer?" surfing buddy Amigo Dave Lichtenstein asks me long-distance from his new digs near San Francisco.

"Sure. Don't know how to use one, but all businesses have them, right?"

"I'll tell them you'll be picking it up."

Dave had left a heavy-duty computer and printer in the apartment he still owned in Manhattan.

"Thanks, bro . . . Think it would be cool to call your dad about this?"

"I don't see why not."

"Roy?" I say into the phone. "I'm coming in to pick up Dave's old computer. I'm starting a business, sort of."

"Well." The famous painter pauses. "A business."

"Sort of. A nonprofit. When we get our 501(c)(3) status, we'll be able to get dough from foundations, and, and, I'm sure you know all this. We're calling it A.R.T., Artistic Realization Technologies."

"Well . . ." Roy says, patient and curious, cool, dry, and always supportive. "Would you like to drop by sometime? We could talk over lunch."

Roy has a beautiful studio space on Washington Street in the city. The industrial skylights are half the size of the coop.

After lunch, Roy and his assistants gather around a VCR in the studio. The crude twelve-minute tape of the painters in Room 333 plays.

"Thanks for checking it out, Roy." I hold back from laughing at the look on his face. "I know it's pretty harsh-looking for most people first time." I put the tape in the pack. "Thanks again."

"Ah," Roy asks, "is there, ah, well, some associated charity I could make a contribution to?"

On the sidewalk, I look back to see Roy standing with the door held open, the city hushed by two feet of recent snow, now melting. Trucks shish by both ends of the block spraying slush slop to either side, delivery trucks; most of the cars still buried. I look downtown, then up.

"Tim," Roy says.

"Yeah?"

"Do you, ah, have, well, ah, money for a cab?"

"Actually," I laugh, opening my wallet, then show it to him.

In Amigo Dave's New York apartment, Angel and I stand befuddled. "What the hell are all these cables?" I ask my beefy buddy. Angel eyes the tangle of computer cords and cables. "Guess we better not disconnect them. May never figure out which goes where."

We make our way down the nighttime city sidewalk with all the components, computer, monitor, keyboard, mouse, and giant printer still tethered together, Angel with half the stuff, me with the other half. The lighted windows of the tall buildings stand out crisp and cold against the clear black sky. A mountainous ridge of snow runs the length of the block. Rather than walk all the way to the end of the block and back up the street to the car, we struggle on our knees up the humongous drifts the plows had created.

"Be careful!" I order my assistant.

"Screw you, pato," Angel huffs at the summit.

And, of course, on our way home we have to spin out. The car, with us and all the computer gear, spins off the turnpike, spinning up a mild rise between the north- and south-bound four-lane traffic. It spins back onto the turnpike, directly at a tractor-trailer that rushes by. The friction of the pavement jerks

us out of the spin; suddenly pointed in the right direction, the car drives on as if nothing had happened.

"Hey hey hey!" Angel laughs.

Roy sent five thousand dollars. When that ran out, he sent five thousand more. I hired a small, intense, young woman who was getting her art degree from Rutgers University. Before she had gone back to school, Sylvia had worked in a bank. Before that, she had worked with lawyers. Before that, she had been an emergency medical technician. Holding my hand, she walked the fledgling nonprofit through the thickets of forms and filing dates. We worked in the basement of the house where I lived; a piece of plywood for a table, Dave's computer, a white Princess telephone nailed to the wall, a few copies of the video, and a tin can full of pens.

With smaller works, a stick or the pointed handle of a long narrow brush would have done it, but for this monster Carol holds a tomato stake as you would a saber. When the expensive chrome paint has been blended with acrylic gel, the two-inch thick mixture applied in swirls at JR's direction, Carol stands *en garde*. A hand on her hip, she rests the tip of the stake on the floor in front of the painting, looks to the seven-foot canvas, to the tip of the stick, then to the artist.

"Ready?" she whispers.

The laser streaks up the face of the huge, open silver field, Carol's wooden sword slashing upward in its wake. JR blasts the painting with all the ferocious energy he has stored up inside. Fierce, clean, aggressive energy he has had no outlet for until now. Zing! Zing! Rip! Rip, rip, rip! Silver blobs sent flying into

the air. His classmates shout, all crazy with the extreme violence of the slashing sword.

Another half hour of this and the artist breaks the laser from the field of chrome. From the sum total of thousands of flying incisive lines stands an awesome, stately, silent geyser of raw power.

Completely untutored, the painting stands with the best of classical Abstract Expressionism. As good as some Pollocks I have seen, both artists having driven with abandon to make visible the energy of their interior lives.

Carol steps back to look at the painting, leans the tomato stake against the wall, then pulls up a chair and sits next to the artist. All of us sit for a couple seconds, in silent appreciation of the painting. It is one of the best the class has ever produced. Not the work of the child the doctors told his mother "would never be capable of anything," but the stunningly sophisticated, visual realization of repressed sexual energy: released.

"Wow!" Carol's shout startles us. JR, with his glasses, curly brown hair, and tiny body, looks over at me, cocky as a clever British schoolboy, eye sparks dancing with elfish light.

"Unreal," I say. "Wanna roar like a tiger?"

The tech people have a little unit rigged to JR's chair. It allows him to trigger a short, recorded message by pressing his head back into the right side of his headrest. The staff has it loaded with a whiny voice that asks, "Can I get a little help over here?"

The tiger idea gets a big smile, and a big knee up from the artist. I press the tiny record button, place my mouth close to the device, make the sound of a snarling tiger, then turn it up to maximum volume.

"Yarrrrow." JR arches back to ignite the threatening effect. "Yarrrrow." It warns the world to get back. "Yarrrrow."

Carol raises her hands to protect herself. JR chortles, then fires it again.

"Yarrrrow."

"*There* you are, Jimmy," one of JR's therapists says. She takes the handles of his chair and wheels him, backward, out of the room. It is time for JR's relaxation class.

Carol waves. "Bye, JR."

Relaxation class is held in the room next door. Through the open door, we listen to his therapist speak to him. "Happy Face means JR, very relaxed" she says, displaying a huge flashcard. "Straight-mouth face means JR, sort of relaxed. Frowny face means JR, not relaxed."

All of us in 333 lean to catch his choice.

"Frowny Face. Frowny Face?" the therapist asks. "After you just make your pretty picture?"

"Oh, Lord," Eric groans. "They won't get it till we're all dead."

Carol holds her sides to keep from laughing out loud.

"I'm serious," Eric grumbles. "They won't."

I hold a finger to my lips for quiet, and we settle down to listen for more from the therapist's room.

Without further conversation, we hear the rise and fall of a droning synthesizer and the tinkling of wind chimes meant to induce mesmerization. Slowly up, and slowly down, the drone drifts. Up and down. Side to side it breathes, in the room full of sleepy students. Sleepy students who live each day in a world as motionless as sleep itself. A few minutes more and one of the students begins to snore.

"Yarrrrow," the big cat calls out. "Yarrrrow."

"We hear you buddy," Eric calls out the door. "We hear you."

<center>✳</center>

In the last of the afternoon's classes, the arts director appears in our doorway.

"Tim?" she says. "Can we talk?"

I walk into the unlit corridor and stand with her, aware of her being extremely tense.

"What's up?" I ask.

"Bob got one of your A.R.T. outreach packets."

"How's that?"

"All the newspaper clippings you included in it refer to Matheny. So whoever you sent it to, sent it back to us."

"Whoa." I laugh a laugh that sounds fake, then stand, eyes wide.

"Bob is very upset with you," she says.

"A.R.T.!" I raise two fists.

"I know the name of your organization." The director looks away, down the hall, toward Bob's office. In making light of the possible car wreck, I see the faces of the artists of the class, and imagine never seeing them again. "Want me to go down to talk to him?" I ask.

"No."

I see the point of Bob's anger. Bob sees the school as a company. My class has value to the company. For me to share this advantage of the company with other "companies" makes me a disloyal employee.

But I do not work for Bob. I work for the artists. If they were mobile, we could regroup somewhere else. But they are not. They are here, and I am here with them.

I step back into the room, look at the painters, then pull up a five-gallon pail. No matter how I may try to mask how I feel, they always know. Their eyes rest on me, quiet, sure, waiting for me to share what went down out in the hall with the tense arts director.

"I'm worried about A.R.T.," I say. "I wonder if we are really going to be able to get out there and get things going. Like Eric says, 'People don't seem to get it.' "

I had been invited down to Washington, D.C., to meet with a federally funded arts and disabilities organization. The gallery director was interested in giving us a show. We avoided disabilities galleries, but I had decided to go down anyway. We might form an alliance. They could link us with the many programs they sponsored around the country. The idea of reaching all those new artists was really exciting, yet becoming part of their network was questionable. There was a big difference between the operation of their fancy headquarters and that of the actual programs out in the boonies. The Washington headquarters put on galas at the Kennedy Center. They trotted out slightly disabled musicians to play Beethoven's Ninth, then gathered for champagne receptions with the who's who, their consciences cleared. In the day-to-day reality of the actual programs, staff put colorful, translucent, salami-like balloon hats on the immobile students' heads, and painted wide smiles on their faces.

Headquarters was a seven-story building made of white stone. It had a lobby, a receptionist, and a security guard. In the first-floor gallery I looked at one of the paintings they had on display. It was a small, bland canvas made of muddy colors with a dull finish. Next to the painting, much larger than it, was wall text. It read, "I lost my hand in a plane accident." And toward the end of the lengthy text something about "being nothing without my disability." Encouraged to bow like this, the artist had thrown away his chance to climb the steeper path to the real power of Art.

In the conference room on the top floor, I handed the directors A.R.T. outreach packets, then showed them our videotape.

In spite of an unsettling lack of response to it I went ahead with my presentation.

When I finished the directors said nothing. Uncomfortable with the long silence, one of them finally asked a question.

"How much time do you allow the artists to contextualize their work?"

"Contextualize?" I asked. "You mean, talk about their work?"

"Yes."

"Most of them," I said, "don't talk."

"They are not really doing it themselves," a different director said.

"How would you suggest they do it themselves?" I asked. "With their hands? And have the thing they want to see come out all screwed up? The idea is not to struggle to do things the way able-bodied people do. The idea is to make Art."

"The facilitators inject themselves into the process."

"No," I said, "they do not. They remain neutral. Everything that goes on the canvas is by exacting direction of the artist. It is the same as the giant Picasso sculpture in Chicago. The steel workers built it. But we call it a Picasso. Do you see what I mean?"

None of the directors say anything, suspicious as cows at an unfamiliar open gate. I almost laughed at the looks on their faces, then felt a sudden, dizzying flash of knife-like anger. These people, the heads of a national art program, knew nothing about Art. These heads of a national disabilities organization knew nothing of people like Cindy, Chet, or JR.

"I could run a demonstration down here," I said, "have you come see it work."

No interest. Not a word.

"What are we going to do," I asked, "in order for us to work together to reach the others like the people A.R.T. works with?"

One of the directors got up from her chair.

"We don't reach people this disabled," she said. The other directors stood up. They tossed the outreach packets into a pile on the conference table and filed out of the room. No handshakes, no "thank you for coming." No nothing.

In the dark lavatory of the rocking train back to Princeton, I stood above the bowl, allowing my release to purge the experience from my system. Part of having retinitis pigmentosa is not having good low light vision. The lid of the toilet was black, and had been down the whole time. Suit pantlegs, and socks, soaked, I returned to my seat for the ride home.

In 333, the light in the sky is waning. I look at Chet, then Cindy, Eric, then Natalia.

"None of the places I've called have had much interest in our program yet," I say. "I think they would if they had a chance to see how it works, but so far they seem too busy to take the time. Now it looks like I'm in trouble with Bob."

"Do not worry," Nat says.

Cindy catches Carol's eye, then bows her head to indicate a set of folders on the tray of her wheelchair. "Virginia Home," Carol reads from the folder.

"What's the story, Cin?" our tracker asks. "You thinking of transferring?"

Cin lets loose a resonant whoop, "Alley oop!"

"I know you're a Virginia girl." Carol smiles. "You'd be a lot closer to your family. It would be so good for you, but bad for us. We would miss you.

"You," Carol turns to me, "used to live in Richmond, didn't you?"

"Yup," I say.

Cindy looks carefully at me, then makes her stallion bow to the folders, then fixes her eyes on her most recent painting taped to the side wall.

"Show them your work?" Carol asks.

Cindy looks at all the walls.

"Tell them about A.R.T.?"

Cindy pushes up slowly, drawing Carol to take another step further.

"Get them to put the systems up so when you get down there you can paint?"

The cowgirl's eyebrows unfurl. She shouts. Looking again to the brochure, she turns her eyes to the paint-smeared phone.

"Call them?" Carol asks.

With Cindy's nod, and her look back to the phone, Carol looks my way.

"Now?" Carol asks, eyebrows raised.

The receptionist in Richmond does not know where to transfer my call.

"This is a what kind of program?" she asks.

"Art-making," I say.

"I'll transfer you to Recreation."

The person who answers tells me the director of recreation is not in today.

"I'll call again tomorrow. Thanks for your help." I place the receiver on its hook inside the plastic wall mount. Cindy slumps.

"Tomorrow, Cin. We'll try them again tomorrow."

Grounded solid in her plan to find a path home, her disappointment elicits stronger feelings from me than a person who cried.

"Don't worry, Cin. I have some good connections down there, in the art department, so when we get Virginia Home up and running, we can get you a good tracker."

The members of our revolutionary cell sit a little dispirited.

"See what I mean, you guys?" I ask.

"Tim," Eric speaks up.

"Yeah, Eric."

"I want to help you with your company."

"You are helping more than you can know, Eric. Your paintings are where our power comes from."

"But what if they don't get them? What if they don't get what we are doing?"

"The ones that get it, Eric, will help us talk the ones who don't into it."

"You think this thing is gonna ever really take off, JR?" I ask. Left knee up.

"You think so?"

Knee up.

"You sure?"

He holds his knee in the air.

"Well," I say. "Okay."

"Nat, do you want to save this color for next time?" Carol nods to a bowl of brown gel Natalia had used for the painting she is working on.

"Feed it to Chet," she says. "He will eat anything."

Chet writhes around, crazy as a guy who would eat paint. His gyrations crack us up.

Carol, who is always standing, leaning, reaching during all the classes, pulls up a chair to sit with us. A few minutes of calm, quiet, and I get up.

"We have to hit it. See you Monday, right?"

All the other painters on their way to bed, Natalia remains in 333 while we clean up. Her powerchair is in the shop. She is in a manual, her Liberator jury-rigged to it.

"You need a ride, Superstar?" I ask.

As I wheel her down the hall, she gets a funny, too fast computer voice version of the song "Blue Skies" to play from her Liberator.

"Blue skies, da da da doo, dahdoo, da da da doo, nothing but blue skies, from now on." The doors whizzing by, Nat throws her head back and lets out a peal of laughter.

"You're late," the stout PCA snarls. "You missed your shower."

"Put her against the wall," she orders me.

I sit on a chair in the center of the studio, my shirt off, a length of canvas draped over my shoulders. Carol snips artfully at my hair, with scissors that have one tip broken off. It is not a day we are scheduled to be at the school. In preparation for the visit from CBS, I have called a meeting with Eric, and Nat.

"Don't go off with the clothes," I warn Nat. "You dress up too wacky and they might not use you. Got it? Got any normal clothes?"

Nat sniggers, me telling *her* what to wear?

"I'm serious, Nat. Cool it for one day. Fine, laugh it up."

"Eric." Eric meets my serious look with his. "Thought about what you want to say?"

"Yup."

"You mind running through it for us?"

"They need," he says, "to ask me where Art comes from, my heart or my head. I say, 'my heart.' I make the paintings in my heart, not my head."

Carol whistles.

"It comes from my heart," Eric tells us again. "It does."

"You're too much, Corbin. You really are."

"I am?" His eyes widen.

"Yes, you are."

The two of us do an awkward, but effective, high five. And, of course, I say, "Nat is too much, too." Nat rolls her eyes.

The haircut complete, Carol and I stand on chairs to tape up the best of the recent unstretched paintings, the idea being that no matter where the camera aims, it will catch at least a part of the artists' work.

The morning of the shoot, the air above the peaceful valley is clean and cool. Carol and I cross the parking lot.

"We got company," Carol says without turning her head.

"Yeah?"

It is the PR girls from New York and the Matheny PR director, lying in wait for the guy they need to talk to. Carol takes the lead. She enters the building with such authority, the women back away and before they know what has happened, I am past them and halfway down the main hall.

"The crew is here," they cry, the three of them running to catch up with me. "Say Matheny!" they call out. "Don't forget! Say Matheny!"

In the unlit corridor I turn on them. "The most important thing is that all of you stay clear. This is the artists' day."

I step into the studio, and pull the door closed. In its narrow pane the PR women's faces one on top of the other, pressed against the glass.

"Hi, guys," I greet the painters.

"This is Wyatt." The producer, Jill Rosenbaum, introduces me to the nationally known correspondent.

"Hey there." He offers me his hand.

"This is Jim."

The tall cameraman nods our way. "Hey."

"Thanks for coming," I say. "This is Natalia Manning, Eric Corbin, James Rodkey—JR—and last but certainly not least, Michael Young. This is our tracker, Carol."

Jill steps back into the corner of the room, by the sink. She stands quietly with a pad of yellow-lined paper and a pen.

"Ready?" Wyatt asks the cameraman.

"Well, Natalie . . . ," Wyatt begins the interview.

Boop. "Natalia."

The cameraman takes his eye from the ocular and looks over at Wyatt. Jill touches her lips with the hand that holds the pen.

My jazzy little friend has not taken my advice. She wears tiger-striped toreador pants. On top of her hair, a large pink hair clip shaped like a scallop shell, the scallop shell emblazoned with a happy face, her fingernails: blue. "Natalia," Wyatt asks our little radical, "this is your painting? Can you tell us something about it?"

Tap, tap, tap. Boop. Boop, boop, boop. "It's not about words."

The cameraman takes his eye from the ocular again, to take in Wyatt's expression. Wyatt looks to Jill. Jill's eyes open wide as if to say, "Don't look at me!"

"What," the veteran correspondent asks Nat, "has being part of this program meant to you?"

Boop. "It lets me show who I really am."

With a pause in the questions, Carol preps the first canvas. Natalia taps at her Liberator. Boop boop boop. Boop. "We are very, very intelligent," she informs the crew. First at the board, Natalia chooses the laser, and creates huge triangles. One pointing adamantly down, the other adamantly up. Down and up as clear in contrast as Nat's own moods. On top and between, all over, in a flash of abandon, she whips ribbons of color like streamers at a party.

"What would you like to tell us about this process?" Wyatt asks me.

"They make every decision you would make if you were to paint. Their work is going to dismantle the misconceptions that hold them back."

His questions for me finished, I excuse myself to ease out of the room.

"What did you say?" the PR girls ask. "Did you say Matheny?"

"They didn't ask about Matheny."

"But did you mention it?"

"Hmmm." I hold my chin. "I don't think so."

Joining me in the hall, Carol beams.

"They done?" I ask our master tracker.

"No way." She shakes her giant ponytail.

"How did JR do?"

"Fine. Like any other superstar," she laughs.

A half hour later, the crew and the students emerge.

"We would like to shoot Eric after lunch in the boardroom," Jill says. Eric's big painting from Rutgers, "Something Inside Me," hangs there with six of the other large masterworks. Jill eyes her yellow pad. "We would also like to shoot their next show and one more day here at the school and maybe your studio, Tim." Jill offers me a page from her pad. "Here. This is my number in D.C."

The PR ladies, Carol, the crew, and I eat our lunch in the boardroom. Bob stalks in, refusing the chair the director of public relations offers him. His few words are slurred with anger—over, I would guess, our banning his PR people from the studio. Jill takes a nip at her sandwich, her pen held in her other hand.

Bob having stalked out, the director of public relations strikes up a chatty tone, revealing she does not know the students too well. Her intention is to get the crew interested in the school as a whole. Jill eyes Wyatt.

"Which of these is Eric's?" Wyatt asks, scanning the wall of seven-foot paintings.

"That one." I point to the pale shimmer of a barely touched field, fine lines lasered up from the bottom, exploratory reachings into a larger open space.

Jill, Carol, and I sit together at the forty-foot table. Wyatt, Jim, and the soundman set up in front of Eric's painting.

"Hey, Corbin," I greet Eric, sitting tentatively in the doorway.

"Hey, Tim," Eric says, moving cautiously along the long table.

Situated in front of his masterpiece, Eric watches the crew prepare to roll tape.

"Ready?" Wyatt asks.

"Yes," Eric says in a shy voice.

"Your painting," Wyatt says in his clear, sure voice, "is your way of reaching out?"

Eric's eyes light up. They bat once, then once more.

"Your way of showing us who you really are."

Eric's lips move without making a sound. "Yes!" he whispers. "Yes." His voice chokes. His eyes fill with tears. "Yes. Yes, yes, yes."

At the end of the day, in the intersection at the end of the main hall, Jill and Wyatt stand with Carol and me.

Jill smiles. "They are so great."

"Bob is ready for you. He has an opening in his schedule," the Matheny director of public relations interrupts our conversation. "He will meet you in his office."

When she is gone, Jill looks at Wyatt. "You want to do this?" Wyatt looks to a point on the ceiling, his lips pursed as if to whistle a tune.

Looking down at her pad, Jill wrinkles her nose. "What," she asks herself aloud, "do we need him for, really?"

For the two partners, it is a light moment; it is a funny moment for Carol and me, too. At the same time, it is critical in that it marks our first big break from the parochial grip of the school. As the school loses its control, the artists gain their freedom.

A month later Wyatt stands in the wide expanse of the Princeton gallery, in front of Eric's painting. "To connoisseurs of abstract art," he says into the lens of the camera, "this show is quite the rage."

Jill Rosenbaum, with her ever-present yellow-lined pad and pen in hand, stands with Carol and me. Across the gallery, Bob stands with the arts program director. The show already successful in terms of excitement and attendance, the artists roll in.

"Hey, Ms. Shanks," I greet Cindy, her short brown hair moussed back, wide shoulders drawn back.

Scanning the gallery, she gives her body a shake, then slumps in a pose that makes me laugh.

"Pretty neat, huh?"

"James Lane. Looking good tonight."

Nat flies by us, then brakes to a dead stop. She puts her chair in reverse at high speed, stopping quick; the front end of her chair whips around to face me. She wears a sexy-tight, red silk dress, with audacious plunging neckline. I cannot believe she got out of the school in that thing.

Seeing me in my get-up, gray pinstriped suit, silk tie, polished black wing-tip shoes, Nat's mouth and eyes pop wide open. She fake shrieks twice, then crumples as if she has fainted.

"Knock it off," I growl.

Her eyes pop back open, she blinks, then lets out another shriek before she whips around and darts into the crowd.

Leaping Chet Cheesman. "Yo yo yo, Chet! Think your mom's here somewhere."

JR is rolled by. He looks so excited, mischievous in his glee, his eyes blinking. Then, for me, a left knee up.

And the master, Eric Corbin. I do not say hello to Eric. There is no way I can pretend to approach the intensity of his desire, the power of his anticipation. The word is that his father will be here. I let him go by.

My happiness is for the artists. A feeling reserved inside is a frustration, mixed with hope that sooner or later one of these shows will result in more than a couple hours of excitement. I have noticed fewer and fewer dopey questions from attendees. I think the newspaper articles written about the program are having some effect, as well as word of mouth from the people who have attended the shows and gotten really excited. But still nothing has really happened, at least nothing tangible, from the shows, to move our plan to do outreach forward. We need someone or some group to join us, people who understand the critical need to reach the others who, like my class, are out there, day after day, night after night, with no means to emerge from emptiness and isolation. I hunger for the break we need. Tonight might be it.

The camera crew follows Nat. Setting up to take head-on shots of the work, they move to the area where Eric and his family are gathered. Behind Eric is the painting he had shown at Rutgers, "Something Inside Me." Next to it is new work, but because of the size of the gallery and the beauty of the earlier piece, we decided to show it here again. A good thing we did. With the Evening News camera purring, an attractive young woman steps forward to speak with Eric.

"I saw it," she refers to his painting, "at your Rutgers show. It is the only painting that ever made me cry."

"Really?" Eric asks.

"Yes. I would like to buy it."

No student at the school has ever made two thousand dollars, maybe not in a lifetime, much less for something they themselves created, something seen among all other things in our cultural life as High Art.

Eric's father, a shock of white hair and the bandy limbs of a man who worked outdoors, looks at the camera crew. He looks at the small crowd around the artist. He looks at the artist, his son.

I watch Eric with his family to see if there is joy on his face. There is not. When the young woman told him he had moved her, there was, but now there is none. He does not look unhappy, but at the same time he does not look fully satisfied. His father has said little to him. Stately, serious, and hardened to his father's inability to compliment him, he reclaims his composure.

"Heard you sold your painting." I poke him.

Looking to the seven-foot canvas, he gives me a strong smile.

"Two thousand smackers, Eric. That's some serious dough. You buyin' me a steak dinner or what?"

"I will, Tim," Eric laughs. "I will do that, really I will."

"Have you thought of what you will do with the money, I mean, for real?"

Eric considers.

"Maybe put it back into the program," he says.

The painters line up in a row of their own directly in front of the portable lectern. The crowd gathers behind them.

"Thank you for coming," I say into the microphone. "I was asked to give a little talk at the artists' last show. The next day in the studio I asked them, 'How'd I do?' They told me two things: talk less about yourself, and more about us."

The crowd bursts into laughter, accompanied by lots of loud clapping. A few great belly laughs. Writhing in their chairs, the artists shout.

The night the CBS piece airs, three friends and I sit around the TV. Up at the school every night at the same time, for as long as my class has lived there, the receptionist makes an announcement. "It is eight forty-five. In fifteen minutes, the doors will close, at which time, we ask that all visitors leave the building. At nine o'clock the doors will be locked." The locked doors will not hold the painters in tonight. Tonight, Eric will be in a dou-

blewide trailer in Nebraska, Cindy in a West Coast airport lounge, JR in a bar in say Baton Rouge, Natalia all over Manhattan, in Chicago, Topeka, Miami, Seattle, and Bangor, Maine. In every city, in every state, in every town, on every street in America, they and their paintings will be seen.

After the last set of commercials ends, the anchorman appears. "This is a special segment we call 'Eye on America: The Best of Us.' People overcoming the obstacles of life. For connoisseurs of abstract art," Wyatt tells us, "this show is quite the rage." The camera plays over the paintings, close-ups, the crowd.

"First, they notice the art. Then, they notice the artists." Yes. The camera captures the elation of the painter's faces. Taking the viewer into Room 333, the camera captures JR directing the laser. The viewer enters the boardroom, Eric answering one of Wyatt's questions with a tearful, "Yes, yes, yes!"

The final shot is of Nat at the height of the artists' opening reception; sitting in front of her huge, jazzy painting, streamers of color flying all around her. Her brash smile flashes: "I got a life, how about you?"

*T*he sky above the school is a high, fine blue. In the fields, dried cornstalk shafts—flaxen, honey, mallard-bill lean, stiff against the color of the earth. I stand by the car as Carol gets her stuff from the back seat. Held by the hard beauty of the stubblefields, I slip out of time for a second. A red-tailed hawk whistles from the treeline.

"I can't wait to see the painters," Carol laughs. "I imagine they will be pretty revved up. You know, being celebrities, and all."

"Oh yeah." I clap my hands, the sharp smack, resounding in

the icy air, hitting the metal cars, ricocheting off the brick of the school. The receptionist looks up at us then back down to her papers. To our left, in the polished hallway of the administration wing, Bob stands with the arts program director and the director of student services. They do not look happy. Halfway down the main hall two teachers, absorbed in conversation, walk our way, Carol and I stepping to one side to avoid running into them. The two, their conversation unbroken, turn left into a classroom.

The look in Natalia's eyes, as that in the eyes of her classmates, tells the story.

"Don't tell me you didn't see it," I say.

No response.

"Did you see it?"

Silence.

"Did you see it, Eric?"

"Nope." He shakes his head. "Ridiculous," he adds under his breath.

"What happened?" I ask. "Why didn't you see it?"

"Our ADLs," he says.

ADLs are the cleanups the students have after meals.

"I told them we were on TV," Eric says.

"But they did the ADLs and you missed it."

"Yup."

"All of you? Mike?"

Stony face.

"JR?"

No movement from his famous left knee.

"Cindy?"

Her chair swipes violently to crack into the wall next to her; her Virginia Home folders fly off her tray onto the floor.

"None of you," Carol says. She closes her eyes.

"Not to worry," I say, taking the little canvas pack off my shoulder. "I have a copy. Here." I pull the video from the pack. "Care to check it out?"

Looks of anticipation between the classmates. I step out of the studio to borrow one of the cart-mounted VCRs. Reorienting their chairs, the artists get as close as they can to the TV, Carol maneuvering Chet and JR for a clear line of sight.

"Everyone set?" I ask. "Ready? Superstars? It's show time!"

With respect that borders on awe, the anchorman introduces the piece. I watch them watching, seeing the filmed reception in full swing, their paintings flashing among the bodies of the crowd. Their paintings, and them, and more of them; their names announced, JR's knee snapping up to punctuate Wyatt's declaring how talented they are.

Rings full of keys, static sizzle-clack from the walkie-talkies on their belts, two men step into our room. Two of Bob's maintenance guys.

"You gotta get out of here," the taller of the two men says. "Now."

"The students won awards." The narrative on the video runs smooth and sure. "Galleries requested shows." The image — JR, arching back with the laser, fresh color ripping over his painting.

"I don't think they heard us," the taller man says, his voice louder than the TV.

The artists tense.

"Are they going to leave?" the director of student services asks from just outside the door.

The tape shows Eric, the narration running on, in the boardroom, in front of his beautiful painting, the one he sold at the show.

"You need to get your stuff out of here," the man says. "Today."

"Are they going?" the director asks again.

"Are you going?" the man asks.

With the pressure of my fingertip the TV clicks and the artists' celebration shrinks to a point of white light, then disappears.

"You going?" the man asks.

Adrenaline fires through my body. Its hot voltage makes my fingers twitch, barely restrained from their wild desire to make a fist. I stare into his eyes.

"No problem," I say.

His arms unfolded, he places his hands on his hips. "Good," he smiles.

Told where we are to relocate to, the men gone, I look around the room.

"Clue me in, if you would, Carol, to what just happened."

"Well . . ." She cocks her head, not yet able to absorb the humiliation.

"Well . . ." She tries again. "It appears he is a little more than unhappy."

"Bob?" I ask.

"Yeah. We stole his show."

"It mentioned Matheny."

"Barely."

"It said the name."

"In passing. It was about us, Tim. Not them. It was about us and what we want, not them and what they want."

"And he is angry enough to send his goons down to throw us out?"

"Apparently."

"You're right, Carol," Eric speaks up. "You're damn right."

"Why don't they like us?" I ask.

"You see the teachers chatting in the halls?"

"Yeah."

"How many times have we stopped to chat with them?"

"Never?"

"For them, paint on clothes is dirt."

"Dirt?"

Did the CBS crew come to their classes?

"No."

"You think they're enjoying the arrogant slobs getting the big spotlight?"

"Jealous," Nat's Liberator fires.

Carol and I laugh lightly with her unglossed summation, the painters cracking up with rowdier laughter. It is clear, in spite of the nasty interruption, that the three minutes they had seen of the CBS piece had made its mark. They look more cocky, in a militant way, than they do angry. Seeing the images of themselves on national TV hammered home that the high regard they felt for their achievement was grounded in fact. No one here had believed in them, but now they were news. The network anchorman called them "extraordinary." Their pride radiates, low and sure. When I smile at them, I get a set of wry smiles back.

"It's too late for them to stop us now," I say. "We're on our way."

"Say good-bye to 333," I say.

"Bye." Eric looks around the room.

The rolling cart overladen as in a peasant's retreat from warring armies, I push it down the hall, Mike, Nat, and Cindy ahead of me, Carol wheeling Chet with one hand, pulling JR along backward with the other. James and Eric use their pressure switches trying their best to keep up. We slowly make our way up the long hall that runs from the intersection to the cafeteria. Staff at the nurses' station we pass do not look up from their newspapers as the ragtag caravan rolls by. We roll through the cafeteria, past the TV room, up the hall to Lifeworks, which

is the intensive wing where JR lives, past the office of student services, left down a hall that borders the courtyard, right down a short hall of terracotta tiles. Chet's body leaps out over his tray, his head pointing the way. Bump bump bump bump. "Ah-ooo!" His howls bounce off the walls as we enter into a huge empty room they use as the gymnasium. A new tile floor laid down, the maintenance guys, including the two who had thrown us out of 333, are at work carting off the gray carpet they had ripped up. On the far side of the gym directly across from the terracotta hall is the door to our new room. Slaloming between her classmates, Natalia darts across the gym, stopping sharp in the doorway to the room; accelerating back out in reverse, she flies back to rejoin the head of our pack.

A recreational therapist uses the room as his work area. On the tables there are ceramic objects created at a factory from molds, a vase, a relish tray, a gingerbread house, Jesus on the cross, a handled drinking cup with a three-dimensional face, clay shoes sticking out the bottom. The floor is terracotta. A door at the back of the room opens onto a courtyard that has a raised wooden deck surrounded by four-foot sections of grass, dead from the winter cold. In the back corner of the room there is a kiln and in the corner next to it a desk, a chair, and a free-standing coat rack with a jacket on it. The tables are arranged to claim all the available floor space, so there is nowhere to put any of our stuff.

"They said we are supposed to share this room with you," I say.

The recreational therapist looks at me, looks away, blinking once or twice.

"It wasn't our idea," I tell him.

The supplies unloaded onto the gym floor, the painters gather around the pile, intrigued with the sum total of our junk in the center of such a giant empty room.

"Well, guys," I say, "what do you think of our new digs? We'll have a door onto the courtyard."

No one answers. The crew seems a little dreamy. In leaving our home, we have been set adrift. Adrift, but not lost, all of us still together, clinging, as it were, to each other and our raft of supplies.

"You're gonna have to move this crap," the maintenance guy who had thrown us out of 333 informs me.

The painters' eyes hold me steady.

"We have to hang in there," Eric says.

"Yup," I say. "Just a little while longer. We're almost there."

"Work," Natalia declares.

Massaging my forehead with my fingers, I laugh to myself, then get up.

"Yes, ma'am. Time to get back to work."

In the room we are to share, gaps between the tables could be closed to create a square of open floor by the wall of glass and the glass door to the courtyard.

"Take an end." I invite an unhappy Carol to help me move the nearest table, loaded with gift shop figurines.

"Don't move any of that," the rec therapist instructs us from the doorway. With him stands Mister Ring Full of Keys, custodial militiaman for Bob, far across the school.

"They told us we're going to be sharing this room with you," I say.

"You can move that table, if you have to," the therapist says, "but do not touch the others. I want them left right where they are."

In the small area of floor we open up, Carol and I re-pile our pile.

"This here's a fire door," Mr. Ring Full of Keys informs us. "You can't have nothing in front of or even near a fire door."

"Looks," Carol says quietly, "like Bob's called in the dogs."

"Think he wants us out?"

"I don't know. Maybe it's just his way of letting us know who's boss."

Bumping and clicking, the artists direct their chairs to find space in the room that will be our new studio.

Brown velour rugby shirt, tight curls cut close along the sides of his head, sanguine in the swirl of this emotional day, James Lane is first to the board. Outside the glass door, low snow clouds have moved in. Wind presses through the bare trees in the courtyard. Choosing a large canvas, nearly square, James creates a beautiful mixture of metallic and pastel colors for his ground-coat. Guiding the straightedge, a triangle appears in the center of the pastel field. Two shades of finely brushed blue. A second triangle, taped off, will connect the two, to create a pyramid. In this taped-off section, James directs a new technique we call flicker, where Carol dips her fingertips into a bowl of watery color, then flicks them at the area of canvas James points to with the laser. He controls the distance and angle of Carol's hand in relation to the canvas. With multiple applications of five or six flicked metallic and iridescent colors, the area glimmers. Tape removed, the magic pyramid floats in the center of the pastel field.

"Nice," I say. "Done?"

"Nee."

James directs the straightedge to create a rectangle, the same shape as the canvas. It cordons off the pyramid with masking tape. He calls for a mixture of rose, with a little silver added.

"Do you want this transparent?" Carol asks.

"Nee."

"Opaque?"

"Yee." James nods an inch.

"Over the whole area?"

"Yee."

"You know you are going to lose this." Carol runs her finger around the pyramid.

"Yee."

The rose square painted in, the tape removed, Carol tosses the paint-smeared masking tape in the trashcan.

"What's next?" she asks.

"Nee."

"Done?"

"Yee," he says. Carol looks at the painting, so apparently simple, the magic we know is there hidden from the eyes of the uninitiated.

"Wow," I say. "Way radical, Lane." I shake my head with appreciation.

"What do you think, Nat?" Carol asks.

"Very cool."

After lunch, Carol, JR, Cin, Chet, Mike, James, and I gather at the entrance to the gym. I run my finger over a thick layer of shining wet, pasty wax; the entire expanse of floor is coated, the room we need to get to separated from us by fifty feet of the glossy slime.

"They could have put this on at four, when we break for dinner," I say.

"Come on!" Carol snorts. "You think they consider the students when they do things?"

"We'll have to go around through the courtyard," I say.

In spite of the blowing snow, the howling wind, JR's elfin eyes spark a little jig, then shoot up to say yes.

"I hate to break it to you two," Carol informs us, "but the door to the courtyard doesn't open from the outside."

The front wheels of Cindy's big chair sweep this way then that with her frustration. I imagine what it must be like for her having only a couple hours a week to work on her paintings. The

lost tribe sits stymied, the school having, one way or the other, managed to shut us down.

"Tim."

A voice comes from across the shining sea. "Tim."

"Eric. Is that you?" I call out.

"Yes."

Eric's voice echoes in the empty gym.

"Where are you?"

"In here."

"In the studio?"

"Yes."

"You're in the studio?" I ask, widening my eyes to Carol. "How did you get there?" I call.

"I came across," he says.

"You came across?"

"Yes."

"I had to get here," he moans. "I swear to God, Tim. I have to get to my painting, don't I?"

"Damn straight, Corbin."

"Alley oop!" Cindy lets loose a whoop. Mike jockeys around to stop at the edge of the wet wax floor.

"What do you think, Cheesman?" I ask.

Chet dives out over his tray, holding his body as a headfirst battering ram.

"All right," I say, placing my hands on my hips. "Let's do it."

Half an hour later, the artists settled in with Eric working at the board, we hear the maintenance boys go crazy. "You see this shit?" Mr. Ring of Keys shouts from the doorway to the gym directly opposite the open door to our studio, the footprints, the imprints of the wheelchairs, leading from them to us. "You see this goddamn shit?" he screams.

The students look scared as the great buffers roar, slow and

shaky, into the gym. When a path of properly buffed floor reaches our studio, Ring of Keys attacks.

"What the hell you think you're doing here?" he shouts. "Who the hell do you think you are?"

Even the boldest, Cindy and Mike, cringe.

"What's the problem?" I ask.

"The problem?" Ring of Keys' voice cracks. "The problem? Are you trying to fuck with me, mister? You just ruined our floor."

"Let's see the tracks," I say, pretty sure they had all been buffed out.

"What did you say?" Ring of Keys hisses.

"This is their school, not yours!" Carol shouts. "This is *their* home," she says more quietly, her eyes filling with tears, "not yours."

Drawing herself to her full five-foot-eleven inches, in her rainbow-smeared white bib overalls she looks like she is about to walk toward the skinny man.

Ring of Keys takes a step back toward the door.

"I'm going to have to write you up," he says.

"You do that, buddy-boy. You do that."

"I'm taking this to Bob," the receding voice calls from the gym.

"Run to mommy," I say, more or less under my breath, no hope of him hearing anything but the loudest shout.

Mike chokes. His head falls back, and he cracks up. JR's left knee shoots up, a burble of laughter rising from his body like bubbles from a water cooler.

"You liking all this?" I ask.

Big knee up.

"I don't think it's funny." Carol glares at the wall. "It's a war. It's turning into a war."

"You hear that, JR?" I ask.

His knee shoots up, his eyes still laughing.

"You started this whole thing, Corbin." I point at him. "Are you maybe, feeling a little scared, right about now?"

"No, Tim," he says.

"Eric," Carol nods to the large fresh canvas pinned to the board. "Let's rock."

*T*he following Monday, color charts, brushes, rolls of tape, and our gallon pails of paint lie strewn in the center of the studio floor. The six-foot rolls of canvas rest on the pile, tossed like logs on a fire. One of the pails, on its side, exudes a pool of red liquid acrylic, now congealed.

Carol blinks. "Nice," she whispers. "Where's the gel?" she asks, looking around the room. "And where"—she feigns innocent curiosity—"do you think our box of brand new custom colors could have gotten off to?"

"Guess you were right about that war."

"This really stinks," she says under her breath. Her arms fall to her sides. "I have to tell you, Tim. I think I have just about had it with this place."

"You talking about calling it?"

Carol looks away.

"What about your buddy JR?" I ask. "What about the painters?"

She stares at the floor, then looks at me. "They'll have to gut it out, until we come back on our own terms, as A.R.T."

"We'll wait him out."

"Who? Bob?" she asks. "That could be a while. It could be years before he goes."

"I have a real big show I'm working on. Stick around at least 'til then."

"Hmmmm," Carol breathes out.

"It's too late for them to stop us."

"You think so?"

"Yeah. That's what this is all about." I nod to the supplies on the floor.

"I'm going to go look for JR," she says.

"Okay. I'll work on this."

When Carol returns with JR, she pulls up a chair. He has rarely seen her sit. His eyes fix on her.

The winter clouds are dark and low. Gusts of frigid air bump against the wall of glass. The three of us sit quietly.

"Carol tell you they stole our stuff, JR?" I ask in a voice sharp enough to break the vacant feeling that hangs in the studio.

Knee up.

"Chet says they hate us, and I guess for whatever reason, they do. They want to drive us out, and sometimes, it gets pretty tempting. But we're going to hang in there, right, Carol?"

Carol breathes in.

JR has not taken his eyes off her. His work with us, his being able to paint, makes the difference between him having and not having a life. Always impressed by the elation he radiates arriving at the studio, Carol and I had recently talked with him about how he feels about painting.

"Do you think about painting during the week?" we asked.

"Yes."

"Every day?"

"Yes."

"You think about what you're going to do?"

"No."

"You don't?"

"No."

"You have no idea what you are going to do when you start to paint?"

"No."

"But you think about it all week?"

"Yes."

"Is the thing you like that you don't know what's going to happen?"

"Yes. Yes. Yes."

Carol reaches out, and draws him closer to us. "Hi Nat, Hi Cin," she greets the young women in the doorway.

"What's wrong with Carol?" Nat asks me with her eyes. If there is trouble for us, there is trouble for them.

"Hey, Eric," I say.

He looks at us without speaking, then drives his chair over to park next to JR, the little circle now complete. After a minute of silence, Cindy makes a gentle attempt at conversation. She lowers her face to her tray, then up to me.

Reaching out, I tap the Virginia Home folders on her tray.

"We haven't forgotten, Cin. We sent them all our stuff."

No one says anything for another minute. The fury of the snowstorm just outside the wall of glass gives our little circle a feeling of our being both lost, and close.

"Have a minute?" the arts program director asks.

"Sure," I say. "What's up?"

"Perhaps," she suggests, "we should talk in my office."

"See you in a bit." I give the artists a thumbs-up.

The light fixtures on the ceiling of the arts director's office, fluorescent tubes encased in milky plastic, buzz and hum. She pulls the hollow-core wood veneer door closed.

"Have a seat," she nods to a vinyl-padded rolling office chair. She looks at me, then at a pile of papers on her desk; she breathes in, then out.

"I understand from Bob you are going to be the subject of another television interview."

"It's not an interview," I tell her. "It's a cable news station that wants to feature our class."

"Bob does not want you to go ahead with this. He said if you do, you're through. And that I was not to tell you he and I had talked."

"Kind of like a trap?" I ask.

She says nothing.

"Why," I ask, "should we be held back by this guy?"

"Why," she asks, "should he give up his power?"

"Give up his power?" I make a face. "First of all, the power isn't his. Do you think it is right his keeping this thing up here like some cow to be milked when there are all these other people out there who need what we have?"

"Couldn't you go ahead with the interview this time without mentioning A.R.T.?"

"No."

The director winces, as if she had sat on a pin. Looking absently at her desk, she moves some of the papers. "You won't," she asks, "reconsider this time, wait a little while longer before you . . ."

"No."

"Do you realize how this might set you back, how much better it might be for you if you lay back, just for a little while longer, let things sort themselves out."

"No. Things will never sort themselves out between Bob and A.R.T."

The director steadies her eyes on mine.

What now? I grimace.

"The school," she says, "is using A.R.T. in its grant proposals."

"What do you mean?"

"The foundation they applied to asked, why, if the arts program was so effective, the school did not do outreach."

"And?"

"They told them we do outreach, through you."

I get up, open the door, step out, and pull it shut.

"What happened?" Carol asks.

"Don't ask."

"You okay?"

I look at her, then pull up a five-gallon pail and sit down next to JR.

Both elfin and anxious, his eyes sparkle a little jig. They say: "I am with you all the way" and "Do not leave. Do not leave me."

"You ever feel like telling someone off, JR?"

He blinks a few times with his remembering, then raises his left knee.

"Yeah? Really? You want to tell someone off?"

JR sees the fun behind my harsh tone.

Eyes wide, he gives the left knee a sharp snap.

"May I?" I nod to the unit on the back of his chair that will allow him to fire a short, recorded message.

Hissing the insult into the recorder, I turn the volume up to max, then step back to face him. The painters watch, pleased to see the mopey mood replaced with some fun.

"Well, Jimmy." I strike a patronizing pose, "Have you been a good little boy today? Hmmmm? Have you?"

Arching back, he triggers the switch.

"Why don't you kiss my ass?"

His classmates burst out laughing: gasps, shouts, and a general pandemonium of rowdy celebration. In the spirit of boldness that has been a hallmark of our crazy family, Chet makes loud, wet, kissing sounds.

"Come on, Chet." I give him a look. "That's gross."

Nat's clear appreciation encourages him to make a few more smooches. Everyone laughs. From the boom box on Nat's tray the thunder beat of a dance club tune pounds the air. Eyes bright, the center of our attention, Natalia holds her right forearm up, the elbow cupped in her other hand. She does a little

cha-cha move: right, left, right right right; cha, cha, cha-cha-cha.

Her eyes linked with Nat's, a big smile on her face, Carol gets to her feet.

"It's party time!" she declares. The dance move she does raises a wild cheer from the artists.

"How is the show?" Eric asks, suddenly serious in the midst of all the fun and noise.

"I'm working on it."

"Is it, you know, in New York?"

"As a matter of fact, Eric, it is."

"When is it going to be?"

"We don't have a firm commitment yet. I'm working on it. Let's just put it this way, Eric. If we get it, there'll be no stopping us."

"We don't have that much time, Tim."

"I know, Eric." I hold up my hands. "I'm doing the best I can!"

Seeing the twinge of hurt register in his eyes, I feel a twinge myself. "You're right, Eric," I say quietly, the noise in the room lowering to silence. "It's kind of like a race now. We need to get this show before they drive us out. This show being in New York, there will be lots of people who will really get how important what we're doing is. I'm talking about people with serious, serious clout. People who, when they understand the stuff you all put up with here, will help us straighten things out."

A PCA pushes between the wheelchairs. Standing over Nat, the woman places her hands on her hips, then reaches down and turns the music off.

"You missed your shower again. Where were you?" the stout woman barks. "I want an answer! What do you have to say for yourself? Well? Well? What do you have to say to me?"

"Why," a voice from behind the woman suggests, "don't you kiss my ass?"

When she spins around, JR looks up at her.

"Who said that?" his eyes ask.

The moment the woman tromps out of the studio, the maniacs erupt, JR's expression unbearably deadpan, his quizzical glasses half off his face.

As we speed on the great arcing stretch of highway, the island kingdom of tall buildings across the river revolves. Catching the sun, a hundred thousand panes of skyscraper glass flash in unison—the city's dynamic wink to me: "Come on!" Showing their work in this city was the highest mark Eric could set for himself and his classmates. It is a very high mark, but one that, once his confidence had been freed to emerge, he had no doubt he and his classmates deserved.

The toll paid, crazy talk radio blaring from the booth, we lower into the dark that runs beneath the river. A few minutes of humming tires and flying fluorescent tubes, and the car emerges into the natural light of a different country. The promised land of Eric's artistic dream. Manhattan. The place where art is Art. Two hundred languages being spoken, the crowds run on caffeine, carbon monoxide, work, and crazy ambitions the city encourages with the cumulative human energy of a great electric grid. A supermodel crosses the avenue with new immigrants. This is a city that encourages the underdog and outsider as valuable messengers of change. Conformity is not the goal. This is not the Matheny School and Hospital.

Sylvia, little tiger of the A.R.T. office, and I had been in touch with the gallery for a long time. After many phone calls,

spaced months apart, and mailings of additional support materials the gallery requested, I had been invited in for a face-to-face meeting. Block after changing block, making our way uptown, vendor's carts, limousines. Hopeful, anxious, I savor the moment. It is not every day that a dream is realized. This is it.

The building I am looking for appears. Standing out from the others, far taller. Its top floor is the gallery.

"Give me an hour, then cruise back every half hour," I tell my driver.

"Screw you."

"Why do you have to say screw you?" I ask.

"I'm not your slave," Angel reminds me.

"Just be here in an hour. Okay?"

"Yo," he calls out the car window. "Buena suerte."

"Yeah."

Revolving doors feed me into the lobby. The urbane receptionist points me to the bank of elevators.

As I step off at the penthouse floor, a woman is there to meet me. Red suit jacket, black collar. I'm struck by the way she speaks as we walk. Such crisp, intelligent, enthusiastic acceptance.

"I saw the work," she says. "It knocked me out."

At the door to the director's sun-filled office, the woman stops.

"Mr. Lefens is here."

The director gets up from his desk, and comes around to offer me his hand.

"Let me show you the gallery," he says.

Tall windows look out over the city, to the west, north, east, and south. The walls are white.

"They receive a fresh coat between shows," the director says. "The opening would be catered, a full wait and floor staff. We take care of the insurance and transportation."

He describes how a staff of white-gloved art handlers hang the work.

"For each show," he says, "we create a full-color catalogue of the artists' work."

I know the cost of making a catalogue like the one he shows me. Ten grand. Wait until I tell Eric. I told him if we got this show, it would be big. The director invites me to take a seat at a round glass table in his office.

"This is Mister So-and-So." He introduces me to a man with unruly hair, adviser to the director in this final stage of the decision-making process. All of us seated at the sun-bright glass table, the adviser holds the transparent plastic sheet of slides of the artists' most recent work up to the light. Without looking at him directly, I see his eyes narrow in serious consideration.

Rejected: we fall back into the arms of the school. Accepted: we find powerful new allies, able to lift the artists high. The window I look out faces west. The Hudson River, beyond it: New Jersey. I think of the class, and picture what they might be doing right now, there, on that hill, inside the school. It is a long, long, way from there to here. From here, in easy walking distance: the Metropolitan Museum of Art, the Guggenheim Museum, the Whitney Museum, the Frick Collection, and the Museum of Modern Art. This is where we are. This is where the artists will be if we close this deal. The man with the unruly hair picks up the second sheet of slides. Far below on the street, a siren's wail rises and falls. A bead of sweat moves down my back. We have done everything we can to make this thing happen. It is all up to this guy. All he has to do, is say yes. And finally, he does.

In the massive shafts of afternoon sun that claim the cross streets, waiters move about the crowded cafés, subways rumble beneath the sidewalk. A mounted policeman with a robin's-egg-blue helmet. Pigeons fly up as people cross the intersection.

*

Carol had told the artists why I had not been at any of the earlier classes. She had told them the details about the gallery, and how we would probably know what was what, when I got back after their dinner. So they are all here. They sit, keen with anticipation, none of them, including Eric, daring to ask me any questions.

"Good to see all of you," I say evenly, then take the time to drink in each set of the eyes I know so well. I look out at the courtyard, then back to the artists, then lace my fingers behind my neck.

"We got the show," I say.

The painters cheer. Eric rests his head back against the padded neck brace. His eyes sparkle. His eyelids bat the way they have before the few times I have seen him cry.

"You guys ready for the big time?" I ask.

"We're ready!" Eric calls out over the painter's cheering. "We're ready!"

*C*arol and I drive up the hill.

"Heard that woman who was in our studio, talking with the arts director," Carol says quietly.

"What's up?"

"She isn't a volunteer. The arts director hired her."

"She did."

"Yes. Really."

The perky recent college graduate, frothing with her degree in art therapy, had sat in on a few of our classes. She had taken notes, and asked if she might shoot some video. We discovered a crude painting on the board, when we had come in the following Monday morning.

"They're getting ready to replace us," Carol says.

"I thought the arts director was our friend."

"She's one of *them*," Carol says. "We're going to get bumped."

The car pulls off the road beneath the trees that run along the back of the school.

On the other side of the road, Natalia waits for us, sunlight lowering onto her through an ocean of green leaves that swish back and forth in the balmy breeze; the air fresh, with the clean smell of new plant growth, and warming earth.

"Hey, Nat," I call from the car.

"How are you?" she asks.

"Good, and you?"

She in her little high-tech wheelchair, her hair cropped short, dyed some outrageous new shade of orange, me in my painted clothes, the little canvas knapsack on my shoulder; we pause outside the glass door.

"When you moving out?" I ask.

"Soon."

"You ready?"

"Scary."

"Any second thoughts?"

"No." She shakes her head.

"I didn't think so. Got a call from some housing group. They said you gave them my name as a reference."

"What," Nat asks, now quite serious, "did you say?"

"Not to worry, Nat. When they asked if you smoked, I said, 'only crack.'"

Nat screams her fake scream, then laughs.

"I don't get what's so funny, Nat. I wasn't supposed to tell them that?"

Natalia lets loose another scream.

"I told them all good things," I assure her. "Ran them up and down with all your achievements, told them you are the kind of a person I would like to have as a neighbor. That's the only part

I had to stretch. I didn't tell them about the wild parties you will have. You know, with the music cranked really freaking loud, all kind of weirdo artist types hanging out at all hours of the night."

"Thank you."

"Not a problem, Superstar." I pull open the glass door.

Nat scoots up the slight incline, into the building, then stops.

"Good-bye," she says.

"Where you going? Not going to paint?"

"Thank you," she says. Flooring it, she accelerates away down the long hall.

"Bye, Nat," I call after her speeding figure.

With Carol on her way down to Lifeworks to get JR, I hunker down against the wall next to the back door. When Cindy sees me, she drives over.

"Hey, Cin. How you doin'?"

She bows, then nods. "Good."

"All right." I smile, then reach out to tap the folders on her laptray. "You heard we paid a little visit to the Virginia Home?"

She freezes. When she finally allows her eyes to open, I give her a nod.

"Yeah. Carol and I flew on down there. Turned out pretty good. A bunch of good new painters down there. And you know, Cin," I hold her eyes with mine, "it was *you* who made it happen."

Eric concentrates so hard at his pressure switches, he is a few feet past us before he stops. He looks back.

"Hey, Tim."

"Hey, Eric."

Carol pushes JR up to join us, the crew of friends tucked in together, close, to allow traffic to move around us.

"Hi, Eric," she greets him. "How are things with your girl-friend?"

We had seen him, sitting with a young woman in the court-yard. She sat in a wheelchair, but unlike Eric, she had the full use of her hands. She fitted a straw in the can of Pepsi she had placed on Eric's tray.

"How do you like it so far?" Carol asks.

Eric blushes, but does not look away.

Mike maneuvers between the wheelchairs to give me a shove.

"Cool it, dude," I tell him.

This gets me a harder ram. Pressing his joystick back toward him, he rolls backward, laughing. Inhaling a big breath, he glides back to press his chair into me again, lightly this time, re-maining there, easy, relaxed, in my face, Cindy to my left, JR on my right, Eric next to Mike and facing me. I listen to their breathing. When we first met, some of the painters seemed not to breathe. They sat stiff, then would, unexpectedly, gasp for air. All the breathing around me is steady, easy, even, relaxed. I lean, hunkered against the wall. The low window behind me lets dif-fused morning light from the courtyard illuminate Eric and Mike's faces. It falls over Cindy and JR's head, and shoulders, catching her laptray, his legs and sneakers. Cindy reaches out to place her hand on my shoulder.

"I have been looking at those magnificent paintings in the gym," our friend the doctor says.

All the paintings that were being shipped to the New York show were stretched and framed and leaning against the walls.

"I especially like that one with the turquoise, and yellow," the doctor says.

"That's Eric's." I jerk my head to the artist.

"I must say, Eric"—the doctor looks grave—"it's really beautiful."

"Yeah," Eric exhales. "It's the style that made me famous."

All of us bust up laughing. All of us, that is, except Eric. He remains cool and confident amid the hooting, no sign of a smile on his lips but perhaps a hint of one in his eyes.

"I'll see you at the show," the doctor says. "Nice work. Very nice. See you all there?" he asks, then continues down the hall.

"Tim," Eric says. "My family is taking a limo to the show. I want to ride in the limo."

"You know what that would mean, Eric? You'd have to use a manual chair, one you could fold, you know, to get it in the car. You wouldn't be able to take your power chair. You want to be up there without your power chair?"

Eric considers.

"Someday when you're rich," I say, "you can buy your own limo."

"Tim." Eric smiles.

"Yeah."

"I'm already rich." His smile widens. His eyebrows go up. "I am, Tim. If you think about it."

Ring of Keys, the director of student services, and the arts program director round the corner. Mission-oriented, they stride past us, no acknowledgment of their seeing us. They saw us. They saw the people who were getting a little too full of themselves. The New York gallery director had come out to look at the work. Eric met him at the school's front doors, in a button-down white shirt and tie. The two had made their way down the long halls to the studio, administrators and teachers looking on.

"Let's head for the studio," I say.

When all the painters have themselves situated, I wave my hands to get their attention.

"People. We need everyone, and I mean everyone, that is if you intend to title your work, to take the next half hour or so to

cruise the gym with Carol. I'm sure you are dying to check them out. They look hot."

Bright eyes, the artists bristle with excitement.

"Get this, you all. The gallery says it can handle a couple hundred people, and we have already had RSVPs from almost twice that many. We have RSVPs from people from at least nine or ten different states."

"You're kidding!" Eric says.

"Would I kid you, Corbin?" I continue, "There will be all kinds of powerhouses coming. Big wigs, and heavy hitters. Rich people, artists, other gallery owners, executives, people from CNN, and ABC, a documentary film-maker, not to mention all my and Carol's friends."

The painters rustle, then twist to catch each other's eyes.

"More important than all that," I call over the growing noise of the artists' excitement, "Cindy, your parents are coming up from Virginia."

"Alley oop!" Our cowgirl lets loose a whoop. She pushes up the back of her big chrome chair, her smile showing her white teeth.

"And your mom, Chet. Your whole family, Eric. Your parents, JR, are driving up a day early from Maryland."

Sunlight filtered through the green leaves, stills on the wall of glass. With a gust of fresh air, the pattern shakes; fingertips of light play over the artists.

Ring of Keys pushes between the wheelchairs. He yanks the door to the courtyard shut, selects one of his tethered keys, and brings it up to the little black box that will sound an alarm if the door is opened. The unit is programmed to emit a shrill chirp when it is turned on. What Ring of Keys does not know is that the unit is dead. We learned to kill its batteries by leaving it on while we were at lunch.

I flash a look to JR, then to my watch. The last three weeks, his timing has been impeccable.

As Ring Full turns the key, JR arches back to ignite the recorded sound of the chirp.

Chirp!

Everyone laughs. I have never seen Carol laugh so hard. Ring of Keys, still unaware of the game he is part of, takes the key from the unit, and wedges his way out of the room.

"Okay. Let's get it on," I call over the noise. "Chet's getting his picture taken for an article that will be coming out to announce the show. We have to knock out the photo op, then we'll join you back here. You ready, Cheesman?"

Chet makes a crazy face, then gives a jaunty nod to his classmates.

With Chet arranged in front of his huge painting, the photographer positions himself for the shot. He aims the camera at Chet, but does not trigger the shutter. He looks over the camera at his subject, then returns his eye to the viewfinder, no sound of the shutter's clack. He steps to one side, lowers to a crouch, aims the camera, but does not shoot. He gets up, walks over to me, and leans to speak in my ear.

"Is it possible that every time I am set to shoot he is sticking his tongue out at me?"

The artists, and Carol, clipboard and pen in hand, move in stately, single-file promenade, from one of their stunning new paintings to the next; I hear Carol work the alphabet board for those artists who want to name their paintings but do not have Liberators: The tip of her pen rides over the letters, stopping when she gets the signal. "Push Not." "A Bear." "I See You Empty." "Casino." "Crazy." "Sun Hiding the Moon." When this final business is taken care of, the painters and Carol, who has snagged Chet from his photo session, reenter the studio. Cindy

remains with me. I notice Bob and the arts program director standing together, fifty feet away, at the entrance to the gym.

They speak with each other, then look my way as if they might be about to come over with something to say. From the studio, a sea of sounds grows loud with laughter: warm with friendship, intoxicated with anticipation for their big night in the city.

Bob says something to the arts program director, and both turn and walk away, back down the terracotta hall. When the sound of their hard shoes fades, I take in a long breath, then turn to Cindy. She is quaking with excitement. Her high cheekbones flushed, she takes quick breaths, her happiness almost too much for her to handle.

"You ready for the big city, Cin?" I ask.

She inhales a huge gulp of air, shuts her eyes, and holds them closed tight.

"Imagine, Cin," I whisper, "we're on the street. The night of your show." Her eyes open, then narrow like mine, a smile appearing with the fiery glint of her picturing the scene.

"Shall we?" I ask.

Her big chrome chair revolves, and together we move across the shining floor. When I stop, she stops. I hold open an imaginary door. Cindy passes through, and stops to wait for me. We turn this way, walking, gliding, and then that.

"Our elevator," I say.

She rolls forward four feet, and stops.

"The penthouse?" I ask.

She bows.

"I hear there is an important show of paintings. You are one of the artists?"

No hint of a smile, Cindy nods once. "Yes."

Pressing the button, I count the floors as we rise. "I imagine

everyone will be here tonight," I say quietly. "Your whole family."

Cindy lifts her chin, draws back her shoulders. Her eyes trained straight ahead, she sits back, comfortable, poised for the door to open.

Epilogue

As I stepped off the elevator into the penthouse gallery, the giant freight elevator opened, and there they were: the whole pack, the painters, a humming bomb about to go off.

Among the capacity crowd of art mavens, execu-cats, and jet-set socialites, waiters leaned to offer the painters hors d'oeuvres from silver trays. The parents, a little stunned, stood by their children, the artists' smiles radiant. The lights of the tall buildings glittered like stars outside all the windows.

In the din of excited conversation, the paintings were selling. The entire show sold out. JR's seven-foot, eighty-pound chrome painting he had named "A Bear" was purchased by a Disney executive, who would have it shipped to his home in California. An art collector claimed two. On a quiet, separate wall, one of Chet's very first wheel paintings hung as a reminder to us how it had all begun. The full-color catalogue of their work came out beautifully.

After the show in New York, Carol, exhausted with the school, stayed on long enough to train our new tracker, Mary Beth. The two worked side by side. Two boards, two paintings, two painters, doubling the energy and the fun. Mary Beth took

the baton and ran with it. An absolute natural, she had a clean, crystal-clear connection with all the painters. It is a beautiful thing to watch her work. The bad part for her is that she joined us when the school had made its final determination to drive us out. One night, after the last class was over, I lay on a platform in the far corner of the dark gym as she rinsed her brushes. Eyes closed, I became aware of violent shouting. Not an argument, but someone screaming at someone who is saying nothing. It was Ring of Keys, screeching, frenzied, at the quiet, selfless Mary Beth. She was shaking. As Carol had said, "enough was enough." It was time to go. In a last-gasp attempt to fend off the inevitable, I wrote a proposal to be submitted to the president of the school. They would formally recognize A.R.T., and agree to a set of terms that would allow us to operate without interference. I discussed the proposal with the artists.

"If I go down there, and it doesn't go well, that will be the end," I said. "You all understand that?" Dead serious, they showed me they did.

"Should I go down there, or not?" I asked, looking from face to face. Poised with emotion, they released me.

While I was in the president's office, Mary Beth waited on a bench by the school's front doors. Cindy wheeled back and forth in front of the closed door of the office where I sat. My offer was rejected. Stepping out of the building I felt anger, relief, exhaustion, and an indescribable sadness. For a long, long time I thought about the painters, every day. In the end, it was one of those brutal things that *was* actually for the best. The clean break freed us to concentrate all our energies on establishing new programs, reaching new painters who had never had the chance to assert themselves as the original crew had. There was a whole country to reach. A whole world.

A.R.T. has started programs at six new schools. The odd ma-

levolence we experienced at Matheny is proving the exception to the rule. The staff at the new schools embrace us with warmth and enthusiasm. The maintenance guys sit with us to plan how to create the best storage racks, the best lighting. The PCAs wheel the artists in with a flurry of greetings. Staff drop in to watch the process, asking questions, complimenting the students in tones of honest admiration. It is such a big change for us. Such a pleasure. Such a relief. The new artists are really great. An unbelievably fun thing for the trackers is working with the little kids: four, five, six years old. They are the best. Wild with energy, one miniature artist, turned on by her drive to paint, said her first word for us. The first of many: laser. This had us whooping and clapping in celebration, the little artist amazed at herself, her teacher wide-eyed.

The A.R.T. artists met with New Jersey governor Christie Todd Whitman. She spent a good part of her morning with them, resting on one knee, to speak quietly, privately, with each of them in turn.

A Japanese health foundation sent a group of seventeen people to see our program.

"Who are you?" a curious student asked.

"We are from Jah-pahn," the gentleman in the suit informed her with great calm and courtesy.

"Do you know Godzilla?" she asked.

They observed the painters at work, pocket camera flashes popping, some so moved they drew up close, got on their knees to look more closely at the fresh paintings laid out on the floor. A.R.T. has gotten support from people in the arts. The Pulitzer Prize–winning author John McPhee not only helped kick-start my writing this book, but joined the A.R.T. board of trustees. The actor Willem Dafoe joined. He carried slides of the A.R.T.

painters' work to galleries in Soho. We have a constellation of expert advisers in the fields of technology, business, art, health, and education.

We are working on some new tools, with a remarkable designer/fabricator from Philadelphia.

The Flying Eye permits artists to direct the motion of a video camera, bringing them the power to explore the world beyond the limits of their wheelchairs. Monitoring the wireless image from a TV on her laptray, an artist can signal when an image should be captured as a still, to be printed out later. Photography.

The A.R.T. C3D is a high-tech sculpture stand that artists can raise, lower, and rotate. It lets them see their sculptural work in progress from every vantage, in three dimensions.

And there's music. The latest breakthrough piece of gear is called the A.R.T. Lassy—the Light-Actuated SYnthesizer. It is a wall-mounted ring of photo-receptors, each receptor wired to a key on the synthesizer. To play a series of notes, the immobile artist simply looks at the target for the note they want to sound; the head-mounted laser beam reaches out to activate the musical note just as a finger reaches out to touch a piano key. Two separate racks of targets control an infinite variation of rhythms and a selection of seventy-five musical instruments.

Writing this book, conceived as a path to reach more people than the paintings could, was no walk in the park. I kept notes during the years with the artists of 333, so I had the story, but writing a book was a whole different thing. I naturally think in an "abstract" fashion, and jumping from the essential singleness of painting to linear, nonfiction narrative was a real leap for my brain. I found myself finishing drafts with the sun coming up, unaware of time having passed, emotions running strong from the reliving of a certain scene, in an uncertain time.

The students changed my life. They taught me to value, and

to accept, kindness. They made me laugh, so hard, so many times.

Through distance, time, and the clarity that comes with writing, I see how I failed to appreciate certain things about Matheny as much as I could have. In the superficial chill of the school, I sensed the place as void of love. This was not true. Take, for instance, Nat's braids. Someone took the time to do those braids. And her wild clothes. Someone cared enough to work with her to get the crazy styles she liked. And that boom box James got for Christmas, and the CDs. He had no immediate family, yet someone on the staff made sure he got some gifts. Maybe it was that these people we never had contact with were quiet. Maybe they were happy for the excitement that came to the students with their work with us, but were too shy to come down.

Much good work goes on up there. People like me could never run a place like that, keeping that many people alive. In important ways, Matheny is a leader in its field. Bob saw that the students got the most innovative, profoundly effective technologies available. Fantastic gear such as the Liberator, and the amazingly agile power wheelchairs. Many students across the country who could use a powerchair such as these spend their lives in manual chairs that leave them immobile. The Liberator brings speech to those who would have lived a life of silence. Bob worked to create the group homes some of the students are now moving into: a giant step toward independent living. He was, in fact, a key player in the creation of the arts program. Always working to further the goals of Matheny, he came to see me as interfering with the methodology of his administrative strategy. It was unfortunate that we came into opposition. Both of us strong-willed, confident in the rightness of our approach; neither of us would bend, and so we broke. In the end we were after the same thing: a better life for the students of the school.

I worried about the artists not having a good tracker, but hear that Eric, with his usual dogged determination, has trained the new studio assistant that the arts program director brought on. We have a new independent site that a few of the original crew have managed, through parental support, to make their way to, and they rejoin us Tuesday evenings. Nat has been down. JR is scheduled to join us. I spoke with Eric on the phone tonight, letting him know about the site. Hopefully, soon, we will reconnect with all of them.

Finished with writing the book, I have moved, in spite of my worsening vision, back into the studio, to paint. The latest, thirteen-foot-wide, narrow, irregular, diamond-shaped monstrosity is getting great reviews from my friends.

Carol continues with her painting. Using her skill with color and composition, she took the blue ribbon at the Philadelphia Flower Show. Saturday mornings, she reads for RFB and D, Reading for the Blind and Dyslexic, in Princeton.

Back from a fiasco in California, where he hired on to help cast a thirty-foot bronze Buddha—fired the first day for talking too "loud" for his silent partners—Angel is working again for us, building the stretchers and frames. Our harsh style of banter goes on, the years rolling by, the two of us still hanging out.

I saw him yesterday. He invited me to accompany him to court. When I asked him why, he explained that his license was "no good" and that he wanted the cops in the courtroom to think I was his driver.

Michael Young got out of the school. He moved into a group home. He attends the school Monday through Friday, days only. Last time I saw him, I'd brought up a photographer who wanted to include Mike in his book on sculptors. Mike wanted nothing to do with the camera, until the guy, aware of his keen interest in construction work and machines, promised him a real con-

struction worker's hardhat if he would cooperate with the photo shoot. This agreed to, the photographer returned weeks later with the aluminum hat. Once it was placed on his head, Mike buzzed off, who knows where, none of us able to find him. James, placid as ever, is on the waiting list for a new group home. I spent time with him at our annual A.R.T. backyard picnic. A balmy, sunny September afternoon, the first of two blues bands playing on the deck, James and I sat together under the canvas tent, sipping on our drinks, Chet stuck in the mud down by the creek, where Angel had taken him for a ride.

Chet is writing a book on his favorite subject: himself. It will include reproductions of his paintings, autobiographical essays, and some wild short fiction he has written, the narrator a teen who at night turns into a werewolf, wreaking terror and rock-and-roll mayhem. Mary Beth went up to Matheny to give him a werewolf mask, the kind that fits over your whole head, replete with real hair and gaping fangs. Wearing it, he had her wheel him through the halls, his howling startling sleepy students sitting against the walls.

JR has stayed in touch through his mom, who joined our board of trustees. When his group home is staffed, and he is able to take more control of his life, he will be back to work with Mary Beth and me. He has survived some serious medical scares. An article in the *New York Times* about A.R.T. included this: "Last year, when Mr. Rodkey was hospitalized, a nurse looked at his name tag as he emerged from an M.R.I. machine and surprised his mother, Betty Pursell, saying: 'We have two of his paintings. My husband loves his work.'"

The next spot that opens up at the Virginia Home, Cindy is in. She will love living in Richmond, so much closer to her parents, so many things to do about town. Next to the home, there is a huge park we used to explore back in art school, with natural

rolling acres that lead down to the James River. The staff encourage the residents to cross the few streets that will take them there.

Eric has won his father's understanding and respect. His dad started showing up at all Eric's shows, repeatedly witnessing his son's work purchased by inspired, well-heeled appreciators of fine art. His mom, his most constant supporter, by his side as well, glowing with pride; the yearning of Eric's heart was fulfilled, fresh vistas opening for him, beyond the longings of the past. He has shown again in Manhattan, alone among able-bodied artists. He tells me he has his sights set on a show in California. Having won an award for his painting, he asked me how he might get transportation to the awards banquet.

"It's in Baltimore, Eric," I said. "I don't know who would drive you that far, for a one-hour gig. Know what I mean?"

"I could fly, Tim," he smiled. "Couldn't I?"

Natalia lives just down the road from me. Her latest fashion statement: a large, dragon tattoo on her inner thigh. Green, and gold.

"It hurt, but I did not cry," she said. Mary Beth and I have been to a couple of her parties. Her paintings hang on all the walls of her apartment, and the music is always cranked up really freaking loud.

Resources

To learn more about A.R.T., visit their website:

www.artrealization.org

To contact Artistic Realization Technologies:

Telephone: 908-359-3098
E-mail: art@artrealization.org
Fax: 908-359-9206
Mail:
A.R.T.
11 Whippoorwill Way
Belle Mead, NJ 08502

Acknowledgments

I would like to thank the following people:

Anne Banister, firebrand. In the last years of her life, I trotted over from the coop to sit with her in the precolonial farmhouse she vowed to leave no other way than "feet first." Unpaid, she spread pages of the crude draft over her dining room table, put on her glasses, and, shouting when necessary, drew me into the process of learning. I wish she were here to see a bound copy of the book she shaped.

Cullen Stanley is much more than my literary agent. Believing in the book, back when it was in its roughest form, she stayed with me for the long haul. Busy with many other books, she gave me many, many hours of her time, energizing me to press on.

My father was a sounding board for each step of the writing process. Our phone calls were a haven for me to clear my thoughts.

Joyce Engelson scared me by always being right, about everything.

My brother, Mark, suggested writing a book rather than the technique manual I had planned.

Helene Atwan made the manuscript a book.

Thanks also to: Ron Siwoff, Suzanne Barabas, Angel Berrios, Carol Critchlow, Mary Beth Hill, Bruce Hall, Jonathan Becan, and Rena Pullman for believing in the power of Art. I want to thank my mother for the hours she has given to A.R.T. Crucial help in making the dream of A.R.T. real came from the awesome Mariella Tan Puerto, Scarlet Johnson, Carol Lerner, Roger Puente, Mark Antoncic, Daly Enstrom, Bette and John Pursell, Arlene and Henry Opatut, Joe Yadvish, Robert Neusner, Wade Martin, Peter Tobeason, Barbara Vaughn, and my mental health adviser David Orr. Critical key players include: Kate and Steve Somers, Chris Wheeler, Anne Marie and Agostino Teresi, Ivan Becker, Dave Lichtenstein, Gordon and Llura Gund, Sara, Jock, Steve, and Betsy. Thanks to Barb Golden and all the people at Golden Artist Colors. Thanks to the Bristol-Myers Squibb Company. Thanks to the three who kept the writing in good order on my computer: Sylvia McCarthney, Jan Weber, and Suzie Boyd. Thanks to those who took the time to review the manuscript: Art Helmke, Logan Fox, Yolanda McPhee, Eric Carlson, and Kathy Siciliano. A special thanks, in memoriam, to Roy Lichtenstein, for his support, from my teen years to the inception of A.R.T.

Thanks to Rev. William De Young and the congregation of the Harlingen Reformed Church for providing us space for our first independent studio.

Cape Branch stepped forward to aid us when no other foundation grasped the imperative of our mission. They stayed at our side through the rough-and-tumble formative years. Major thanks.

A high five to the teachers who held the torch of Art for me to see my way: Richard Carlyon, Sal Federico, Adrian Van Suchtelen, Darby Bannard, H. B. Kulkarni, Clement Greenberg, and James Alexis Johnson.

We remember three of the painters we grew so close to, who passed away so young: Todd Dupree, Jessica Opatut, and Anthony Williams.

Here's to Raphael, Beanie, V, Ellen Kane, Louis Carmona, Danny Teresi, Danielle Conte, and all the painters not mentioned in the book who touched our hearts and blew our minds.